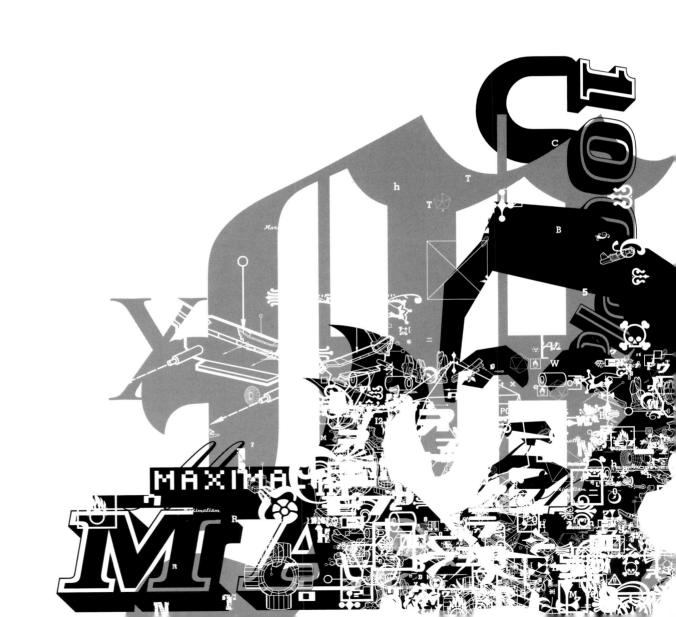

PUBLISHED AND
DISTRIBUTED BY
ROTOVISION SA
ROUTE SUISSE 9, CH-1295
MIES, SWITZERLAND
ROTOVISION SA, SALES &
EDITORIAL OFFICE.
112/116A WESTERN ROAD
HOVE, BN3 1DD, UK
T +44 (0)1273 72 7268
F +44 (0)1273 72 7269
SALES@ROTOVISION.COM
WWW.ROTOVISION.COM

10 9 8 7 6 5 4

ISBN 2-88046-794-2

BOOK CONCEPT AND
STRUCTURE BY SARA
MANUELLI. INTRODUCTION,
HELENA FRUEHAUF AND
KAM TANG ENTRIES BASED
ON TEXT BY SARA
MANUELLI. BOOK DESIGN
BY WILSON HARVEY:
LONDON (020 7420 7700).
ROTOVISION ART DIRECTOR:
LUKE HERRIOTT.
PHOTOGRAPHY XAVIER
YOUNG, PHOTOGRAPHS OF
SWALLOWS AND BEES
WALLPAPERS ON PAGES
30-31 BY JONATHAN
WARREN. PHOTOGRAPHS OF
VOGUE PARIS, FALL 2002
VOGUE PARIS, OCTOBER
2002 COVER ON PAGES
116-117 BY INEZ VAN
LAMSWEERDE AND
VINOODH MATADIN
REPROGRAPHICS IN
SINGAPORE BY PROVISION
PTE, PRINTED IN CHINA BY
MIDAS PRINTING
INTERNATIONAL LTD.

RotoVision

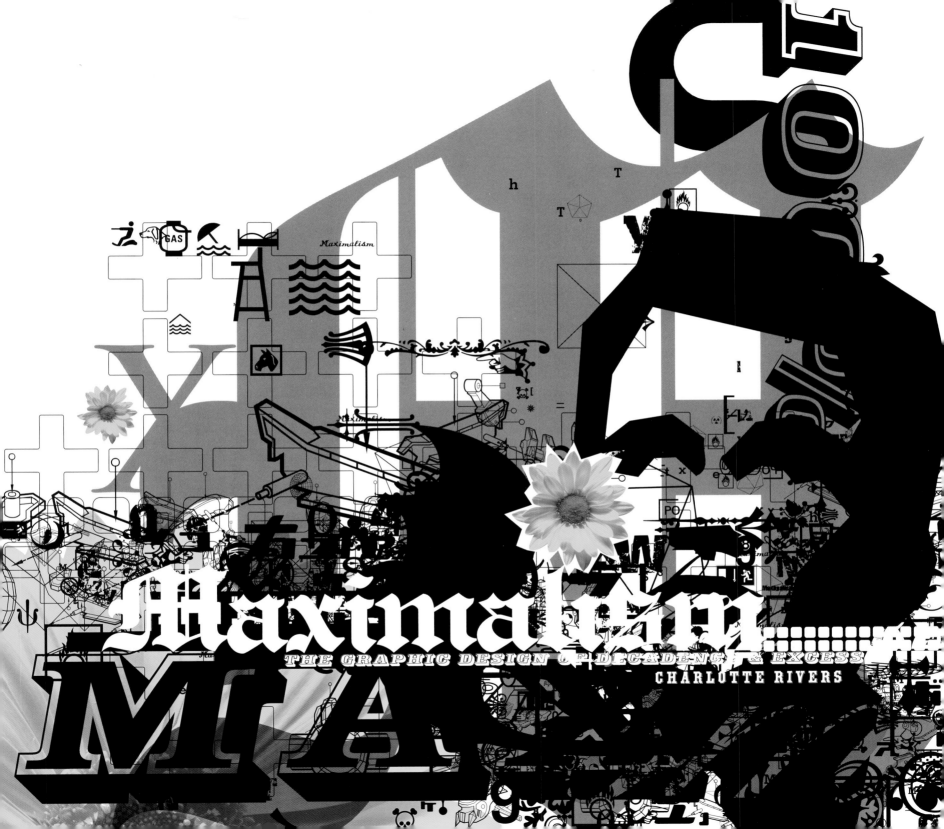

Maximalism

THE GRAPHIC DESIGN OF DECADENCE & EXCESS

CHARLOTTE RIVERS

ACKNOWLEDGMENTS FIRSTLY, I MUST SAY THANK-YOU TO ALL THE DESIGNERS AND CREATIVES WHO SUBMITTED WORK FOR INCLUSION IN THIS BOOK. WE RECEIVED SOME REALLY FANTASTIC PROJECTS AND

ULTIMATELY WITHOUT THEM, THIS BOOK WOULD NOT HAVE BEEN POSSIBLE

AS ALWAYS, THANK-YOU TO THE TEAM AT ROTOVISION, PARTICULARLY LINDY DUNLOP, JANE ROE, AND LUKE HERRIOTT. THANKS ONCE AGAIN TO XAVIER YOUNG FOR HIS GREAT PHOTOGRAPHY THROUGHOUT, AND ALSO TO PAUL BURGESS AND THE TEAM AT WILSON HARVEY FOR THE OUTSTANDING DESIGN OF MAXIMALISM.

THANKS

A FINAL BIG THANK-YOU TO JASON. THIS BOOK IS FOR MEG, CHARLOTTE, RIVERS

Contents_ Introduction

Introduction

AFTER YEARS OF MINIMALIST RULE, GRAPHIC DESIGN HAS SEEN A RETURN TO A MORE DECORATIVE, MAXIMALIST APPROACH. ORNAMENT IS NO LONGER A CRIME. ARCHITECTURE IS MORE CURVACEOUS, FASHION MORE GLAMOROUS, DESIGN MORE DECORATIVE. SILHOUETTE AND BOTANICAL MOTIFS ARE TAKING OVER FROM RIGOROUS, SIMPLE LINES AND MUTED TONES. A PROFUSION OF COLOR AND LUXURY, BRIMMING WITH EXCESS, IS STATING THE CASE FOR A RETURN TO SENSUALITY.

As design has become increasingly maximal, it has also become more sensual. Designers in print are trying to turn emotion into something visceral, not just through layout and composition, but also through choice of materials and processes. Graphics to touch, and even to taste and smell, are being employed to grab the audience's attention. Textures are becoming indulgent, sexy, and decadent, developing similarities with the workings of the fashion world.

With the demand for luxury goods and the pervasive 'bling bling' attitude of rock and fashion stars in the late 1990s, it was inevitable that this would filter down to design, in particular to packaging for luxury products. Here, the client allows the designer licence to create maximum impact by all means available. To capture the consumer's eye, perfume, beauty products, spirits, wines, and limited-edition...

Then came the mid-1990s and with them, the pared-down, loft-living generation. The birth of London-based magazine Wallpaper* helped uncover a taste for 1920s Bauhaus modernism, 1950s Eames furniture, and contemporary architects like John Pawson with his notion of 'minimum.' Revival modernism, while generating the desire for quality, gradually became an easy way of selling exclusivity to the young and wealthy.

Responsible for 1,000 show-flat interiors and retail concepts, 'modern' became mainstream and ubiquitous, diluted by cheap imitations which carried the look but none of the idea. As much as we liked the idea, it was also a difficult standard to...

In design, highly decorative elements have always enjoyed popularity, from the Arts and Crafts movement of William Morris to the art nouveau of architect Victor Horta, and the aesthetic movement of artist Aubrey Beardsley. In furniture, the futuristic and fluorescent shapes of the sixties appealed to a visionary generation of designers that included Verner Panton and Joe Colombo, but it was during the eighties that maximalism held sway, with the gaudy colors and ironic, kitsch references of Ettore Sottsass and his Milan-based design collective Memphis.

In the late nineteenth century, Alphonse Mucha provided some of the best examples of art nouveau–style graphic design. His sensual posters, with their beautiful women, decorative type, and free-flowing organic forms, became iconic images of that glamorous era. In the sixties, the psychedelic poster art of designers such as Victor Moscoso and Wes Wilson reflected the general makeup of popular culture at the time; a more liberated society embracing the newly discovered phenomena of rock music and LSD. And, of course, David Carson's design within Raygun magazine is likely to have had an influence on designers in the early nineties. His layered approach to design and seeming disregard for what is deemed "normal" saw credits displayed larger than headlines in the magazine.

The return to maximalism in design is part of an historical cycle; one that maps the struggle between minimalism and maximalism that was evident at the beginning of the twentieth century. It was Austrian architect Adolf Loos who argued against decoration by pointing to the economic and historical reasons for its development. Loos looked on contemporary decoration as mass-produced trash, famously equating ornament with crime, and holding a belief that the suppression of decoration was necessary for the regulation of passion. In design and architecture, the reaction to the decorative and ornamental styles of the day took the form of modernism and art deco. Minimalists and maximalists have been fighting over style ever since.

At the International Art Exhibition organized by the Venice Biennale in 2003, British painter Chris Ofili heralded the return of a decorative aesthetic with a pavilion saturated with sumptuous, kaleidoscopic colors. Luxury label Louis Vuitton commissioned cult Japanese artist Takashi Murakami to pepper its LV logo with cartoon characters encrusted in diamonds. Overstatement is in, understatement is definitely out.

But then came the mid-nineties and the pared-down, loft-living generation. The birth of London-based magazine Wallpaper* helped uncover a taste for twenties' Bauhaus modernism, fifties' Eames furniture, and contemporary architects like John Pawson with his notion of "minimalism." Revival modernism, while generating a desire for quality, gradually became an easy way of selling exclusivity to the young and wealthy. Responsible for thousands of showroom interiors and retail concepts, "modern" became mainstream and ubiquitous, diluted by cheap imitations that carried the looks, but none of the values. As much as we liked the idea, it was a difficult standard to live up to in everyday life. As designers, and eventually consumers, grew bored with minimalism, the need arose for a movement that could provoke with rather more extravagance.

Today, designers are embracing decoration, but refracting it through the lens of modernism. This is most evident in product and furniture design thanks to practitioners like Tord Boontje in the U.K., and Marcel Wanders and Hella Jongerius in the Netherlands. Part of a "new romantic" approach, this breed of designer is not just reviving the old "Arts and Crafts" aesthetic, but combining handicraft with technology to produce rich, individual work. In digital media, Daniel Brown's startlingly organic digital flowers bloom and blossom with extraordinary delicacy and life. The collaborative work of Petter Ringbom (at New York design agency Flat) and Agnieszka Gasparska shows how Web design can be a real visual feast. This is the very antithesis of digital design's trend toward mechanical and geometric precision.

In interiors, more is more, with American designer Adam Tihany creating luxurious, overstated hotels, restaurants, and bars in the United States and Europe. Restaurant/bar/club Sketch in London, arguably the most expensive establishment in the world, features lavish interiors and unisex toilets studded with Swarovski crystals. In its Tea Salon, a cherry-blossom tree decorates the wall, painted freehand by fashion designer Ann-Louise Roswald, and trompe l'oeil–flower carpets cover the floor.

Less exclusively, every homeware catalog is awash with patterns and swirls, with retro florals covering wallpaper and fabrics. This style appeals to mass consumerism much more than the understated blond wood approach.

However, it is in the unlikely medium of graphic design that maximalism has become widespread, and it is this that Maximalism celebrates. Graphics has been dominated by the values of hard design, gleaned from a blend of Swiss typography and Mac-generated minimalism. After 10 years of rigorous layout, designers are increasingly embracing decoration and abandoning Helvetica in favor of repeat patterns, vivid contrasts, embellishments, and gothic typography. Decoration in particular, composed of repetitive symbols and elements, reflects a trend toward more metaphoric and narrative values. In illustration, vector-based line drawings are being supplanted by hand-drawn, elaborate renderings. Illustrator Kam Tang's highly ornate signature style has been applied to magazine covers and design identities. Artist, illustrator, and fashion designer Julie Verhoeven's kooky, pretty approach is more than a nod to the hippy style so favored by iconic seventies fashion companies like Biba. On top of that, illustration is going through a renaissance that has seen designers favoring illustration over photography, ultimately giving way to more experimental, decorative, and patterned design.

As design has become increasingly maximal, it has also become more sensual. Designers in print are trying to turn emotion into something visceral, not just through layout and composition, but also through choice of materials and processes. Graphics to touch, and even to taste and smell, are being employed to grab audiences' attention. Textures are becoming indulgent, sexy, and decadent, developing similarities with the workings of the fashion world. It is the fashion world that can give us some of the best examples of maximalist design, including London-based SEA design's work for Matthew Williamson, Michael Nash Associates' work for John Galliano, and, of course, the legendary fashion magazine Visionaire, issue no. 42 of which comes complete with 21 original and exclusive perfumes.

However, as in every area of design—fashion, architecture, interior design—graphic design moves in cycles. My discussions with designers in researching this book proved that while there is no general consensus that maximalism is the new minimalism, there is an overriding sense that there has been a definite influx of decorative design, due to all manner of cultural influences. As this book attempts to show, this is being expressed in many different ways. DECORATION charts the return of ornament and embellishment with work like the in-store design of the Levi's Girls store in Paris, by design group The Kitchen (see pages 054–055). SENSUALITY states the case for a multidimensional approach to print, looking at work that appeals to our senses, including Gunnar Thor Vilhjalmsson's musical CD package and Visionaire magazine (see pages 074–075 and 064–065). LUXURY looks at sumptuous packaging and design, including Sartoria's collaboration with legendary photographer Harri Peccinotti and graffiti artist Mode2 on a limited-edition calendar (see pages 104–105).

And finally, FANTASY looks at the parallel world inhabited by diverse design manifestations, in particular illustration, by artists and design groups including Michael Gillette, Vault49, and Insect (see pages 108–109, 112–113, 138–139, and 143), with childlike, dream-style illustrations.

Whether this "return to maximalism" is just a passing trend, only time will tell. In a sense maximalism has always coexisted with minimalism and no doubt always will. Ultimately, it is a question of whether the design is appropriate (some things should simply never be brimming with excess), of what a client might want, and what a product may require. The minimalist/maximalist argument is part of a continuing cycle, a tug-of-war between function and decoration. As humans we go through phases, and that is reflected in everything we create and everything with which we surround ourselves, from clothes to music to home decoration. We get into minimalism, become bored, and start decorating, then we get sick of that and return to functionalism. Inevitably, as our desires, demands, and tastes change, so too will architecture, fashion, and graphic design.

WITH A CLOCKWORK PRECISION THAT SEES MOVEMENTS AND TRENDS COME IN AND OUT OF FASHION, IT APPEARS THAT DESIGN HAS SEEN A RETURN TO DECORATION IN RECENT YEARS. DECORATION REACHED ITS HEIGHT AT THE BEGINNING OF THE TWENTIETH CENTURY, IN WHAT BECAME KNOWN AS THE APPLIED ARTS, BEFORE FALLING VICTIM TO MODERNISM. NOW THE CULT FOR ORNAMENT HAS APPEARED IN GRAPHIC DESIGN AS A REACTION, PERHAPS, TO THE PARED-DOWN DESIGN APPROACH THAT WAS SO POPULAR IN THE NINETIES.

If you were to argue the case for decoration, it would mean taking on a charged historical debate. A brief look reveals that at the turn of the twentieth century, inspired by Oscar Wilde, the aesthetic movement, and artists such as Aubrey Beardsley, design promoted the romantic ideal that a better quality of life could be made available to everyone through beauty. However, in 1908, Vienna-based designer Adolf Loos challenged that ideal through his writings in Ornament and Crime, becoming the first designer to reject the need for ornament in architecture and interior design.

Loos' writings influenced such designers as Le Corbusier, one of the twenties' most prominent modernist architects. He applied the ideals of simple and honest design to his work, stressing the importance of a distinction between art and objects of use, and establishing a divorce between decoration and function. He referred to the decorative arts as "the final spasm of a predictable death," believing that they would not exist in the future. At the same time, art deco was proving to be widely influential in the United States and was bringing modernity to ornament in the design of cruise liners, apartment buildings, furniture, and graphics across the U.K. and mainland Europe.

Le Corbusier's notions of rationalization and the disposability of luxury in everyday life went on to influence generations of modernist architects and designers. This was, perhaps, due to the fact that an aesthetic approach to design, the only end of which was the pursuit of beauty and pleasure, was often regarded as pretentious and decadent, and intricate patterns and motifs were perceived as vulgar. The debate about the validity of form over function ran on and on, and the aesthetic argument became imbued with moral undertones. Today, style has lost its moral and political baggage, allowing ornament a different raison d'être.

Most of the work included in this chapter argues the case for embellishment. Having learned from the experience of modernism, today's decorative approach is aware of function, and embraces it with a variety of techniques and materials. Decoration is often used as a narrative device; repetitive symbols, archetypes, and floral imagery "tell a story" rather than being simply picturesque.

Ornament has also inspired a revival of decorative, sixties-style illustration, a reaction to the digitally generated line drawings that were so common in the nineties. Yet this isn't about retronostalgia; it's a style that heralds a movement toward the "hand-drawn" while still employing a computer to finish off the work. Finally, decoration is shaking off its "disguise" tag and becoming celebrated as a medium through which to stimulate emotion, provoke response, and produce dazzling work.

CHAPTER ONE

Decoration

ornament, handicraft, technology

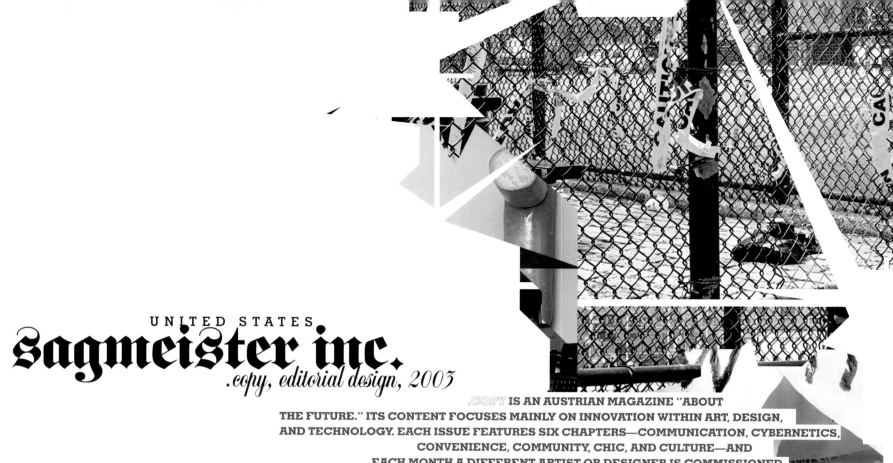

sagmeister inc.
.copy, editorial design, 2003

.COPY IS AN AUSTRIAN MAGAZINE "ABOUT THE FUTURE." ITS CONTENT FOCUSES MAINLY ON INNOVATION WITHIN ART, DESIGN, AND TECHNOLOGY. EACH ISSUE FEATURES SIX CHAPTERS—COMMUNICATION, CYBERNETICS, CONVENIENCE, COMMUNITY, CHIC, AND CULTURE—AND EACH MONTH A DIFFERENT ARTIST OR DESIGNER IS COMMISSIONED TO CREATE A SERIES OF IMAGES FOR THE CHAPTER-OPENER PAGES.

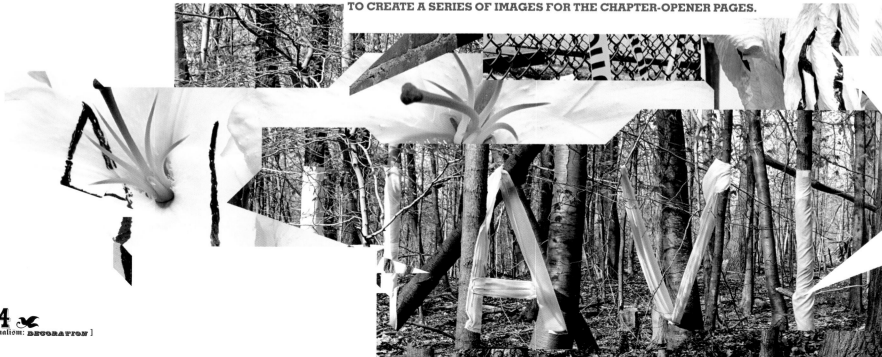

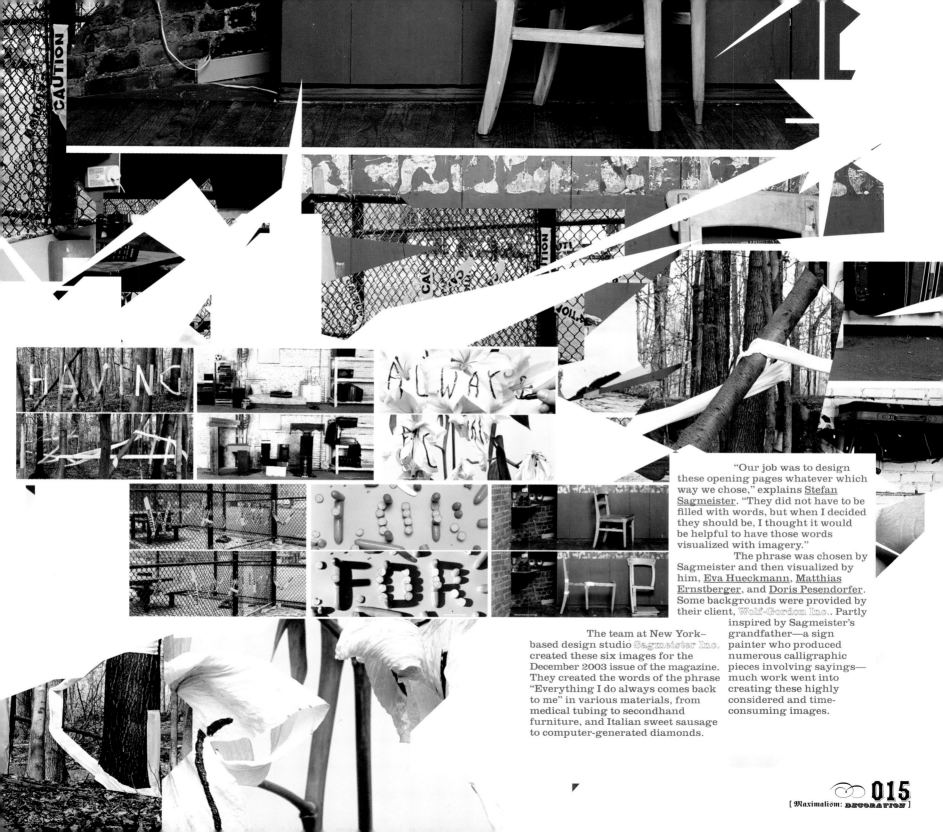

"Our job was to design these opening pages whatever which way we chose," explains Stefan Sagmeister. "They did not have to be filled with words, but when I decided they should be, I thought it would be helpful to have those words visualized with imagery."

The phrase was chosen by Sagmeister and then visualized by him, Eva Hueckmann, Matthias Ernstberger, and Doris Pesendorfer. Some backgrounds were provided by their client, Wolf-Gordon Inc.. Partly inspired by Sagmeister's grandfather—a sign painter who produced numerous calligraphic pieces involving sayings— much work went into creating these highly considered and time-consuming images.

The team at New York–based design studio Sagmeister Inc. created these six images for the December 2003 issue of the magazine. They created the words of the phrase "Everything I do always comes back to me" in various materials, from medical tubing to secondhand furniture, and Italian sweet sausage to computer-generated diamonds.

Honest worked with Schoonmaker to create the identity, Web site, and catalog for this exhibition. Using colorful imagery, pattern, and a variety of typefaces, Honest has tried to communicate Kuti's rich and colorful life. He had 27 wives and, at one point, was targeted by the Nigerian government as among the State's number-one enemies. "We wanted to use the art of Ghariokwu Lemi, the designer of many of Kuti's original album covers, and the one that we ended up using, the collage, was a piece that had never been published before. It really was perfect," explains Cary Murnion, a partner at Honest. "Lemi made the collage when Fela died to honor his legacy, and it captured his many personalities: the musician, the revolutionary, the womanizer, the scoundrel, the father, and the man.

The exhibition, curated by Trevor Schoonmaker, was a multimedia project that explored and commemorated the influence of legendary musician Fela Kuti, who died in 1997. According to many, Kuti was one of his generation's best musicians. He single-handedly created a genre of music, Afrobeat, that has influenced everyone from David Byrne, through Mos Def, Prince, and Erykah Badu, to the Red Hot Chili Peppers. He was the voice of Nigeria's have-nots and used popular music to inspire and incite cultural revolution in Africa.

UNITED STATES

Honest

fela kuti exhibition catalog, 2003

THIS CATALOG WAS DESIGNED BY NEW YORK–BASED HONEST TO ACCOMPANY THE EXHIBITION BLACK PRESIDENT: THE ART & LEGACY OF FELA ANIKULAPO KUTI, HELD AT THE NEW MUSEUM, NEW YORK, IN 2003.

ISBN 0-915557-87-8

"I drew many versions of the type as I wanted it to be integrated with the image, yet really pop off the cover so that people could read it on the book stands," Murnion adds. "It also had to walk that line of referencing the very distinct artwork of Fela's albums yet remaining original."

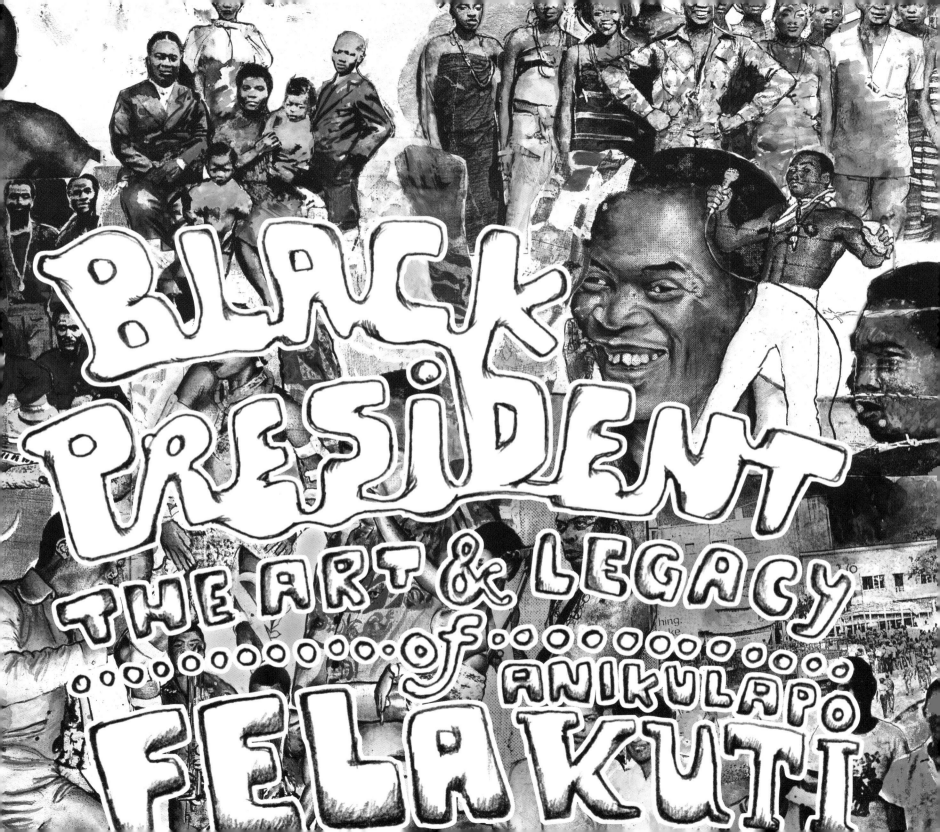

UNITED KINGDOM

chris edmunds,
london creative alliance

trailer happiness interior design, 2003

TRAILER HAPPINESS OPENED IN LONDON'S PORTOBELLO ROAD, NOTTING HILL, IN LATE 2003. IT IS AN INTIMATE LOUNGE BAR, DEN, AND KITCHEN WITH THE EASY FEEL OF A LOW-RENT, MID-SIXTIES, CALIFORNIA VALLEY BACHELOR PAD; A KIND OF RETROSEXUAL HAVEN OF COSMOPOLITAN KITSCH AND FADED TRAILER-PARK GLAMOR WITH CORK TILES AND SHAG PILE, LOVE SONGS AND VOL-AU-VENTS, LYNCH PRINTS AND TIKI DRINKS.

FIV

FIVE P

£5

HeAd BARtEnDEr

THIS NOT
TRA
177 PoRToBE

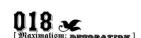

£50

£50

£50

HeAd BARtEnDer

THIS
177 PoRT

TEN POUNDS

£10

£10

£10

THIS NOTE MAY ONLY BE USED AT
TRAILER HAPPINESS
177 PoRToBELLo Rd NoTTING HILL W11

U N

SECuRITY nO.

BE USED AT
PPINESS
oTTING HILL W11

TRAILER CASH

Highly decorative baroque illustrations frame the notes that were given, as vouchers, to potential customers and press to promote the bar's opening. The bar has proved highly popular although, shortly after opening, an original collection of flying ducks was stolen from the bar wall. A polite notice was designed, offering a £500 (c. U.S. $900) bar tab to anyone with information leading to the safe return of the ducks.

Design consultant Chris Edmunds worked closely with Jonathan Downey, owner of London bars Milk & Honey and The Player, to help realize Trailer Happiness and ensure its place as a haven for discerning drinkers. This creative combination was further enhanced with a cocktail menu compiled by the King of Cocktails Dale DeGroff.

Tiki culture reached its peak between 1955 and 1965, thanks largely to the success of Hawaii joining the U.S. union in 1959, and to the stream of Elvis movies that followed, beginning with Blue Hawaii in 1961. Tiki drinks and dining also injected new hope and optimism into a postwar, cold-war society eager to escape to the bright new future of a space age. Yesterday's future never came, but the drinks live on—Zombies, Velvet Voodoos, and Mai Tais, to name but a few—and are as popular as ever.

In keeping with this era, and to create the right atmosphere, sultry J. H. Lynch prints, in their original unglazed Boots frames, adorn the walls of Trailer Happiness, and Tretchikoff's Miss Wong appears in large murals.

This theme is continued in the printed material for the bar; menus feature Tina, promotional literature features period kitsch, prints, and textiles sourced from online auctions.

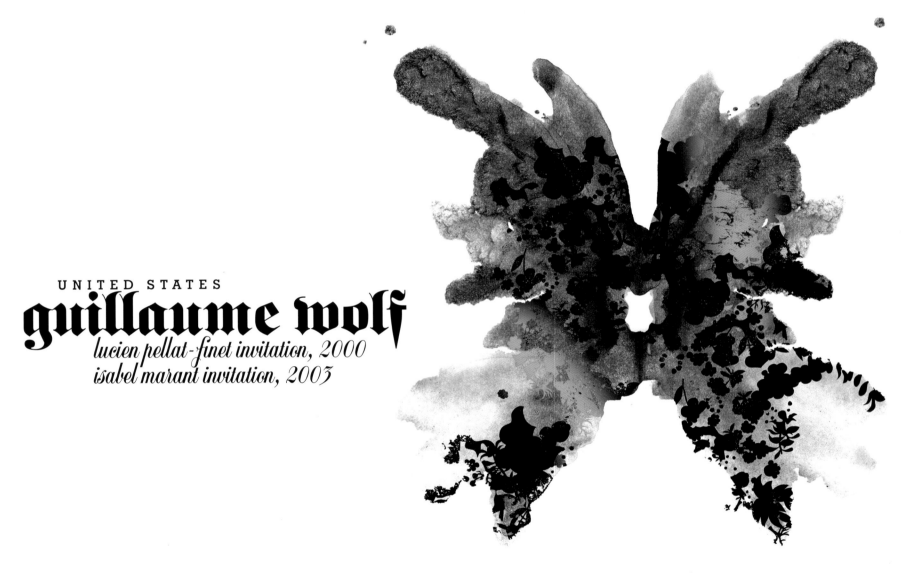

guillaume wolf

lucien pellat-finet invitation, 2000
isabel marant invitation, 2003

ISABEL MARANT

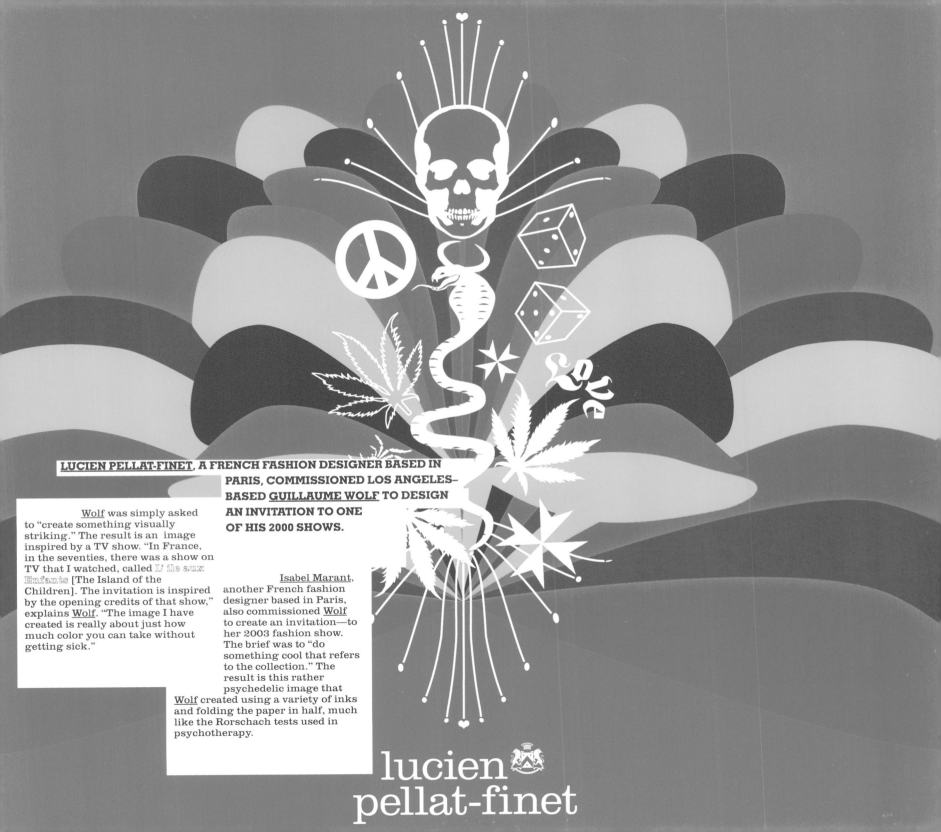

LUCIEN PELLAT-FINET, A FRENCH FASHION DESIGNER BASED IN PARIS, COMMISSIONED LOS ANGELES–BASED GUILLAUME WOLF TO DESIGN AN INVITATION TO ONE OF HIS 2000 SHOWS.

Wolf was simply asked to "create something visually striking." The result is an image inspired by a TV show. "In France, in the seventies, there was a show on TV that I watched, called L' île aux Enfants [The Island of the Children]. The invitation is inspired by the opening credits of that show," explains Wolf. "The image I have created is really about just how much color you can take without getting sick."

Isabel Marant, another French fashion designer based in Paris, also commissioned Wolf to create an invitation—to her 2003 fashion show. The brief was to "do something cool that refers to the collection." The result is this rather psychedelic image that Wolf created using a variety of inks and folding the paper in half, much like the Rorschach tests used in psychotherapy.

lucien pellat-finet

fabio ongarato design

toasted identity and interior design, 2003

TOASTED IS DESCRIBED AS A SMALL SANDWICH BAR WITH A BIG PERSONALITY. MELBOURNE-BASED FABIO ONGARATO DESIGN WAS COMMISSIONED TO DEVELOP AN IDENTITY AND INTERIOR DESIGN THAT SET A BENCHMARK APPROACH FOR THE WAY THIS FRANCHISE POSITIONED ITSELF IN THE MARKETPLACE. THE CHALLENGE WAS TO CREATE A DYNAMIC NICHE ENVIRONMENT WITHIN A LARGE SHOPPING COMPLEX; EVERY DETAIL OF THIS PRODUCTION WAS CAREFULLY DIRECTED. THE TEAM WANTED TO CREATE SOMETHING NEW, FRESH, AND DIFFERENT FROM OTHER SIMILAR OUTLETS.

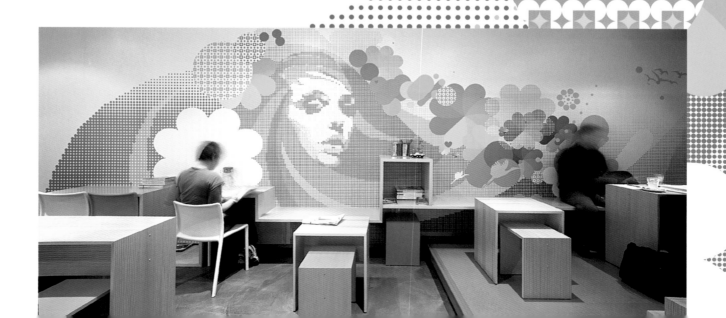

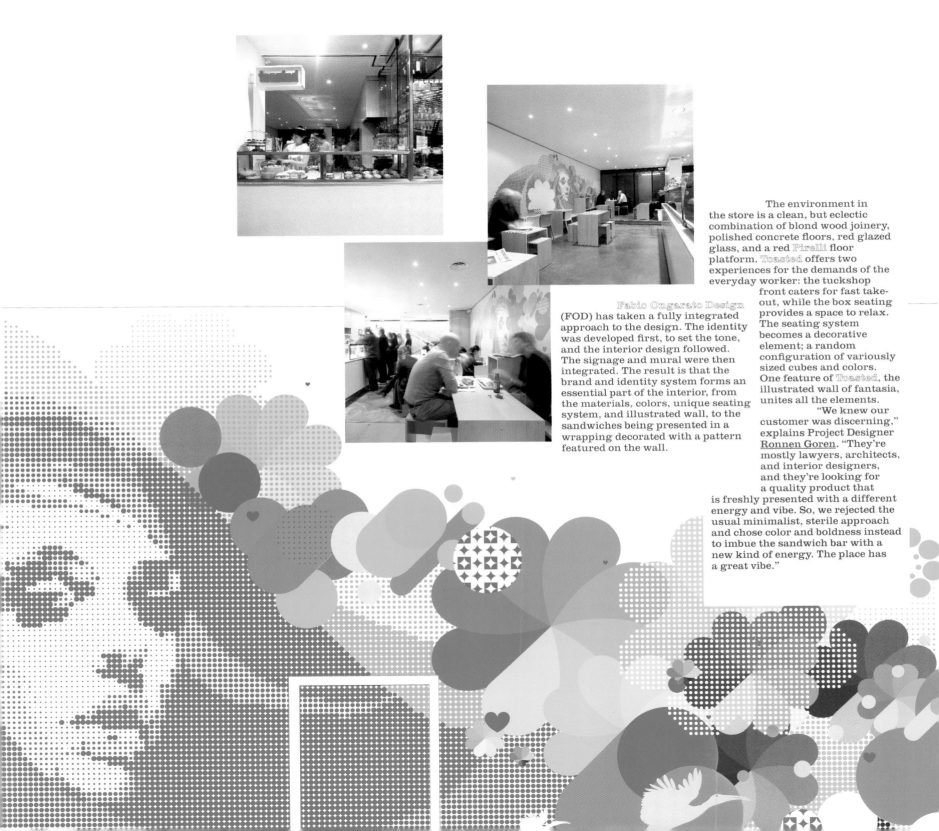

The environment in the store is a clean, but eclectic combination of blond wood joinery, polished concrete floors, red glazed glass, and a red Pirelli floor platform. Toasted offers two experiences for the demands of the everyday worker: the tuckshop front caters for fast take-out, while the box seating provides a space to relax. The seating system becomes a decorative element; a random configuration of variously sized cubes and colors. One feature of Toasted, the illustrated wall of fantasia, unites all the elements.

"We knew our customer was discerning," explains Project Designer Ronnen Goren. "They're mostly lawyers, architects, and interior designers, and they're looking for a quality product that is freshly presented with a different energy and vibe. So, we rejected the usual minimalist, sterile approach and chose color and boldness instead to imbue the sandwich bar with a new kind of energy. The place has a great vibe."

Fabio Ongarato Design (FOD) has taken a fully integrated approach to the design. The identity was developed first, to set the tone, and the interior design followed. The signage and mural were then integrated. The result is that the brand and identity system forms an essential part of the interior, from the materials, colors, unique seating system, and illustrated wall, to the sandwiches being presented in a wrapping decorated with a pattern featured on the wall.

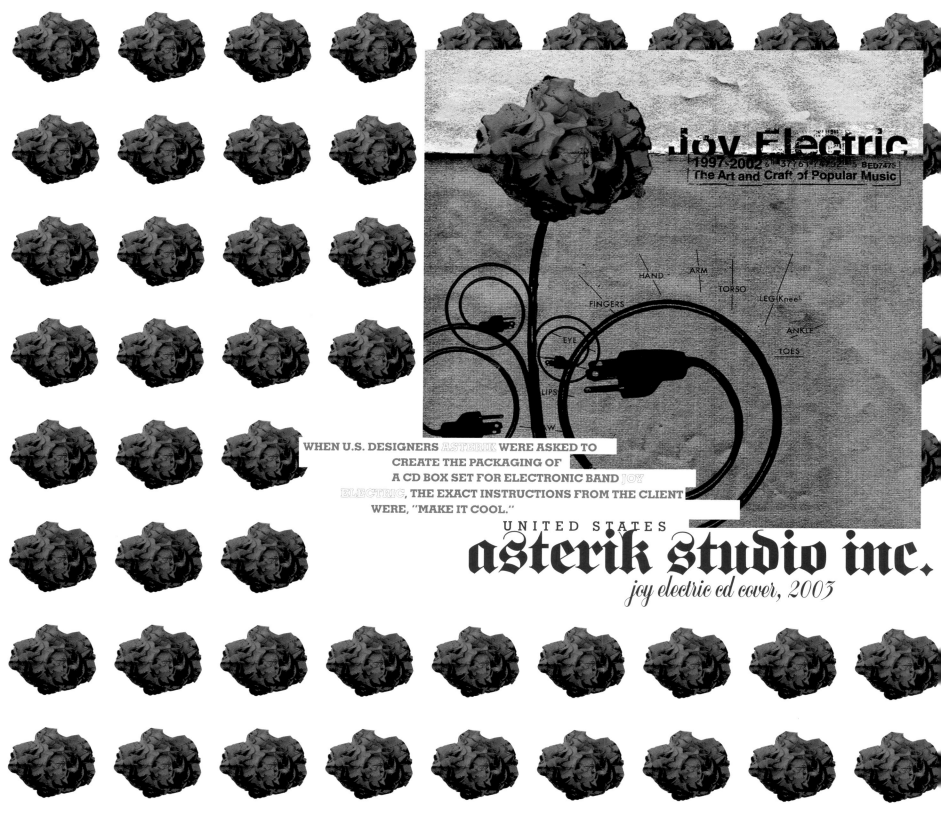

Joy Electric
1997-2002 6 37761 74352 5 BED7475
The Art and Craft of Popular Music

HAND ARM
TORSO
FINGERS LEG(Knee)
ANKLE
EYE TOES
LIPS

WHEN U.S. DESIGNERS ASTERIK WERE ASKED TO
CREATE THE PACKAGING OF
A CD BOX SET FOR ELECTRONIC BAND JOY
ELECTRIC, THE EXACT INSTRUCTIONS FROM THE CLIENT
WERE, "MAKE IT COOL."

UNITED STATES
asterik studio inc.
joy electric cd cover, 2003

So how did they go about that? Well, as designer <u>Don Clark</u> explained, it meant a departure from previous artwork used for the band. "Joy Electric has had its fair share of substandard CD artwork, so we wanted to change that. We wanted to sum up Joy Electric in one image; the growth, all of the years of hard work, the style of music, generally everything about the band.

"Also, we wanted to convey electricity, beauty, and just an overall feel for a collection of many years' worth of work," he adds. We wanted to make it feel like a collection of sorts … a timeless piece that grasped the music in every way."

<u>Clark</u> shot images of flowers and power cables and scanned them, along with random parts of medical books, to compose an image in Photoshop. Helvetica Bold was the typeface used throughout.

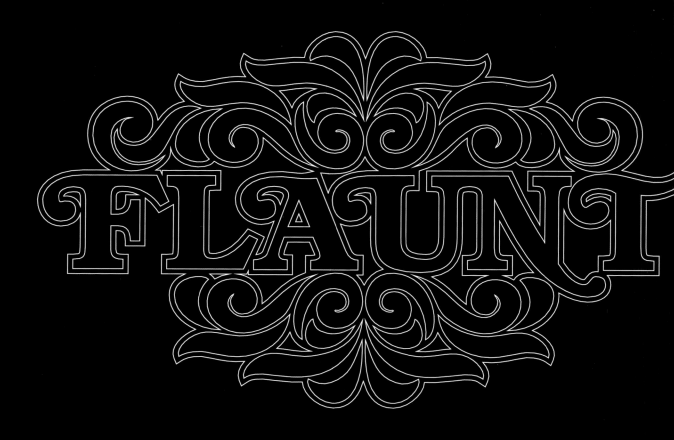

SWEDEN
walse custom design
logo design for flaunt magazine, 2003

HENRIK WALSE, AT WALSE CUSTOM DESIGN, CREATED THIS LOGO FOR THE FIFTH ANNIVERSARY ISSUE OF LOS ANGELES–BASED FASHION MAGAZINE FLAUNT. THE COVER IMAGE FOR THAT ISSUE WAS A SLIGHTLY GOTHIC ILLUSTRATION OF OSCAR-WINNING ACTRESS JENNIFER CONNOLLY. ALTHOUGH WALSE SAID HE IS NOT A PARTICULAR FAN OF GOTHIC AESTHETICS, HE STEERED HIS STYLE AS MUCH TOWARD GOTHIC AS HE COULD.

"The main idea behind this work is the same as that behind most of my work," Walse explains. "In the seventies, before computer-aided design, there were companies doing nothing but design and draw new type letters and logos. I am inspired by that handicraft; it feels like people have stopped making complicated decorative logos."

So, in FreeHand, and freehand, Walse redrew the Bookman typeface, making it far more elaborate and decorative. He also added ornamental patterns around the logo to further emphasize the idea of Gothicism and decadence. The magazine uses different logos on the front cover of every issue, and different artists to illustrate each cover. (New York–based Vault49's cover image and design for Flaunt can be seen on pages 122–123.)

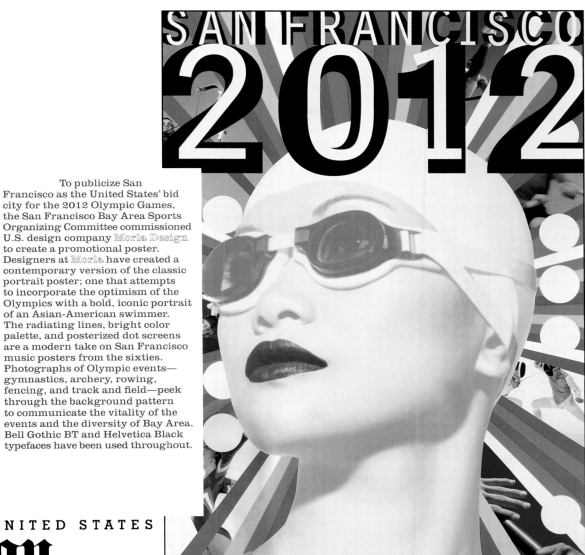

SAN FRANCISCO
2012

To publicize San Francisco as the United States' bid city for the 2012 Olympic Games, the San Francisco Bay Area Sports Organizing Committee commissioned U.S. design company Morla Design to create a promotional poster. Designers at Morla have created a contemporary version of the classic portrait poster; one that attempts to incorporate the optimism of the Olympics with a bold, iconic portrait of an Asian-American swimmer. The radiating lines, bright color palette, and posterized dot screens are a modern take on San Francisco music posters from the sixties. Photographs of Olympic events—gymnastics, archery, rowing, fencing, and track and field—peek through the background pattern to communicate the vitality of the events and the diversity of Bay Area. Bell Gothic BT and Helvetica Black typefaces have been used throughout.

UNITED STATES

morla design
san francisco 2012, promotional poster for the
bay area sports organizing committee, 2002

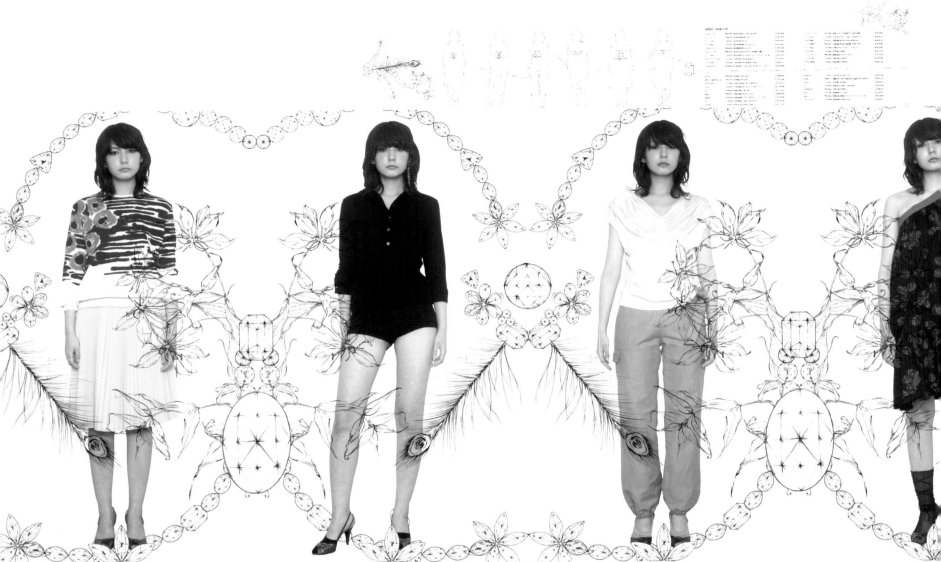

JAPAN
sunday-vision

orine catalog, 2003

JAPANESE DESIGN HOUSE SUNDAY-VISION CREATED THIS INTERESTING CATALOG FOR THE SPRING/SUMMER 2003 COLLECTION OF JAPANESE CLOTHING COMPANY ORINE. THE BRAND TARGETS THE 20- TO 30-SOMETHING WOMAN, SO THE DESIGN OF THE CATALOG HAD TO DIRECTLY APPEAL TO THAT MARKET.

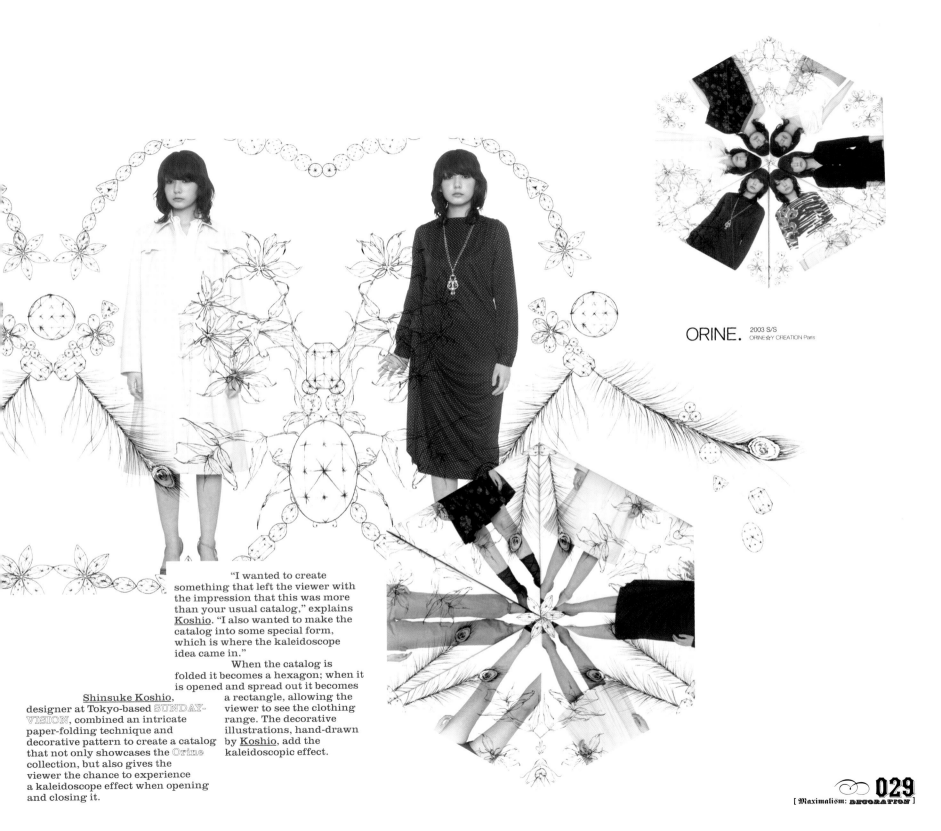

ORINE. 2003 S/S
ORINE☆Y CREATION Paris

"I wanted to create something that left the viewer with the impression that this was more than your usual catalog," explains Koshio. "I also wanted to make the catalog into some special form, which is where the kaleidoscope idea came in."

When the catalog is folded it becomes a hexagon; when it is opened and spread out it becomes a rectangle, allowing the viewer to see the clothing range. The decorative illustrations, hand-drawn by Koshio, add the kaleidoscopic effect.

Shinsuke Koshio, designer at Tokyo-based SUNDAY-VISION, combined an intricate paper-folding technique and decorative pattern to create a catalog that not only showcases the Orine collection, but also gives the viewer the chance to experience a kaleidoscope effect when opening and closing it.

absolute zero°

swallows wallpaper, designed exclusively for flo (u.k.), 2003
bees wallpaper, designed exclusively for flo (u.k.), 2004

PATTERNED WALLPAPER HAS HAD SOMETHING OF A RENAISSANCE IN
RECENT YEARS. IT IS NO LONGER CONFINED TO ROOMS THAT
HAVEN'T BEEN DECORATED SINCE THE SIXTIES, BUT HAS
SPREAD TO NEWLY OPENED BARS AND STYLISH APARTMENTS.
IT CAN BE FLOCKED, SCREEN PRINTED, HANDPAINTED, OR COMPUTER GENERATED, JUST AS
LONG AS IT'S PATTERNED. THIS CURRENT TREND HAS SEEN A NUMBER OF GRAPHIC DESIGNERS TR
THEIR HAND AT WALLPAPER DESIGN, INCLUDING LONDON-BASED
KEITH STEPHENSON AT ABSOLUTE ZERO°.

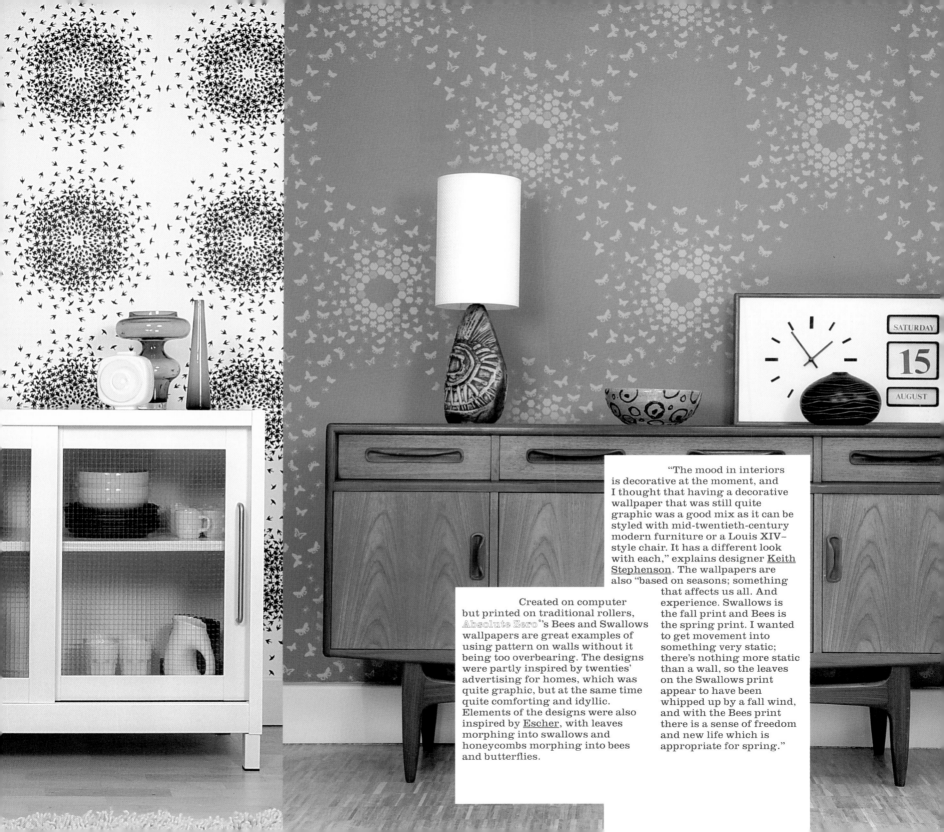

"The mood in interiors is decorative at the moment, and I thought that having a decorative wallpaper that was still quite graphic was a good mix as it can be styled with mid-twentieth-century modern furniture or a Louis XIV–style chair. It has a different look with each," explains designer Keith Stephenson. The wallpapers are also "based on seasons; something that affects us all. And experience. Swallows is the fall print and Bees is the spring print. I wanted to get movement into something very static; there's nothing more static than a wall, so the leaves on the Swallows print appear to have been whipped up by a fall wind, and with the Bees print there is a sense of freedom and new life which is appropriate for spring."

Created on computer but printed on traditional rollers, Absolute Zero°'s Bees and Swallows wallpapers are great examples of using pattern on walls without it being too overbearing. The designs were partly inspired by twenties' advertising for homes, which was quite graphic, but at the same time quite comforting and idyllic. Elements of the designs were also inspired by Escher, with leaves morphing into swallows and honeycombs morphing into bees and butterflies.

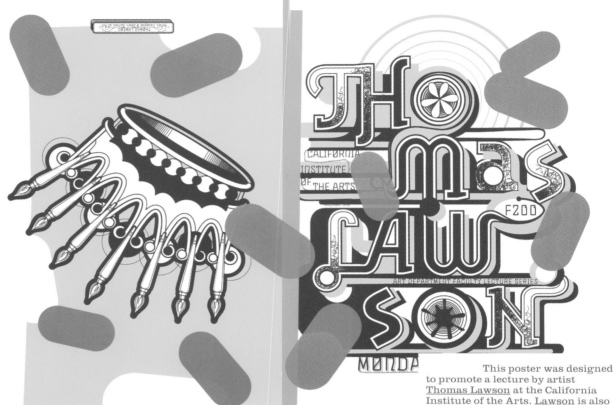

andrea tinnes

thomas lawson, california institute of the arts poster, 1998
haircrimes, self-promotional poster, 2001

ANDREA TINNES IS AN INDEPENDENT
GRAPHIC AND TYPE DESIGNER WHO
WORKS OUT OF THE
INTERDISCIPLINARY
STUDIO COLLECTIVE DAS
DECK, IN BERLIN. HER WORK HAS WON AWARDS,
INCLUDING ONE FROM THE AMERICAN CENTER FOR DESIGN (THE 100
SHOW, 1999) AND THE RED DOT AWARD FOR COMMUNICATION DESIGN
2001/2002, FROM DESIGN ZENTRUM NORDRHEIN-
WESTFALEN. MUCH OF IT DISPLAYS A STRONG ELEMENT OF MAXIMALISM.
SHOWN HERE ARE A NUMBER OF HER POSTER DESIGNS, CREATED
BOTH FOR CLIENTS AND FOR SELF-PROMOTION.

This poster was designed
to promote a lecture by artist
Thomas Lawson at the California
Institute of the Arts. Lawson is also
the Dean of the Art School at the
Institute, where Tinnes studied.
He is known for the distinction he
makes between artists and
designers; he acknowledges the
former and ignores the latter.
Taking the opportunity for free
expression, Tinnes attempted to
walk the thin line between homage
and critique with this project,
combining the two with wit and
humor. The result is a poster that
celebrates the visual potential of
graphic design, while challenging
the relationship of art and design.
Two of Tinnes' own typefaces were
used—Morris and Rudolph.

modern ornament has no forebears and no descendants, no past and no future. It is joyfully welcomed by uncultivated people to whom the true greatness of our time is a closed book and after a short time is rejected.

01

ABCDEFGHIJKLMNO
PQRSTUVWXYZabcd
efghijklmnopqrstuv
wxyz 1234567890

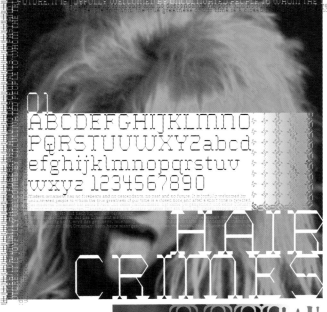

HAIR CRIMES

02

ABCDEFGHIJKLM
NOPQRSTUVWX
YZabcdefghijklm
nopqrstuvwxyz
1234567890

Modern ornament has no forebears and no descendants, no past and no future. It is joyfully welcomed by uncultivated people to whom the true greatness of our time is a closed book and after a short time is rejected. Das moderne Ornament hat keine Eltern und keine Nachkommen, hat keine Vergangenheit und keine Zukunft. Es wird von unkultivierten Menschen, denen die Groesse unserer Zeit ein Buch mit sieben siegeln ist, mit freuden begruesst und nach kurzer Zeit verleugnet.

Der Moderne wird das Ornament als Zeichen der kuenstlerischen Ueberschuesskraft vergangener Epochen heilig haelt, wird das gequaelte, muehselig abgerungene und krankhafte der modernen Ornamente sofort erkennen. Kein Ornament kann heute mehr geschaffen werden von einem, der auf unserer Kulturstufe lebt.

Shown here are two versions of a self-promotional poster for Tinnes' HairCrimes typeface. She describes HairCrimes as a series of modular typefaces that explore the ornamental potential of the alphabet, and pay homage to the decorative language of historical monograms and the beautiful calligraphy of Georg Bocskay. However, since she didn't want HairCrimes to be a purely nostalgic interpretation of historical typefaces, she introduced the principle of systematic repetition of modular elements to achieve a contemporary look. The name HairCrimes is a verbal pun, referring to the thin hairlines the typefaces are made of and the "criminal aspects" of ornamentation. With Adolf Loos' quote "ornament is crime" very much in mind, Tinnes has worked this idea into the posters by showing examples of "criminal" hairstyles and by creating ornamental borders.

HAIR CRIMES

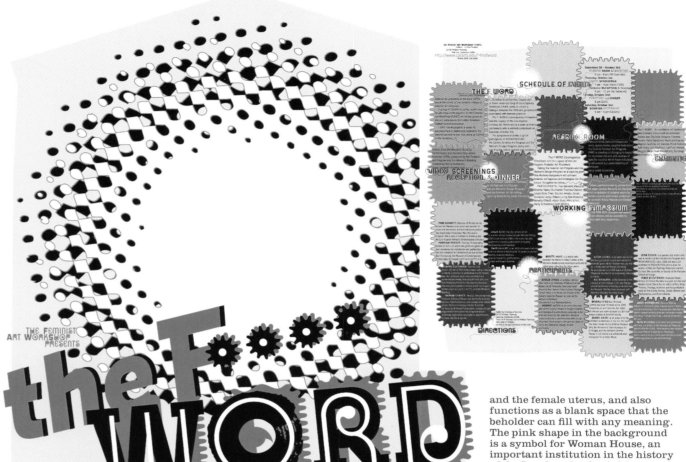

*the f**** word, feminist art workshop poster, 1998*

This poster-come-mailer was commissioned by the Los Angeles–based Feminist Art Workshop to announce a series of events it held about contemporary feminism and the legacy of the Los Angeles feminist art movement. Tinnes wanted the poster to incorporate female aesthetics and feminist art strategies, but at the same time to deconstruct the cliché of a female aesthetic in a playful and experimental way. To this end, the poster's visual language explores all the clichés of a female aesthetic, from color over form, to type. The dominant round form in the center of the poster signifies growth and the female uterus, and also functions as a blank space that the beholder can fill with any meaning. The pink shape in the background is a symbol for Woman House, an important institution in the history of the Los Angeles feminist art movement. Overall, the design plays with references to detergent packaging, a vernacular appropriation to symbolically address a female audience. The reverse of the poster is a patchwork of information about the Art Workshop events, and refers to feminist art strategies of the seventies that worshiped handcraft and female labor. In addition, Tinnes has used the Laika and Acropolis typefaces, in order to combine a strong "male" sans-serif typeface with a playful decorative "female" typeface and communicate a "multigender" voice.

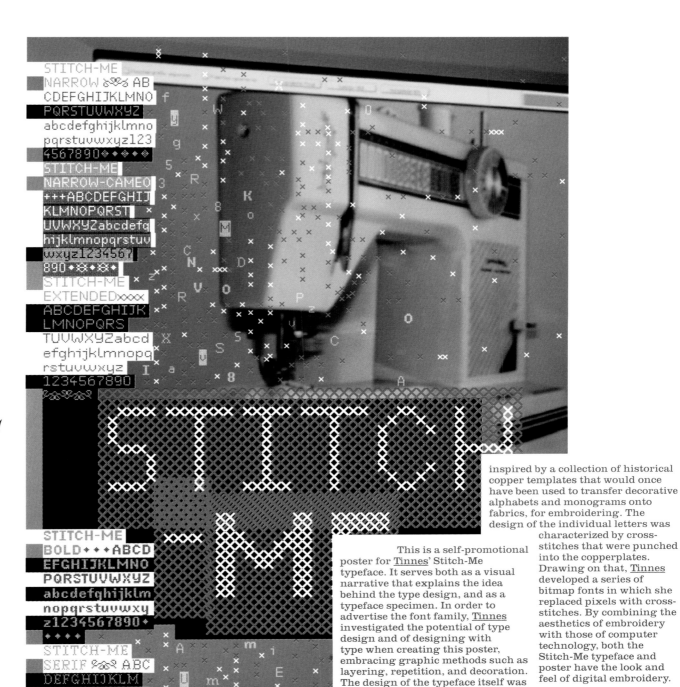

stitch-me,
self-promotional poster, 2001

STITCH-ME
NARROW &%& AB
CDEFGHIJKLMNO
PQRSTUVWXYZ
abcdefghijklmno
pqrstuvwxyz123
4567890◆◆◆◆

STITCH-ME
NARROW-CAMEO
+++ABCDEFGHIJ
KLMNOPQRST
UVWXYZabcdefg
hijklmnopqrstuv
wxyz1234567
890◆&◆&◆

STITCH-ME
EXTENDED×××××
ABCDEFGHIJK
LMNOPQRS
TUVWXYZabcd
efghijklmnopq
rstuvwxyz
1234567890

STITCH-ME
BOLD◆◆◆ABCD
EFGHIJKLMNO
PQRSTUVWXYZ
abcdefghijklm
nopqrstuvwxy
z1234567890◆
◆◆◆

STITCH-ME
SERIF &%& ABC
DEFGHIJKLM
NOPQRSTUVW
XYZabcdefghij
klmnopqrstu
vwxyz12345678
90 &××&

This is a self-promotional poster for <u>Tinnes</u>' Stitch-Me typeface. It serves both as a visual narrative that explains the idea behind the type design, and as a typeface specimen. In order to advertise the font family, <u>Tinnes</u> investigated the potential of type design and of designing with type when creating this poster, embracing graphic methods such as layering, repetition, and decoration. The design of the typeface itself was inspired by a collection of historical copper templates that would once have been used to transfer decorative alphabets and monograms onto fabrics, for embroidering. The design of the individual letters was characterized by cross-stitches that were punched into the copperplates. Drawing on that, <u>Tinnes</u> developed a series of bitmap fonts in which she replaced pixels with cross-stitches. By combining the aesthetics of embroidery with those of computer technology, both the Stitch-Me typeface and poster have the look and feel of digital embroidery.

UNITED STATES

monkey clan

monkey clan promotional card, 2001

WHEN THE BUBBLE OF THE DOT-COM ERA BURST, DESIGNERS AT NEW YORK–BASED **MONKEY CLAN** CREATED THIS AD TO PLACE IN **RES** MAGAZINE IN A BID TO WIN WORK AND STAY IN BUSINESS. IT IS INSPIRED BY BLUNT AMERICAN CAPITALISM, WITH A DASH OF DEATH, DOOM, AND SARCASM. INSTEAD OF FOCUSING ON THEMES OF GREED AND PORTRAYING THE PURVEYORS OF THIS STYLE IN A NEGATIVE WAY, **MONKEY CLAN** STEPPED INTO THEIR SHOES AND CELEBRATED THE INGENUITY AND TENACITY OF SALESMEN IN CONTINUING TO FIND A CLEVER PITCH, EVEN WHEN THEIR SHIP IS SINKING.

This promotional piece ignores many of the most basic design fundamentals—in its lack of focus, unsettling colors, and blatant use of clip art—but its over-the-top visual bombardment supports the concept, as does the copy. "We wanted to make something totally incredible and insulting, yet pathetic and sad, like a drunk coming home from a bar to drink vanilla extract," explains Pham. "We wanted to make the design very American, very loud, and a total backlash against the minimalism that prevailed at the time. Most of that can be attributed to the copy. Instead of our usual clever and slick wordsmithing, we just attacked it, made too much copy and made it blunt. We threw in funny lines and included a dead Mickey, homage to the great American icon."

"At the time there were a lot of companies going out of business. Our friends were getting laid off and we thought we might go out of business ourselves," explains Kai Pham of Monkey Clan. "All these unemployed freelancers were underbidding us on what little work there was out there, so we decided to poke fun at the general depressing situation. It was just ironic to think your last design piece would be your own eulogy. It produced a lot of nervous laughter."

Created to look like a Sunday paper flyer, the designers tried to incorporate the techniques flyers use to grab people's attention; they centered a "going out of business" display and then added small bursts of sale items.

While Monkey Clan never actually got any new work from this ad, they did get two sympathy E-mails telling them to "hang in there," which they evidently have.

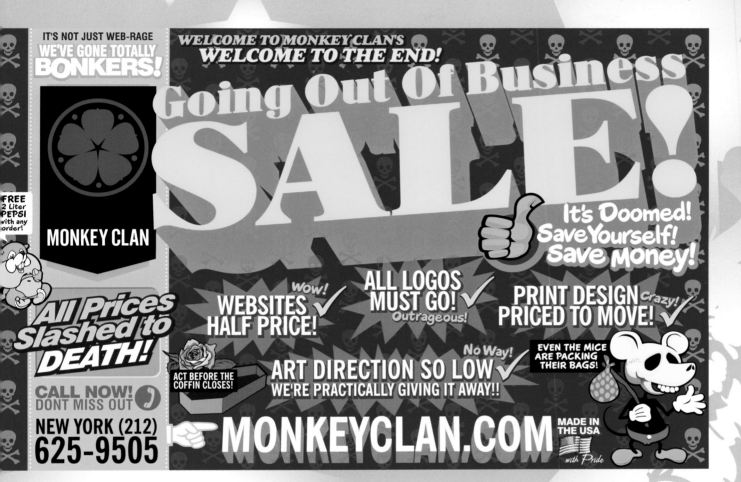

So, the team at Gentil Eckersley proposed a strategy that embraced change; they presented a multichoice and ever-changing brand anchored by a relevant graphic fashion theme. The designs of the packages are updated on a regular basis, in line with emerging fashion trends, with six new designs introduced every nine months.

"Successfully developing a brand strategy that actually advocates constant change, as opposed to defending a particular expression, is very satisfying," explains Franck Gentil. "We are quite involved with the local fashion scene here in Melbourne and Sydney, and getting people who usually see themselves as marketers of feminine hygiene and baby-care products along to high-end fashion shows is really interesting. There is a huge leap of faith on their part because we present the concepts almost a year before production. Telling them that this or that is going to be so in, we'll all be wearing it, and getting it right is a buzz. So is getting to do so much illustration. We all have a new-found respect for decorative arts."

This really is a unique way to look at tampon packaging; the banal nature of the product itself and the ~~maximalist~~, glamorously inspired packaging around it is irony at its best.

CAREFREE IS JOHNSON & JOHNSON**'S MAJOR FEMININE HYGIENE BRAND. AUSTRALIAN DESIGN AGENCY** GENTIL ECKERSLEY **WAS COMMISSIONED TO REPOSITION THE CAREFREE BRAND TO HELP IT CAPTURE THE EMERGING TEEN MARKET THAT HAD PREVIOUSLY BEEN IGNORED. IT IS A DIFFICULT MARKET TO TARGET. WHAT YOUNG GIRLS CONSIDER "HIP AND COOL" ONE MOMENT HAS CHANGED BY THE NEXT, AND THE INFLUENCE OF PEER PRESSURE, AND THE FEAR OF REJECTION THIS CREATES, IS STRONG.**

AUSTRALIA

gentil eckersley
carefree packaging for johnson & johnson, 2002 (and ongoing)

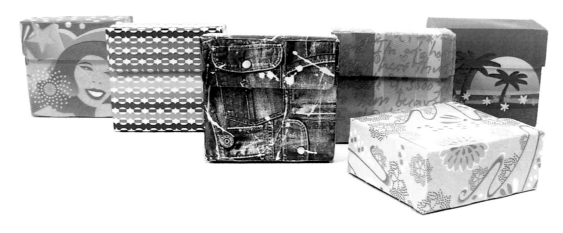

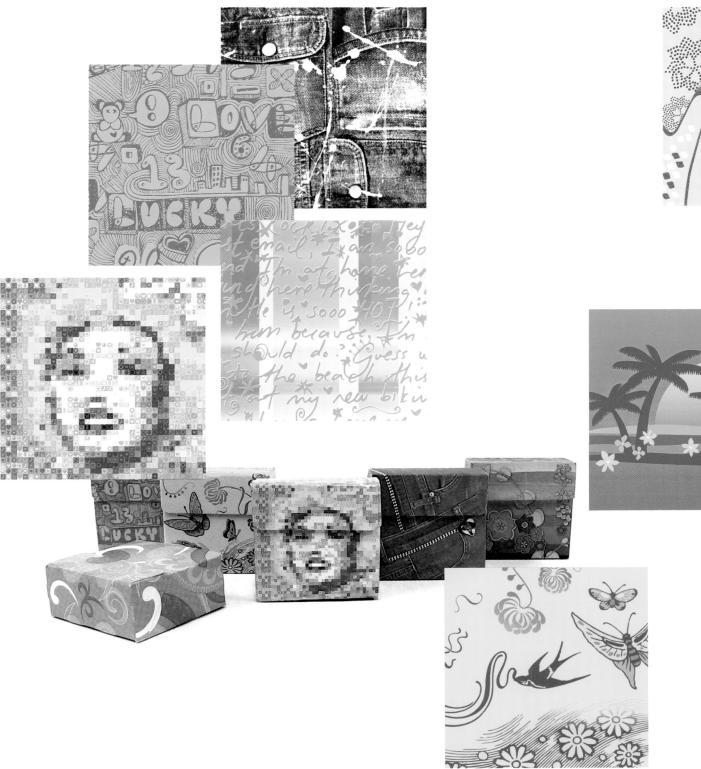

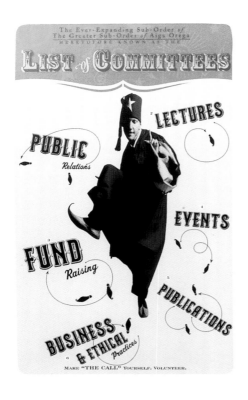

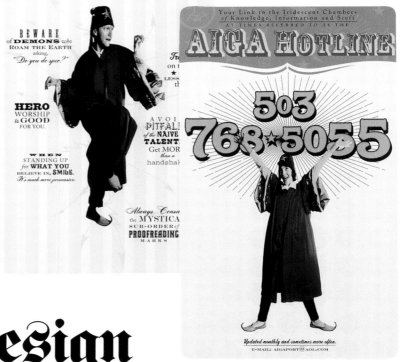

omatic design

american institute of graphic arts promotion, booklet design, 1996

ACCORDING TO DESIGNER <u>GEOFFREY LORENZEN</u>, OF OMATIC DESIGN, THE ~~MAXIMALIST~~ TONE OF THIS PIECE IS PURE IRONY; ITS GRANDIOSITY IS MEANT TO BE SO OVER-THE-TOP THAT IT IS HUMOROUS. THE BOOKLET WAS COMMISSIONED BY THE PORTLAND DIVISION OF THE AMERICAN INSTITUTE OF GRAPHIC ARTS (AIGA), WITH THE INTENTION THAT IT SERVE AS A SIMPLE COMMUNICATION AND REMINDER TO MEMBERS OF THE INSTITUTE'S SERVICES.

"We considered the insular and self-satisfied nature of the design community and created a parallel entity that was a mystical, secret organization with faux rituals and history," explains <u>Lorenzen</u>. "I wanted it to simply be a humorous, aesthetic explosion with heavy ornamentation and historically informed typography that propped up the mystical organization concept."

Inspired by the style of nineteenth-century typography that mixed fonts and font sizes with abandon, <u>Lorenzen</u> has used, in his own words, a ridiculous number of stock typefaces and custom type constructs. He even created a working font from proofreaders' marks that looks like runes. "It was aimed at designers who would pick all of its elements apart," he says.

Photography is by <u>Marcus Swanson</u> and <u>Morgan Henry</u>, with copy-writing by <u>Leslee Dillon</u>.

SANCTIONED

MEMBER

Aiga Orega

I

(*you*)

HEREBY PROCLAIM MYSELF A LOYAL SOLDIER OF

Aiga Orega-PDX

and so do **AGREE** to abide by its RULES *and* PRINCIPLES

under penalty OF THE HACK PADDLE.

Viva Aesthetica!

"A frien
me your
the other
I felt, for t
time in a lo
while, that
was hope fo
mankind."
—A California Customer.

LOS ANGELES–BASED THE GRATEFUL
PALATE DISTRIBUTES AND SELLS WINES, AND OFFERS
MAIL-ORDER ARTISAN FOODS, COFFEE, AND OTHER
DELICACIES. BETH ELLIOTT, AT ELLIOTT DESIGN, WAS ASKED TO
DESIGN A DIRECT-MAIL CATALOG SHOWCASING THE
COMPANY'S PRODUCT OFFERING FOR 2004.

UNITED STATES

elliott design

the grateful palate catalog, poster, and mailing envelope, 2004

The retro pattern on the poster was created using reinterpretations of the patterns and symbols one might find on items in kitchens from the past and present; towels, wallpaper, cookbooks, labels, and food packaging. This poster also doubles as the catalog's mailing envelope. Given the scale and number of folds needed for the poster to successfully function as an envelope, Elliott saw this as an ideal opportunity to use the panels for testimonials and product teasers. Each turn and opening of a fold presents something new to the reader, leading them toward the catalog within. Elliott has used a variety of typefaces, including Gotham, Frankfurter, Table Manners, Radio, Pinball, Pioneer, Oz, Phrastic, Japan Script, Cooper Black, Almonda, Helvetica, and Rounded.

Elliott has worked with The Grateful Palate for a number of years. Her work for them is inspired by the specific foods and products that it offers each year and the sensual world of food and wine in general. "BOOM, BOOM, the catalog's theme, was an obvious source of inspiration in the work; explosive bursts of design flavor," explains Elliott. "The design aspires to making the products tantalizing and the storytelling entertaining enough to chew on throughout the year."

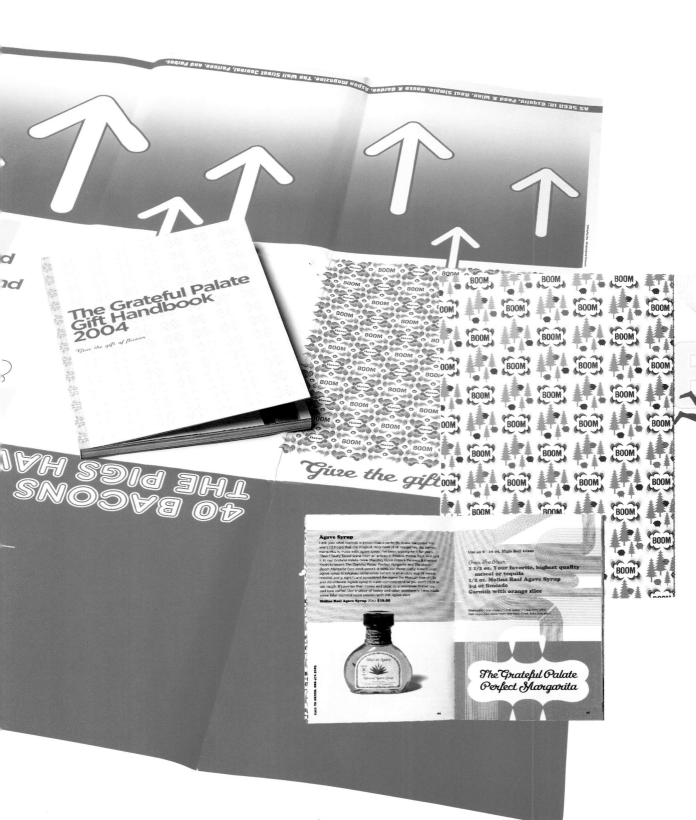

The Grateful Palate
Gift Handbook
2004

Give the gift of flavor

40 BACONS
THE PIGS HAVE

Give the gift

PRODUCT OF THE YEAR

*This year's
winner is* BACON

Every year, our distinguished panel of judges (me) tastes all of our products and selects the artisan who in the view of the judges (me, again) has achieved the greatest flavor heights of the year. Past distinguished winners have included June Taylor, Robert Lambert and Manfred and Elaine Krankl. You know how the Nobel Committee some years gives the Peace Prize to an individual like Mother Teresa or Nelson Mandela and other years gives it to a group, like Doctors Without Borders or UNICEF? **Well, this year the judges (that'd be me) selected a group of products: all things Bacon!** I'm declaring 2004 the Year of the Swine. Maybe after this year, we'll retire the award and make every year the Year of the Swine. (Wouldn't it be great if they retired the Nobel Peace Prize because it was no longer needed?)

product of the year 2004

Agave Syrup

Ask you what cocktail is better than a perfectly made margarita? For years I'd heard that the magical, Holy Grail of margaritas, the perfect margarita, is made with agave syrup. I've been looking for it for years. Then I finally found some from an artisan in Mexico. Molina Real and gave it to our Grateful Palate Drink Handbook Kevin Patrick the mixologist Kevin to invent The Grateful Palate Perfect Margarita and The Mexican Boom Margarita (see back cover). It turns out those crafty Aztecs used agave syrup in religious ceremonies (which is an ancient way of saying chocolate, party, right?) and considered the agave The Mexican Tree of Life and Abundance. Agave syrup is super-concentrated so you don't need as use much. It's sweeter than honey and tastes as a sweetener. I used for and love coffee. Use in place of honey and other sweeteners. I also make some killer oatmeal raisin scones with this agave syrup.

Molina Real Agave Syrup 20oz **$19.95**

Use an 8 - 10 oz. High Ball Glass

Over Ice Pour
1 1/2 oz. Your favorite, highest quality
mezcal or tequila
1/2 oz. Molina Real Agave Syrup
3-4 oz limeade
Garnish with orange slice

*The Grateful Palate
Perfect Margarita*

UNITED KINGDOM
25 survivors
sport & street magazine spreads, 2003

EVERYBODY'S PRESENT IS SOMEBODY ELSE'S PAST

25 SURVIVORS IS A CREATIVE AGENCY THAT FOCUSES ON THE FASHION, MUSIC, ART, AND ADVERTISING INDUSTRIES. THE TEAM— JOHN VANDERPUIJE, YARA AWAD, AND ADAM LOWE—CREATED THIS EDITORIAL SPREAD FOR SPORT & STREET MAGAZINE. PUBLISHED BY LOGOS PUBLISHING, ITALY, SPORT & STREET IS A FASHION MAGAZINE, AIMED AT PEOPLE INTERESTED IN FASHION, STREET CULTURE, NEW DESIGNERS AND ARTISTS, MUSIC, GLOBAL AND LIMITED-EDITION CULTURE, AND BRANDING, WHO HAVE £25 (C. U.S. $46) TO SPEND ON A MAGAZINE.

In short, the 25 Survivors team was asked to play with the ideas of sport and street, to creatively interpret what those words meant to them in an editorial environment. What has been produced is a highly decorative, but at the same time raw series of spreads with illustrations by Matt Duckett and Adam Lowe.

"Matt was obsessed with ornamental ribbons and Will Smith, Adam was obsessed with black-and-white scribbles and consumerist culture, and I was obsessed with invisible models, cold cityscapes, dystopian slogans, and mixing Adam's graffiti style with Matt's hard-core graphic minimalism, to make something that looks like it got lost in the bowels of a photocopier," explains Vanderpuije.

"Also, at the time, every magazine seemed to have a sportswear, or luxury sportswear, or bling bling fashion article featured in it," he adds, "so we decided to strip it down to the lo-fi minimal, produce something that would really get the readerships' attention, something that was entirely off-key. The decorative approach was used to disrupt the flow of the magazine. Decorative is defiantly antieverything sportswear is supposed to be, i.e. cool."

DESIGNER OF THE YEAR

kam tang

london's design museum identity, graphic thought facility, 2003
alice through the looking glass illustration, versus exhibition, british council, 2003

KAM TANG'S DECORATIVE STYLE HAS CERTAINLY TAPPED INTO THE ZEITGEIST. HIS HIGHLY ORNATE SIGNATURE DESIGNS HAVE MADE HIM A FAVORITE OF ART DIRECTORS AND DESIGNERS ALIKE. HIS HIGH-PROFILE WORK INCLUDES THE ILLUSTRATION USED ON THE COVER FOR THE JULY/AUGUST 2003 ISSUE OF WALLPAPER* MAGAZINE, AND HIS HAND-DRAWN "OBJECTS" USED AS PART OF THE NEW IDENTITY FOR LONDON'S DESIGN MUSEUM, CREATED BY U.K. DESIGN GROUP GRAPHIC THOUGHT FACILITY (GTF).

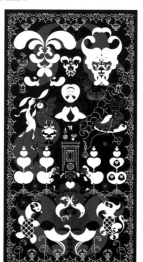

Tang's drawings are always very intricate; with his "microscopic" way of looking at detail, he aims to uncover the essence of things. Although thoroughly modern, his work is steeped in the tradition of Japanese art and its ornamental aesthetics. Tang is also part of the new breed of illustrators who favor a return to a handcrafted approach. All his drawings are mapped out in pen and paper and then worked up by computer. Tang believes that a constantly tweaked image can end up lifeless, and prefers the irregularities of the hand-drawn.

For the Design Museum identity, Tang came up with about 100 hand-drawn objects to scatter around GTF's typography. These objects represent the many areas of design, but the result is consciously ambiguous, so a paper clip looks like a slice of pie with no filling, and a ceramic vessel could easily be mistaken for a pork chop. The intentional effect is that the symbols don't narrate the whole story, but push the viewer to use their powers of imagination.

Tang also instigates projects as an outlet for his experiments. His British Council show in Japan in 2003, featuring portraits to illustrate Alice Through the Looking Glass, was made of flat, organic shapes and patterns. Inspired by the highly symbolic, almost decadent book, Tang created one elaborate illustration that amalgamates the whole plot, with the characters intricately woven into the image.

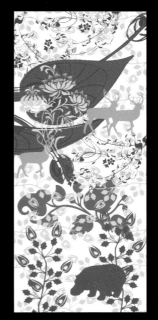
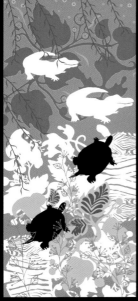
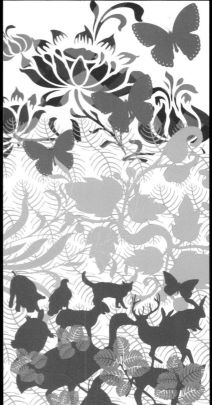
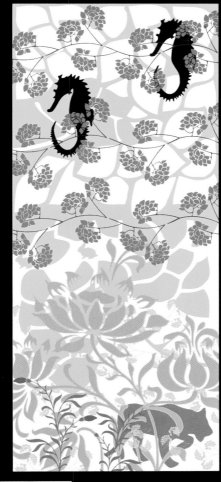

UNITED KINGDOM

hanna werning

animalflowers wallpaper, personal project,
2001-2003

SWEDISH-BORN <u>WERNING</u> TAKES ON THE IDEA OF FLORA AND FAUNA IN HER COLORFUL, GRAPHIC WALLPAPER DESIGNS. PIGS, SEAHORSES, TIGERS, AND BUTTERFLIES—AN UNUSUAL COMBINATION, BUT IT WORKS—ALL GRACE HER DESIGNS. THESE COME IN ROLLS OF WALLPAPER, ON CANVASES, AS POSTERS, AND AS WALL PANELS.

"I'm not sure why I started drawing the AnimalFlowers," says <u>Werning</u>. "I guess they started off as a kind of doodle. Normally I work to a brief and set concept, but these are pure visual, a strange combination of shapes and colors. The AnimalFlowers are built up in layers … It's like an overdose in shape and color, but somehow they work as one piece without being too distracting."

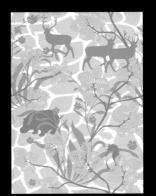

helena fruehauf
halfbreed 02*, personal project, 2002

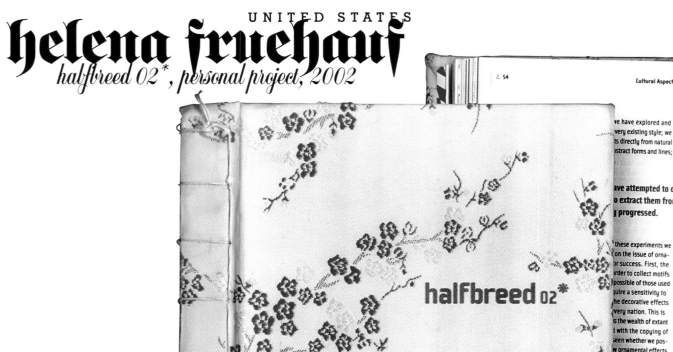

ve have explored and
very existing style; we
s directly from natural
stract forms and lines;

ave attempted to derive ornaments directly from natural motifs, o extract them from abstract forms and lines; but we have not progressed.

these experiments we
on the issue of orna-
or success. First, the
rder to collect motifs
possible of those used
uire a sensitivity to
he decorative effects
very nation. This is
s the wealth of extant
with the copying of
een whether we pos-
ornamental effects,
eir own: at all events,
nly where a mature

The consequence for us today is this: we must seek sti-
mulus and inspiration in the varied decorative effects
achieved in the past; we must rework these in the light of
our own study of nature, and—most difficult of all—we
must take the results and make them fit organically into
the given formal context. This demands a great deal of
study and talent, if we are not to relapse once more into
feeble stylistic imitation. Anything that still has an anti-
quarian air has yet to be adequately reshaped to suit the
age we live in and the people we are. Many things have
lost their intuitive justification for us, and these are there-
fore no longer available to us as sources. We must learn
to face facts. By all means, let the ablest among us con-
duct experiments; but we must be serious, and reject all
frivolous ventures, whether artistic or technical. In this
way, new ornamental values can in due course emerge
to use. [...]

The ultimate a
buildings was
indispensable
isolation from
operative effor
recognize anet
both as an enti
imbued with th

The old schools
since art canno
workshop. The
and the applie
young people u

HALFBREED 02* IS A PERSONAL PROJECT BY U.S. DESIGNER HELENA FRUEHAUF THAT SHE HOPES TO SEE PUBLISHED IN THE FUTURE. THE BOOK PROJECT WAS BORN OUT OF FRUEHAUF'S DESIRE TO DEVELOP HER OWN AUTHENTIC VISUAL LANGUAGE. BROUGHT UP AS A "HALFBREED," WITH A CHINESE MOTHER IN WEST GERMANY, QUESTIONS OF IDENTITY AND BELONGING, AS DEFINED BY TWO DIVERSE CULTURES, LED HER TO INVESTIGATE "HOW CULTURE FORMS THE WAY WE SEE THINGS."

"My own authentic voice
should influence my work, in various
degrees of intensity, regardless of the
project or client," explains Fruehauf.
Fruehauf is interested
in the role of decorative arts and, in
particular, how this role has been
ignored historically by the high
modern approach. As a reaction,
Fruehauf focused on the language
of ornamentation in German and
Chinese cultures. Halfbreed 02* is
covered with a traditional Chinese
fabric while its endpapers feature
the Bavarian national pattern.

The book is structured
around four main sections. The ~~first~~,
The Workings of Ornamentation,
attempts to provide a broad and
general overview of the evolution,
function, and theory of
ornamentation in the
context of design history.
The ~~second~~,
Cultural Aspects of
Ornamentation, briefly
addresses the relationship
of visualization with
culture and introduces
traditional floral
ornaments from the
German renaissance
and Chinese Ming
Period; Fruehauf has
taken these and used
them to produce hybrids
of the two cultures.

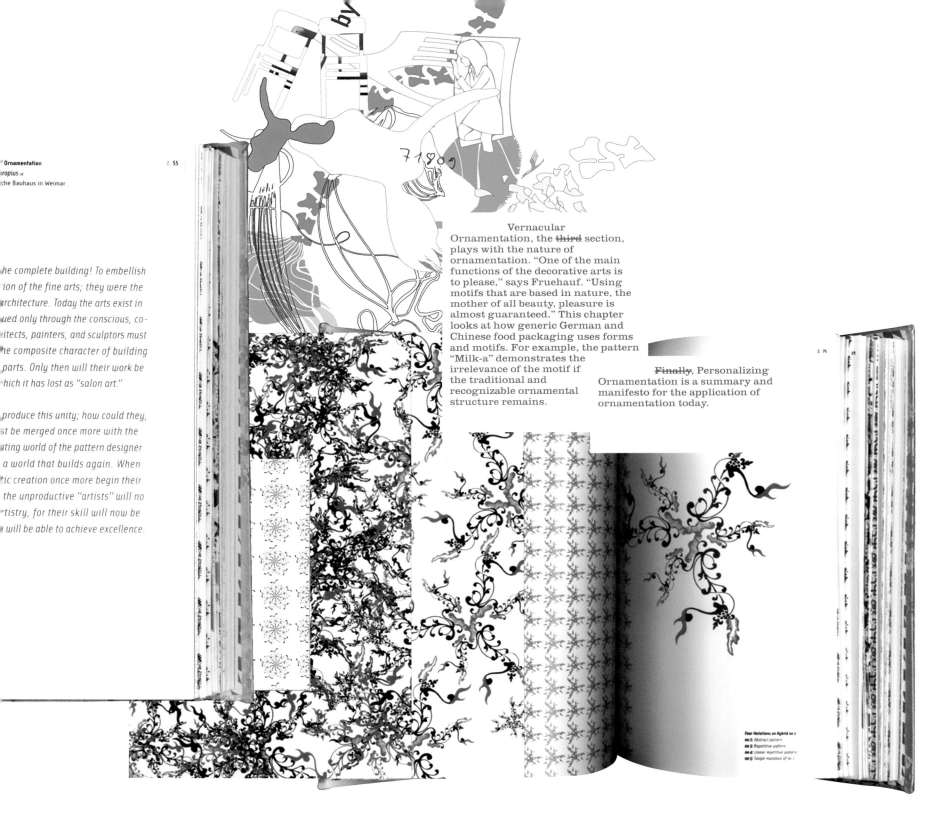

he complete building! To embellish
ion of the fine arts; they were the
rchitecture. Today the arts exist in
ued only through the conscious, co-
itects, painters, and sculptors must
he composite character of building
parts. Only then will their work be
hich it has lost as "salon art."

produce this unity; how could they,
st be merged once more with the
ating world of the pattern designer
a world that builds again. When
ic creation once more begin their
the unproductive "artists" will no
rtistry, for their skill will now be
will be able to achieve excellence.

Vernacular
Ornamentation, the ~~third~~ section,
plays with the nature of
ornamentation. "One of the main
functions of the decorative arts is
to please," says Fruehauf. "Using
motifs that are based in nature, the
mother of all beauty, pleasure is
almost guaranteed." This chapter
looks at how generic German and
Chinese food packaging uses forms
and motifs. For example, the pattern
"Milk-a" demonstrates the
irrelevance of the motif if
the traditional and
recognizable ornamental
structure remains.

~~Finally~~, Personalizing
Ornamentation is a summary and
manifesto for the application of
ornamentation today.

2. 14

Four Variations on Hybrid no 1:
no 2: Abstract pattern
no 3: Repetitive pattern
no 4: Linear repetitive pattern
no 5: Single mutation of no 1

zip design

zip stationery, 2003

ZIP CREATED THEIR PRINT IDENTITY USING A VARIETY OF TYPEFACES INSPIRED BY THE TYPOGRAPHY FOUND ON OLD BOXING, CIRCUS, AND ZOO POSTERS. "WE STARTED BY LOOKING AT OLD HAND-SET WOOD TEXT AND OLD TYPEFACES AS WE WANTED TO USE LOADS OF DIFFERENT TYPE STYLES," EXPLAINS PETER CHADWICK, ART DIRECTOR AT ZIP DESIGN. "WE WANTED SOMETHING THAT WAS COMPLETELY FRESH, THAT WOULD NOT FOLLOW THE USUAL RULES FOR A BRAND IDENTITY. WE WERE BORED OF THE USUAL APPROACH TO STATIONERY AND ALL THAT WHITE SPACE."

For this reason, a variety of colors have been printed full bleed on the reverse of compliments slips and business cards. In addition, there is a version of the letterhead with the address on the reverse, printed across the whole page, for maximum impact when it is taken out of an envelope.

"We wanted the whole stationery package to stand out as individual pieces so we not only used the different text, but we also used a different color on each item," adds Chadwick. "When you see the whole series together it looks very strong, and I think it says that as a company we're not afraid to express ourselves unconventionally, yet successfully."

The typefaces used include Rockwell, University, Didoni, and Rialto, together with a selection of fonts taken from old magazines.

ZIP DESIGN
UNIT 2A
QUEENS STUDIOS
121 SALUSBURY ROAD
LONDON
NW6 6RG
WWW.ZIPDESIGN.CO.UK
TELEPHONE 020 7372 4474
FACSIMILE 020 7372 4484
ISDN 020 7328 2816
ESTABLISHED. 1996

HANNAH W
07970
HANNAH@ZI

DANI
0797(
DANIEL@

RLIE BANKS
70 004663
E@ZIPDESIGN.CO.UK

ISE
71
UK

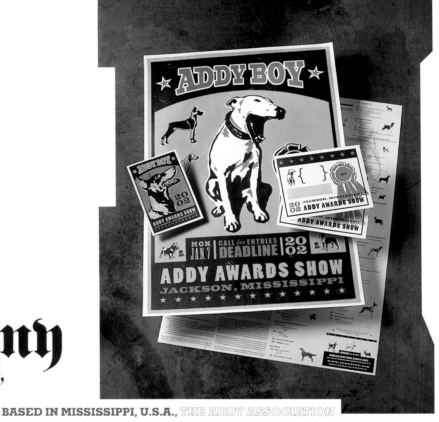

UNITED STATES

squires & company

poster for addy association of jackson, mississippi, annual show, 2002

BASED IN MISSISSIPPI, U.S.A., THE ADDY ASSOCIATION ORGANIZES AN ANNUAL ADVERTISING SHOW FOR THE SOUTHERN STATES. THIS POSTER WAS THE CALL FOR ENTRIES IN 2002.

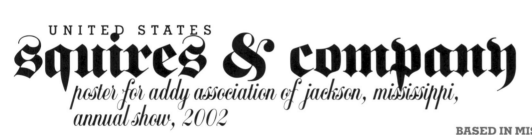

Aimed at fellow designers, art directors, illustrators, and copywriters, the design was inspired firstly by Best in Show, a "mockumentary" about a dog show, and secondly by the style of boxing match and circus performance posters that have become something of an iconic image in the southern states of America. "I knew that the entry poster needed to attract the attention of a pretty jaded audience, so I made fun of it," explains designer Brandon Murphy. "I thought it would be funny to compare the design competition to a dog show. I knew the entrants would appreciate it."

Murphy has used a mix of ornate display fonts on the poster: Clarendon, Poplar, and Cooper Black, among others. These were chosen to mimic the old-time look of boxing match and circus posters. The whole trend for that style of poster was started by Hatch Show Print, a printing shop in Nashville, Tennessee, that has been producing posters using handcarved, woodblock type since 1874. To achieve the same effect, the typefaces were roughed up, using a copy machine, adhesive tape, and a cutting blade. Imagery is from an American Kennel Council manual.

the kitchen

levi's girls' store, paris, in-store design, 2003

IN OCTOBER 2003, LEVI'S OPENED ITS FIRST GIRLS' STORE, IN PARIS.
THE COMPANY WANTED A COOL BOUTIQUE FEEL THAT WOULD APPEAL TO TODAY'S YOUNG
FEMALE CUSTOMER. DESIGN AGENCY THE KITCHEN WAS ASKED TO CREATE AN IDENTITY FOR THE
STORE THAT INCLUDED A LOGO AND IN-STORE GRAPHICS. THE RESULT IS A BOLD, FRESH
IDENTITY THAT HAS A DISTINCT FEMININE ATTITUDE AND AN EDGY STRENGTH.

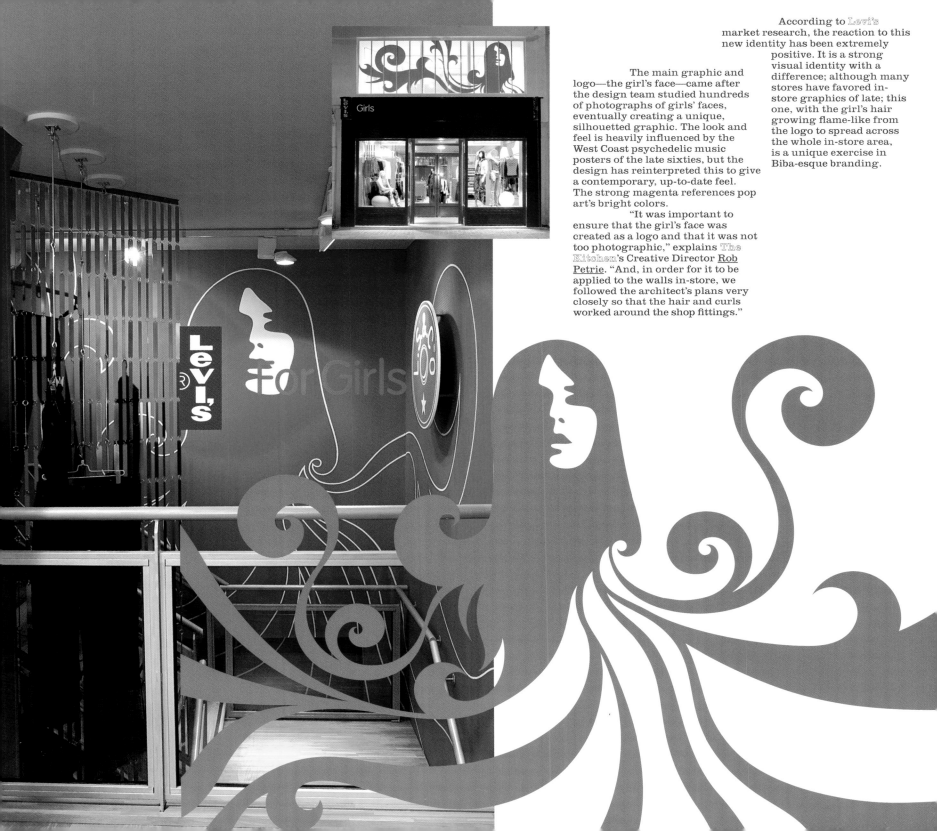

The main graphic and logo—the girl's face—came after the design team studied hundreds of photographs of girls' faces, eventually creating a unique, silhouetted graphic. The look and feel is heavily influenced by the West Coast psychedelic music posters of the late sixties, but the design has reinterpreted this to give a contemporary, up-to-date feel. The strong magenta references pop art's bright colors.

"It was important to ensure that the girl's face was created as a logo and that it was not too photographic," explains The Kitchen's Creative Director Rob Petrie. "And, in order for it to be applied to the walls in-store, we followed the architect's plans very closely so that the hair and curls worked around the shop fittings."

According to Levi's market research, the reaction to this new identity has been extremely positive. It is a strong visual identity with a difference; although many stores have favored in-store graphics of late; this one, with the girl's hair growing flame-like from the logo to spread across the whole in-store area, is a unique exercise in Biba-esque branding.

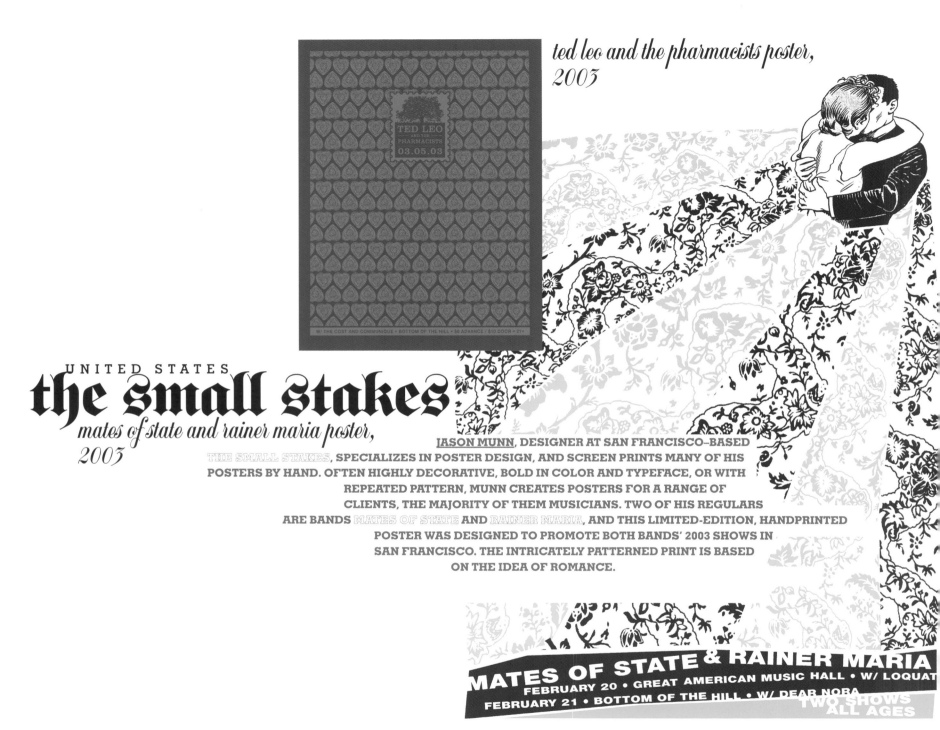

ted leo and the pharmacists poster, 2003

the small stakes

mates of state and rainer maria poster, 2003

JASON MUNN, DESIGNER AT SAN FRANCISCO–BASED THE SMALL STAKES, SPECIALIZES IN POSTER DESIGN, AND SCREEN PRINTS MANY OF HIS POSTERS BY HAND. OFTEN HIGHLY DECORATIVE, BOLD IN COLOR AND TYPEFACE, OR WITH REPEATED PATTERN, MUNN CREATES POSTERS FOR A RANGE OF CLIENTS, THE MAJORITY OF THEM MUSICIANS. TWO OF HIS REGULARS ARE BANDS MATES OF STATE AND RAINER MARIA, AND THIS LIMITED-EDITION, HANDPRINTED POSTER WAS DESIGNED TO PROMOTE BOTH BANDS' 2003 SHOWS IN SAN FRANCISCO. THE INTRICATELY PATTERNED PRINT IS BASED ON THE IDEA OF ROMANCE.

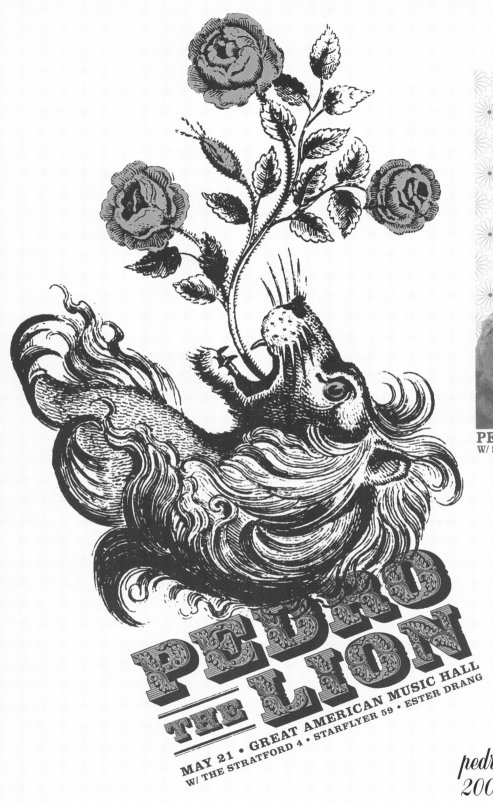

PEDRO THE LION
MAY 21 • GREAT AMERICAN MUSIC HALL
W/ THE STRATFORD 4 • STARFLYER 59 • ESTER DRANG

PEDRO THE LION GREAT AMERICA[N]
W/ SELDOM + SCIENTIFIC NOVEMBER [2]

Munn often uses limited color because of the constraints of the screen-printing process, as for these two Pedro the Lion posters, created for the band's 2002 concerts in San Francisco. "The idea for the design comes from the band's music," explains Munn. "It is usually pretty mellow in sound, but sometimes has disturbing lyrics." In both instances, the lion represents the disturbing side and the flowers represent the music.

The lion's roar is depicted by roses—an inspired idea. "I take this approach to a lot of my designs, basically to try to get some kind of emotion in the viewer," explains Munn. "I often like to mix an image that would create one emotion with another that would create the opposite emotion."

He has gone for emotion again with his poster design for band Ted Leo and the Pharmacists. Another limited-edition, screen-printed example, this is based entirely on the band's most recent album, Hearts of Oak. "That name to me suggested something old and having an antique feel," says Munn. "The repeated pattern refers to 'hearts' in hearts of oak. I wanted it to feel like an endless amount."

pedro the lion poster, 2002

DAVID MASON

UNITED STATES

kiss me i'm polish

identity for david mason label, 2003

DAVID MASON IS A NEW YORK–BASED
ACCESSORY DESIGNER. HIS WORK IS
VIBRANT, COLORFUL, AND FIERCELY
IMAGINATIVE. HE IS PERHAPS BEST KNOWN
FOR HIS HAT COLLECTIONS, WHICH ARE MARKED BY DYNAMIC
COMPOSITIONS, BRIGHT COLOR COMBINATIONS, AND INTRICATE PATTERNS.
HE COMMISSIONED NEW YORK DESIGNER AGNIESZKA GASPARSKA,
WHO WORKS UNDER THE NAME KISS ME I'M POLISH, TO CREATE
AN IDENTITY FOR HIS LABEL THAT CAPTURED ALL
OF THE AESTHETIC SUBTLETIES THAT HE
EXPRESSES IN HIS WORK.

"For his logotype, I wanted to create a symbol that was elaborate and seductive, sweet and menacing all at the same time. Sexy but fierce," explains Gasparska. "We decided to go with a more intricate image in order to set a richness and a level of sophisticated intricacy for the identity of the label. One word just kept coming out of David's mouth as the driving force for the whole design process—fierce."

Working with reference material and imagery supplied by Mason, Gasparska tried to capture the design essence of his products within the logo. His accessories are colorful and bold, with strong and distinctive composition lines, and dynamic, unbalanced forms. Gasparska used a colorful and playful palette for the logo, to contrast with its rather menacing form, with hand-altered Helvetica Extended for the type.

Mason's work has featured in runway shows for Baby Phat and Heatherette on many occasions, has been photographed in countless fashion shoots, and has appeared on magazine covers and on stars' heads—Alicia Keys wore a Mason hat to the 2003 Grammy Awards ceremony.

UNITED STATES

greteman group

THE HUMAN RESOURCES
DEPARTMENT OF ROYAL
CARIBBEAN CRUISES, U.S.,
COMMISSIONED THE GRETEMAN GROUP TO DESIGN
THESE TWO QUIT SMOKING POSTERS. THE DEPARTMENT
OVERSEES COMPANY-WIDE TRAINING AND MANAGES
RESERVATION CALL CENTERS FOR
THE CRUISE BOOKINGS.
IT WAS CONCERNED ABOUT
THE HIGH PERCENTAGE OF SMOKERS
AMONG CALL-CENTER EMPLOYEES AND
THE IMPACT THAT THIS WAS HAVING ON
THEIR HEALTH, THEIR PRODUCTIVITY, AND THEIR ATTENDANCE. AS A RESULT,
THE DEPARTMENT ASKED THE GRETEMAN GROUP TO CREATE TWO POSTERS
THAT WOULD HELP CONVINCE CALL-CENTER EMPLOYEES TO STOP SMOKING.

"My goal was to create something compelling and eye-catching," explains Ginny Sprecker at Greteman Group. "Smokers are tired of hearing diatribes about the long-term dangers of smoking. They are more than aware of how bad it is. Instead, we focused on the immediate benefits of quitting smoking that would appeal to lower-wage workers; money savings and just simply feeling better. We wanted to grab the attention of tired, harried, call-center employees, so the design needed to be compelling, energetic, and forceful."

The color palette and pop art feeling of these posters was employed to reflect and complement the atmosphere of the call centers. Designers at the Greteman Group have attempted to create posters that will stir people's memories of seventies' wacky packaging and leverage the directness of older-style advertising. Classic retro fonts, including Modula, Onyx, and Stuyvesant, have helped achieve this.

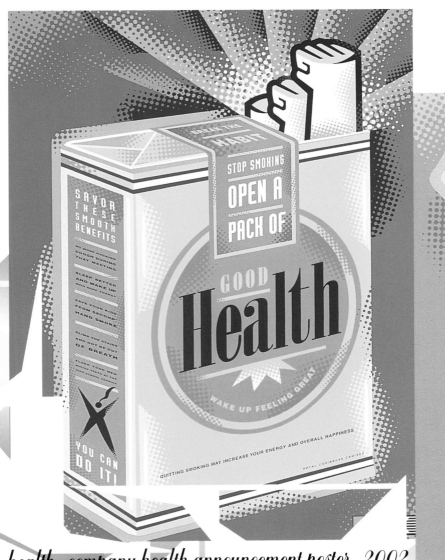

health, company health announcement poster, 2002

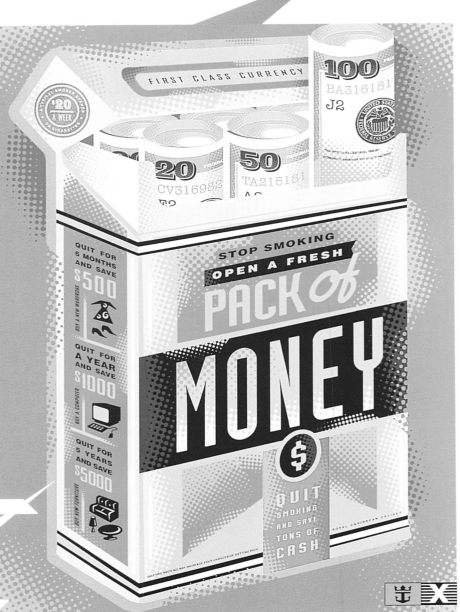

money, company health announcement poster, 2002

GRAPHIC DESIGN IS OFTEN THOUGHT OF AS APPEALING ONLY TO ONE SENSE—SIGHT. HOWEVER, IT CAN APPEAL TO ALL OUR SENSES, AND, AS DESIGN BECOMES INCREASINGLY ~~MAXIMAL~~, IT HAS ALSO BECOME MORE SENSUAL. DESIGNERS IN PRINT ARE WORKING NOT ONLY WITH LAYOUT AND COMPOSITION, BUT ALSO WITH DIFFERENT MATERIALS AND PROCESSES. GRAPHICS TO TOUCH, AND EVEN TO TASTE AND SMELL, ARE BEING USED TO GRAB THE AUDIENCE'S ATTENTION. TEXTURES ARE BECOMING INDULGENT, SEXY, AND DECADENT, DEVELOPING SIMILARITIES WITH THE WORKINGS OF THE FASHION WORLD.

The use of different materials within design can evoke feelings in the viewer that they may not experience were those special sensual touches not there. A book that plays music on being opened, or a package sealed with a silk ribbon and gold buckle engage and retain the viewer's attention simply because they are a little different. At the same time, these "features" need not be gimmicky; they can have great functional values too.

Without a doubt, it is far easier to design a package or book cover that is clothbound or gold-embossed if the budget allows for such frivolity, but often it doesn't, and designers have to find ways around that by creating sensual work in the most subtle ways.

A great example of design that appeals to the senses, is functional, and has been created on a limited budget is the unique packaging for art book Fresh Cream (see pages 076–077). The book came encased in an inflated clear pillow. When it was first released, some stores displayed these pillows in big bins, immediately arousing the curiosity of customers. On a practical level, the inflated pillows actually did a job—they protected the delicate book inside them.

At the other end of the scale is the legendary fashion-meets-art magazine Visionaire (see pages 064–065). One issue, titled "Scent," came complete with 21 original and exclusive perfumes, created for the magazine. The issue was expensive to produce and expensive to buy, but it was an investment.

All of the projects in this chapter appeal to the senses, whether that be through touch, sound, sight, taste, or smell. These projects show how the use of different materials, rather than different typefaces or combinations of color, can send the design message. Whether that is to evoke a sense of luxury and self-indulgence, or to give a sense of the raw and handmade, the sensual nature of these items makes picking them up irresistible, and ensures that they become something special and treasured.

CHAPTER TWO

Sensuality

making the most of materials

02

visionaire magazine

VISIONAIRE IS PERHAPS BEST DESCRIBED AS A FASHION-MEETS-ART PUBLICATION. IT IS NOT YOUR AVERAGE MAGAZINE, IN MANY RESPECTS—IN SHAPE, SIZE, AND CONTENT, NOT TO MENTION PRICE. BUT THAT IS WHAT MAKES IT SO SPECIAL, AND THAT IS WHY ISSUE NO. 1, PUBLISHED IN 1991, CHANGED HANDS IN 2004 FOR THOUSANDS OF DOLLARS.

love, visionaire issue no. 38, 2002

Published three times a year, each issue is produced in exclusive, numbered, limited editions, with work by famous artists—<u>Mario Testino</u>, <u>Karl Lagerfeld</u>, <u>Andreas Gursky</u>, <u>Björk</u>, <u>Baz Luhrmann</u>, and <u>Spike Jonze</u>, to name a few—working in collaboration with Visionaire to produce personal interpretations on a particular theme. The magazine also collaborates with companies and brands such as Louis Vuitton (for an issue that came in a Louis Vuitton satchel), Gucci (a battery-operated issue), Tiffany & Co. (complete with <u>Elsa Peretti</u> heart pendant), Levi's, and Fendi to produce one of, if not the most exclusive magazine in the world.

Movement
The cover of issue no. 27, titled "Movement," employed what was then the latest technology in lenticular photography. Photographer <u>Nick Knight</u>, in collaboration with art director <u>Peter Saville</u>, shot <u>Kate Moss</u> (wearing an <u>Alexander McQueen</u> dress created for the cover) to produce a moving image. As you tilt the issue, Kate swings back and forth on the front and back covers. The issue was printed on vellum, allowing the contributing artists, among them <u>Tony Ousler</u>, <u>Steven Meisel</u>, and <u>Fabien Baron</u>, to experiment with movement through layered images.

Love

Released in July 2002, "Love" was produced in collaboration with jewelers Tiffany & Co. To create the issue, Visionaire found 4,000 old-fashioned, secondhand novels and customized each one by hand, with inserts from contributing photographers, illustrators, fashion designers, musicians, and painters, including Kylie Minogue, Mario Sorrenti, and Peter Lindbergh. The book sits in a drawstring Tiffany jewelry bag, complete with the legendary Elsa Peretti silver heart on a silk string. The book is packaged inside a customized Tiffany box, which is tied with white ribbon.

Scent

The 42nd edition of the magazine, published in December 2003, was titled "Scent." Visionaire collaborated with International Flavors & Fragrances (IFF), to produce a publication containing 21 original and exclusive scents, each in individually marked glass vials that correspond with a specifically created visual. Smells include Cold, Noise, Sadness, Fetish, Strange, and Broken Glass, and images have been created by Nick Knight, Zaha Hadid, Sam Taylor-Wood, and Gus Van Sant, among others. The case design and bottles were inspired by the tools of trade of the fragrance industry.

scent, visionaire issue no. 42, 2003

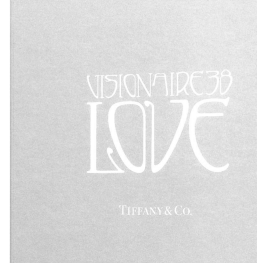

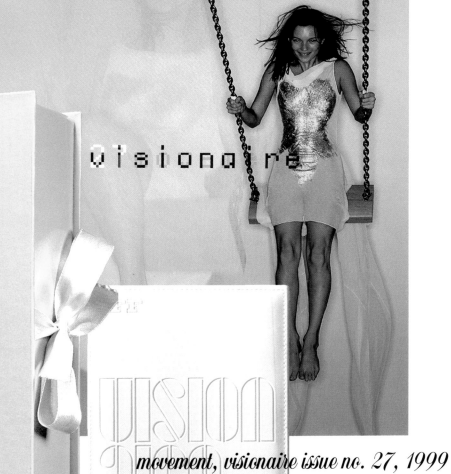

movement, visionaire issue no. 27, 1999

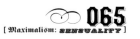

GOLD INK OVERPRINTING FULL-COLOR FLOWERS ON AN
ALBUM COVER IS CERTAINLY DECORATIVE, IF NOT A LITTLE
EXTRAVAGANT, BUT IT IS PERFECT FOR AN ALBUM BY JAPANESE TABLA PLAYER ASA-CHANG.
DESIGNED BY LONDON-BASED SCANDINAVIAN/BRITISH DUO NON-FORMAT,
THIS ILLUSTRATIVE, SEMIABSTRACT COVER IS ALL ABOUT OPULENCE AND
SUBTLE BEAUTY.

UNITED KINGDOM

non-format

asa-chang & junray album cover, 2002

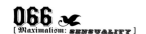
[Maximalism: SENSUALITY]

"We wanted to create something that was seemingly arbitrary in construction: the full-color part of the design was created with no consideration for where the type was going to sit," explains Non-Format designer Jon Forss. "We began by scanning in loads of illustrations of Japanese floral patterns, broke them apart in Photoshop, and then reconstructed them into a pattern that stretched across the front and back of an LP sleeve. Similarly, the type was laid out with no consideration for what was going to be seen through the reverse type, so it was a bit of a surprise when the finished piece came in. Not worrying about the type and image together was quite liberating. Obviously each element was carefully considered, but being able to design the type completely separately from the image and vice versa was interesting for us."

Mixing traditional tabla beats with electronic sounds and a beat-for-beat vocal, the first track on this album, "Hana" (Japanese for flower), was the main inspiration for the design of the packaging.

The floral illustration was created in full color, with subtle blends of blues and purples on the front, and reds and oranges on the back. The whole sleeve was then covered in a warm gold ink, with all the type (Avant Garde bold) reversed out. The gold almost completely obliterates the color underneath, allowing just a little to show through, but where the type is reversed, its full strength can be seen.

067

According to <u>Paul Reardon</u>, of Peter and Paul, the sleeve needed to have a special retainable quality while capturing the quirky humor of the music. "After meeting <u>Fred</u> and <u>Marian</u> we fell in love and decided to create some kind of image that was a personification of them," he explains. "We designed an elaborate logo that is reminiscent of a classic, ornate-looking crest. On closer inspection there are humorous little symbols that fly around <u>Fred</u> and <u>Marian</u>'s profiles. Instead of a lion and unicorn there is a frog and a snail, because that is what <u>Fred</u> and <u>Marian</u> affectionately call themselves, and the decorative, swirling lines become a collection of sperm."

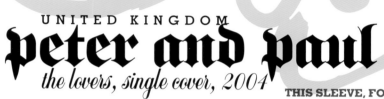

UNITED KINGDOM
peter and paul
the lovers, single cover, 2004

THIS SLEEVE, FOR THE SINGLE "LA DEGUSTATION," WAS CREATED BY DESIGN DUO PETER AND PAUL FOR A LIMITED RELEASE BY FRENCH MUSIC DUO THE LOVERS, AKA <u>FRED</u> AND <u>MARIAN</u>. THERE IS SOMETHING VERY SEDUCTIVE ABOUT THIS PACKAGE. THE COMBINATION OF THE VELVETY FEEL OF THE CURIOUS TOUCH ARCHES PAPER STOCK AND THE GOLD, FOIL-BLOCKED CREST—LIKE A LOGO—GIVES IT A CERTAIN RICHNESS, DEPTH, AND SEXINESS.

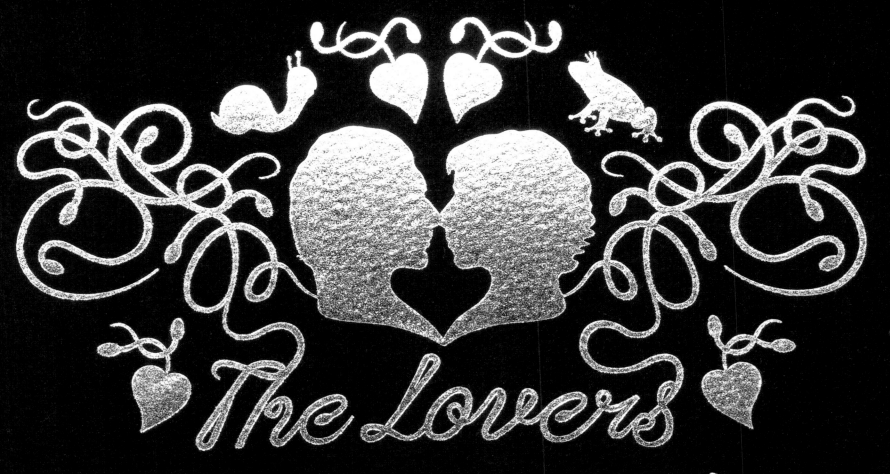

The Lovers

{ face a La Dégustation / Crik Crak face aa Sex Club }

www. voilathelovers.com

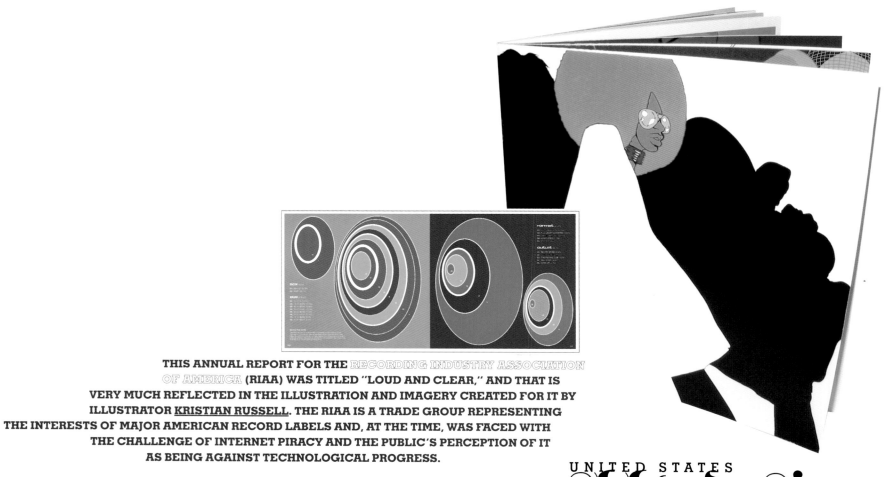

THIS ANNUAL REPORT FOR THE RECORDING INDUSTRY ASSOCIATION OF AMERICA (RIAA) WAS TITLED "LOUD AND CLEAR," AND THAT IS VERY MUCH REFLECTED IN THE ILLUSTRATION AND IMAGERY CREATED FOR IT BY ILLUSTRATOR <u>KRISTIAN RUSSELL</u>. THE RIAA IS A TRADE GROUP REPRESENTING THE INTERESTS OF MAJOR AMERICAN RECORD LABELS AND, AT THE TIME, WAS FACED WITH THE CHALLENGE OF INTERNET PIRACY AND THE PUBLIC'S PERCEPTION OF IT AS BEING AGAINST TECHNOLOGICAL PROGRESS.

UNITED STATES

ashby design

annual report for the recording industry association of america, 1999

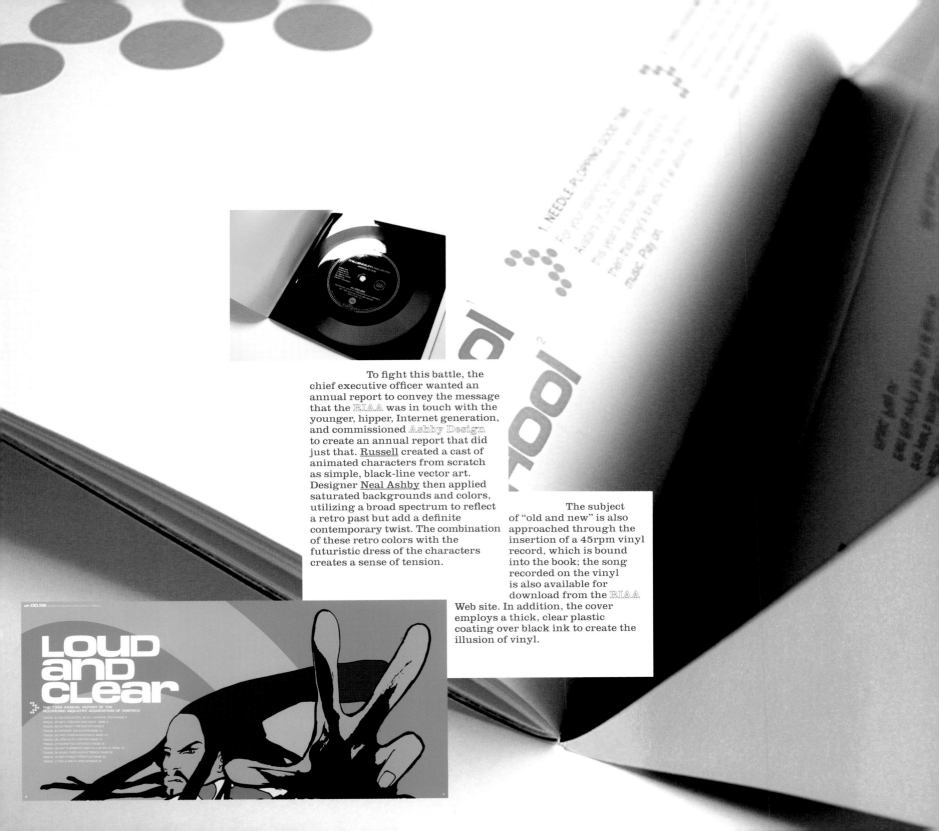

To fight this battle, the chief executive officer wanted an annual report to convey the message that the RIAA was in touch with the younger, hipper, Internet generation, and commissioned Ashby Design to create an annual report that did just that. Russell created a cast of animated characters from scratch as simple, black-line vector art. Designer Neal Ashby then applied saturated backgrounds and colors, utilizing a broad spectrum to reflect a retro past but add a definite contemporary twist. The combination of these retro colors with the futuristic dress of the characters creates a sense of tension.

The subject of "old and new" is also approached through the insertion of a 45rpm vinyl record, which is bound into the book; the song recorded on the vinyl is also available for download from the RIAA Web site. In addition, the cover employs a thick, clear plastic coating over black ink to create the illusion of vinyl.

LOUD
and
CLEAR

"The design was a reaction to the architecture," explains Hitner. "The interior is very clean and white, using colored light to emphasize the different areas of the space—restaurant, brasserie, and bar. We felt, to juxtapose this very cool and minimal environment, we would add an element of decoration that would react against the space, by adding a softer, more tactile human element."

A number of special materials and printing techniques have been used in the production of these various elements, including debossing, screen printing, flock paper, soft-touch PVC, satin-finish PVC, and high-gloss Astrolux card.

Stephanie Nash, Anthony Michael, and David Hitner of Michael Nash Associates designed all the graphic elements for The Second Floor, including the main and dessert menus, the brasserie menu, the bar drinks and food menu, and the bill fold, as well as matchboxes, business cards, coasters, and the cigarette machine.

UNITED KINGDOM
michael nash associates
the second floor, 2003

MICHAEL NASH ASSOCIATES HAS WORKED WITH CLIENT HARVEY NICHOLS—ONE OF THE U.K.'S MOST EXCLUSIVE DEPARTMENT STORES—FOR MORE THAN 10 YEARS, DEVELOPING PACKAGING FOR ITS OWN-BRAND FOOD LINE AND CREATING IDENTITIES FOR ITS IN-STORE RESTAURANTS: THE FIFTH FLOOR, KNIGHTSBRIDGE, LONDON; THE FOURTH FLOOR, LEEDS; THE FOURTH FLOOR, EDINBURGH; AND THIS, THE SECOND FLOOR, MANCHESTER.

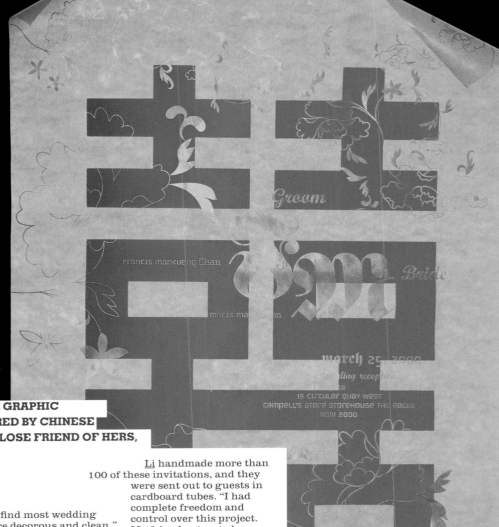

winnie li

wedding invitation, 2001

WINNIE LI IS A LOS ANGELES–BASED FREELANCE GRAPHIC DESIGNER. IN 2001, SHE CREATED THIS INVITATION, INSPIRED BY CHINESE CULTURE, FOR THE WEDDING OF A CLOSE FRIEND OF HERS, HELD IN AUSTRALIA.

"I find most wedding invitations are decorous and clean," says Li. "My client and I wanted to create a piece that was a little more unusual, that was more decorative and rich. I also wanted to design something unique that the recipients might want to keep."

The couple were young and of Chinese origin, so Li used traditional Chinese motifs and the traditional Chinese palette of red and gold. She combined these with Western influences, using Cholla typeface (a new, modern-looking font) and Flemish Script (a decorative, old-style font), screen printing, Glassine, and metallic ink, to create a rich and luxurious invitation.

Li handmade more than 100 of these invitations, and they were sent out to guests in cardboard tubes. "I had complete freedom and control over this project. My friend entrusted me with great confidence," she explains. "The first time they saw it was when I sent it to them in Australia."

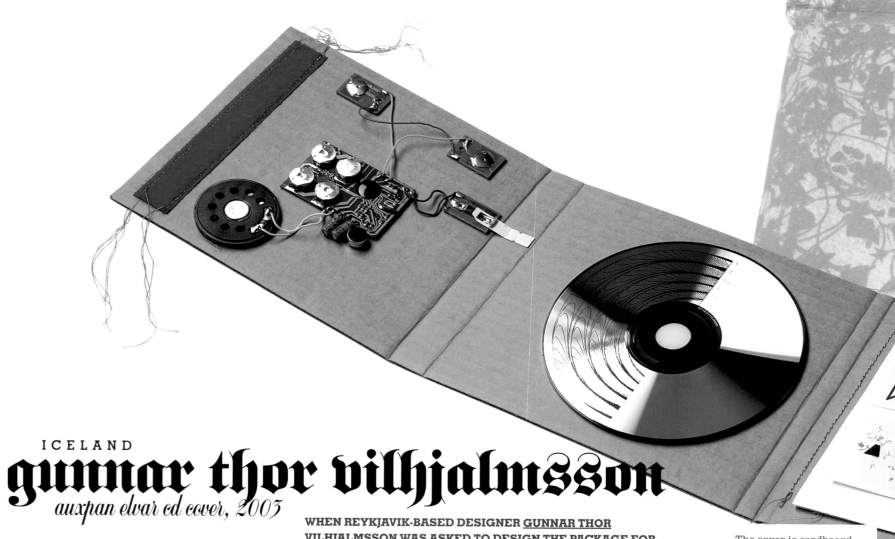

gunnar thor vilhjalmsson

auxpan elvar cd cover, 2003

WHEN REYKJAVIK-BASED DESIGNER GUNNAR THOR VILHJALMSSON WAS ASKED TO DESIGN THE PACKAGE FOR THIS LIMITED-EDITION RELEASE BY ICELANDIC ARTIST AUXPAN ELVAR, HIS BRIEF WAS TO "MAKE A DECADENT CD COVER." TAKING INSPIRATION FROM NONE OTHER THAN WILLIAM MORRIS, HE CREATED A DECORATIVE, ORNAMENTED COVER THAT IS NOT ONLY ATTRACTIVE TO THE EYE, BUT ALSO TO THE TOUCH. THE BUDGET WASN'T BIG, BUT THE RESULT IS A DELICATE PACKAGE THAT APPEARS TO HAVE BEEN CAREFULLY HANDMADE.

The cover is cardboard, on which a sticker, printed with a graphic, has been set. A hand-stitched Velcro strip fastens the cover, and the whole thing comes in a soft Vlieseline (a fleece-like lining fabric) pocket with a screen-printed cover. On top of all this, when you open up the package, an interactive sound module is activated and plays a sinus wave (a specific sound wave), something that artist Elvar uses a lot in his music. As a whole, it is an all-round sensual experience.

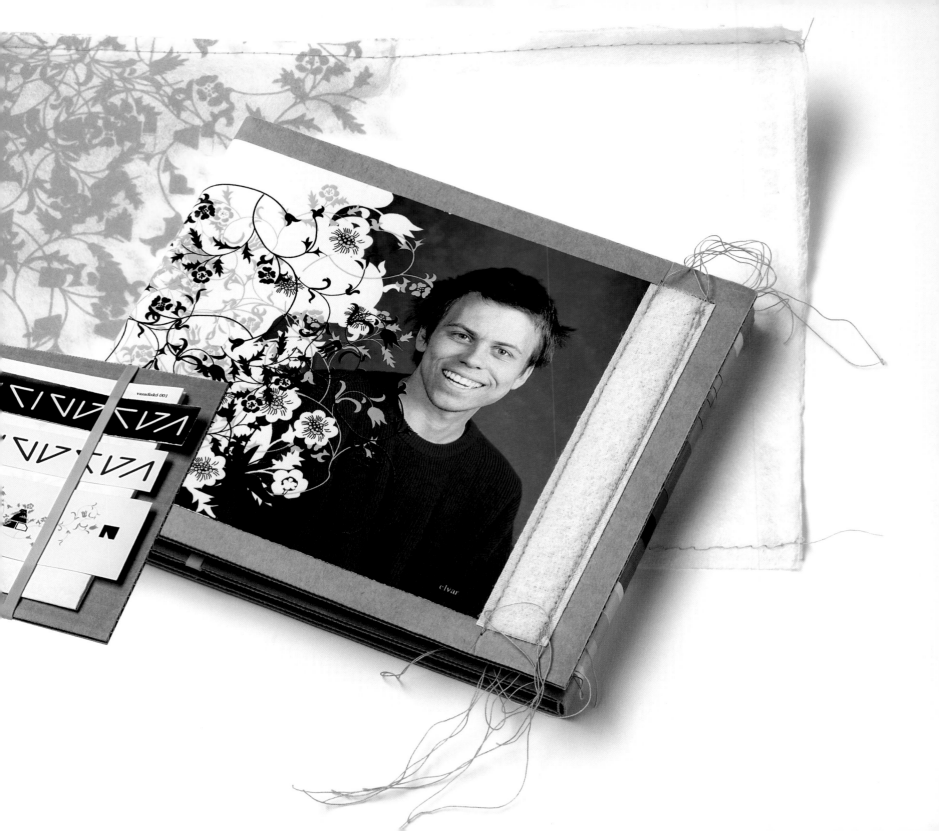

fresh cream,
book design,
2000

UNITED STATES
julia hasting

CREAM AND FRESH CREAM, BOTH CONTEMPORARY ART BOOKS PUBLISHED BY
PHAIDON PRESS, HAVE BEEN DESCRIBED AS "EXHIBITIONS IN BOOKS." IN BOTH,
10 WORLD-CLASS EXPERTS EACH SELECT 10 EMERGING INTERNATIONAL
ARTISTS. THE ARTISTS' SPREADS ARE ARRANGED A–Z. EACH ENTRY FEATURES NUMEROUS
EXAMPLES OF THE ARTIST'S WORK ALONGSIDE A BRIEF TEXT FROM THE SELECTING CURATOR. IN ADDITION,
A "CONVERSATION" BETWEEN THE 10 CURATORS GIVES AN INSIGHT INTO THEIR
SELECTIONS AND INTO KEY ISSUES IN CONTEMPORARY ART.

cream,
book design,
1998

German-born, New York–based designer <u>Julia Hasting</u> is Art Director for the Phaidon Press in New York. Both books won her numerous awards including, for Cream: an award from AIGA (American Institute of Graphic Arts), 50 Books/50 Covers, 1998; a Merit Award from the Art Directors Club, 1999; and a Certificate of Typographic Excellence from the Type Directors Club, 1999; and for Fresh Cream: First Prize in Print magazine's A–Z competition; and another from AIGA, 50 Books/50 Covers, 2000. New York magazine described Fresh Cream as "an artwork in its own right," and it is not wrong.

"I always see the book as an overall object," explains <u>Hasting</u>. "Format, shape, materiality, inside grid, and typography in relation to the outside form an object in its own right. For Cream I tried to reflect the idea of an exhibition in a book, with the book's pages a stage/room for the artworks, and the packaging reflecting the release of a very cutting-edge show. With Fresh Cream the inflated pillow functions as a protective package as well as a display vitrine for the book. It preserves the book's content until release—until you destroy the pillow—or, kept closed, remains a time capsule of its content," she adds.

In fact, the packaging of both books reflects the idea of preserving very contemporary, fresh, up-to-the-minute contents. With Cream, which has been vacuum-packed, the air has been taken away in order to "preserve" it. With Fresh Cream, air has been added to cushion and protect it. These opposite processes link the two books.

You would expect a large budget for such a project, but that was not the case. "We managed to find a way to produce the books within the budget frames. In most cases we found solutions that were a close match to the original design idea in terms of materials, binding, etc," explains <u>Hasting</u>.

Cream, with its uncoated cover and carry handle, and Fresh Cream, with its padded, fake leather cover and inflated, screen-printed pillow, are indeed art in their own right, and I would think that many who bought them bought two of each—one to open and one to keep preserved.

For the 15-year anniversary party of Seattle-based architectural firm GGLO Architects, designers at Hornall Anderson Design Works, Inc. created this "matchbook" invitation. The design was inspired by the date on which the party was to be held—the summer equinox in 2001. As this was scheduled for June 21, a date that is generally considered the brightest day of the year in the U.S., Hornall Anderson played up that theme using a series of deep, bright reds on a selection of vellum inserts for the invitation.

The appearance of the invitation—it resembles an oversized matchbook—is intended to continue the summer equinox theme of heat and fire. The vellum inserts follow alternating vibrant reds. Each contains a printed image of a match or lit candles. Information about the party and its whereabouts is printed on white pages slotted in between the vellum.

The theme is continued even in the language of the invitation, with a series of catch words and phrases such as "spark," "blazing," and "red hot" peppered throughout.

The whole fire theme became the focus of the party. A specially designed, temporary flame tattoo was made available for attendees to wear, fire dancers were hired for the evening, and matchboxes commemorating the anniversary were produced.

UNITED STATES

hornall anderson design works, inc.

gglo architects invitation, 2001

[Maximalism: SENSUALITY]

"Steven's work is so strong that the briefing was simply the images," explains Bianco. "I tried to accentuate their intensity. There was a lot of material to work with, and really I didn't want to leave anything out. I started to focus on details—lights, set pieces, expressions—and it became a book."

Klein's photographs are so "dark" they are almost like paintings. In this instance their darkness was further accentuated by Bianco's choice of highly absorbent paper for the book's pages. New York–based Nava Fabrizio Passioni, who Bianco describes as a "genius in printing," developed both the paper and the printing process for this book, which made the whole look and feel that Bianco was after achievable.

Madonna had a lot of input with this project. She worked closely with Klein on ideas for the shoot, and all aspects of the project were very much supervised by both of them. Images from the shoot appeared in this exhibition catalog, at the exhibition itself, and as a series of spreads in W Magazine.

Only 1,000 copies of this limited-edition book were printed, all numbered. The paper is textured, delicate, and tissue-like, and the whole is packaged in a slipcase autographed by Klein.

THIS LAVISH BOOK WAS
DESIGNED BY NEW YORK
ART DIRECTOR/DESIGNER
GIOVANNI BIANCO TO ACCOMPANY A PHOTOGRAPHIC EXHIBITION AT
THE DEITCH PROJECTS GALLERY IN NEW YORK. THE EXHIBITION WAS OF PHOTOGRAPHS THAT
PHOTOGRAPHER STEVEN KLEIN AND MADONNA CREATED FOR
A SHOOT IN FASHION TITLE W MAGAZINE.

UNITED STATES

giovanni bianco
x-static pro=cess, book design, 2003

X-STaTIC PRO=CeSS MADONNA STEVEN KLEIN

LUXURY EQUALS MONEY, AND MONEY EQUALS LUXURY. OR DOES IT?
HAS THE WORD LUXURY BEEN SO OVERUSED THAT ITS REAL MEANING
HAS BEEN SOMEWHAT FORGOTTEN? WHAT IS LUXURY ANYWAY? WHAT
IS LUXURIOUS? AND CAN WE NOW ALL AFFORD TO BUY IN TO THAT
IDEA? IT CERTAINLY SEEMS THAT WAY. NEVER HAS THERE BEEN SO
MANY LOUIS VUITTON AND GUCCI PURSES, VERSACE JEANS, BURBERRY
CHECKS, PRADA SHOES, AND RALPH LAUREN JACKETS IN ONE MALL AS NOW,
BUT DOES THAT READY AVAILABILITY MAKE THESE ITEMS CHEAP?

That depends which idea of luxury you buy into. Either way, with the demand for luxury goods and the whole bling bling culture of the music industry toward the end of the nineties and early naughties, it was inevitable that the idea of luxury would filter down to design, and in particular to packaging design for luxury products. Here, the client allows the designer license to create maximum impact by all means necessary. This is about capturing the consumer's conspicuous purse, and promotion is the key. For health and beauty products, spirits, wines, and champagne, fashion, and limited-edition publishing, the packaging needs to encapsulate, in a marketable way, the essence of glamorous living. Designing for luxury goods often means creating a "lifestyle" for the consumer to buy into, to help them believe they are part of something that inevitably they will never be. It is aspirational design at its best.

Designing luxury items is, in some ways, a dream for the graphic designer. They offer a higher budget, room for experimentation with different paper stocks and printing techniques, and, of course, the opportunity to create items that ordinarily would not be possible. Luxury can see the idea of maximalism taken to its extreme, with over-the-top design raising questions of taste, or it can present the opportunity to create classic, timeless, high-quality items.

Some of the work presented here is for such luxury names as John Galliano and Emilio Pucci, and some of it simply sees the use of luxurious materials in design for clients including Kylie Minogue and the world-famous London department store Liberty. All are examples of how designers can evoke a sense of luxury, whether that be bling bling or old school.

Well, that is a matter of opinion. There is another, more old-school argument here that sees luxury not simply as a designer label plastered all over a bag, but as a question of timelessness or of surroundings. Isn't that what luxury is about? Surroundings or items that are not essential, but are desirable; things that are comfortable and things that are exuberant; extras that make life easier and help get you through the working week; quality products that last and last. In short, isn't luxury about the finer things in life?

CHAPTER THREE

Luxury

packaging, labels, lifestyle

03

UNITED KINGDOM
saturday
liberty press box, 2003

LONDON'S LIBERTY STORE HAS BEEN ASSOCIATED WITH LUXURY AND EXCESS SINCE IT OPENED IN 1875 TO SELL ORNAMENTS, FABRIC, AND OBJETS D'ART FROM JAPAN AND THE EAST. FROM THE BUILDING ITSELF—THE FAMOUS TUDOR HOUSE, BUILT IN 1924—TO THE DESIGNER PRODUCTS ON SALE INSIDE—PAUL SMITH, ARMANI, AGENT PROVOCATEUR, AND ALEXANDER MCQUEEN—LIBERTY EXUDES LUXURY.

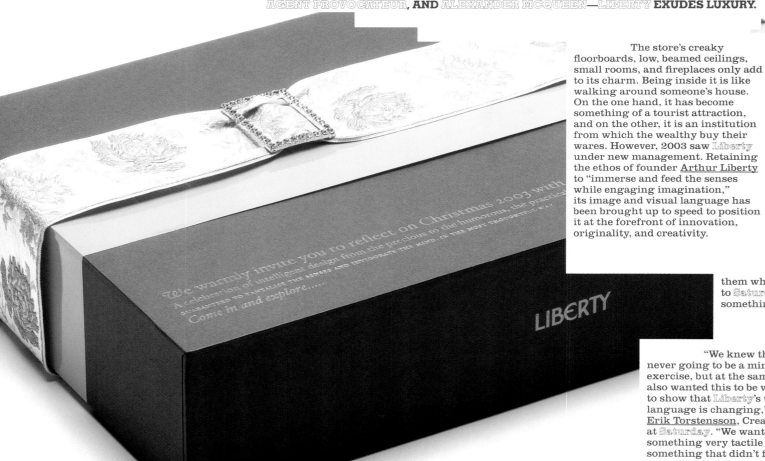

The store's creaky floorboards, low, beamed ceilings, small rooms, and fireplaces only add to its charm. Being inside it is like walking around someone's house. On the one hand, it has become something of a tourist attraction, and on the other, it is an institution from which the wealthy buy their wares. However, 2003 saw Liberty under new management. Retaining the ethos of founder Arthur Liberty to "immerse and feed the senses while engaging imagination," its image and visual language has been brought up to speed to position it at the forefront of innovation, originality, and creativity.

As part of the plan to convey this new visual language to the press and PR community, London design studio Saturday created this "press box." The intention was to take whoever opened it on a tour through Liberty's Christmas 2003, showing them what it was all about. The brief to Saturday was simply "create something stunning."

"We knew that this was never going to be a minimalist exercise, but at the same time we also wanted this to be very modern to show that Liberty's visual language is changing," explains Erik Torstensson, Creative Director at Saturday. "We wanted to create something very tactile and personal, something that didn't feel too manufactured, and something that was feminine, warm, modern, and exciting."

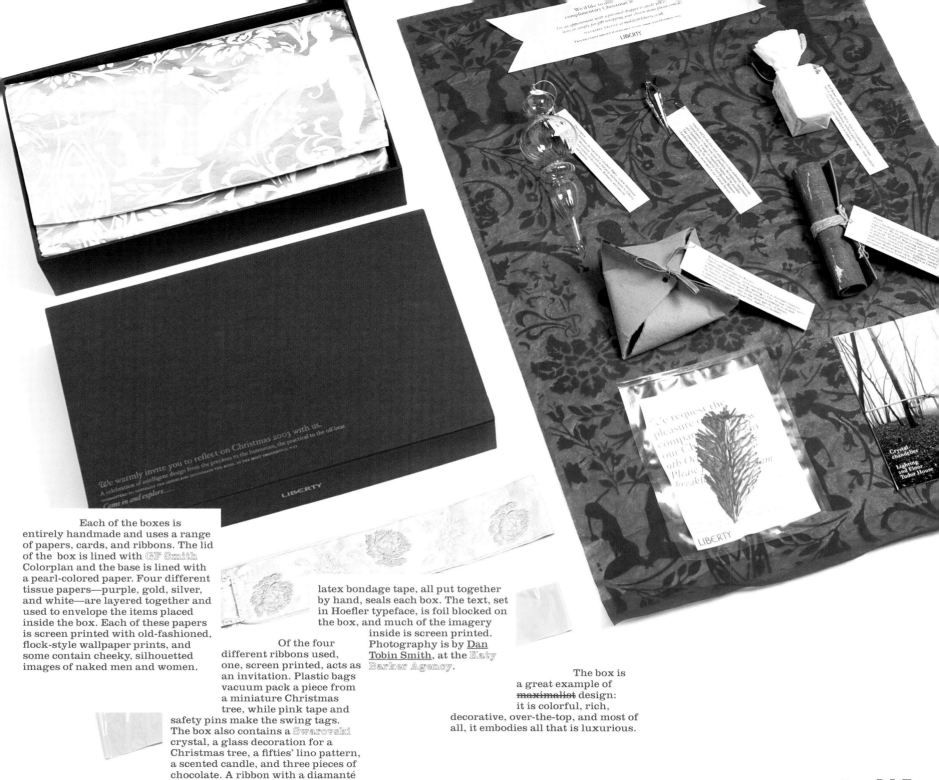

Each of the boxes is entirely handmade and uses a range of papers, cards, and ribbons. The lid of the box is lined with GF Smith Colorplan and the base is lined with a pearl-colored paper. Four different tissue papers—purple, gold, silver, and white—are layered together and used to envelope the items placed inside the box. Each of these papers is screen printed with old-fashioned, flock-style wallpaper prints, and some contain cheeky, silhouetted images of naked men and women.

Of the four different ribbons used, one, screen printed, acts as an invitation. Plastic bags vacuum pack a piece from a miniature Christmas tree, while pink tape and safety pins make the swing tags. The box also contains a Swarovski crystal, a glass decoration for a Christmas tree, a fifties' lino pattern, a scented candle, and three pieces of chocolate. A ribbon with a diamanté buckle, together with some pink latex bondage tape, all put together by hand, seals each box. The text, set in Hoefler typeface, is foil blocked on the box, and much of the imagery inside is screen printed. Photography is by Dan Tobin Smith, at the Katy Barker Agency.

The box is a great example of maximalist design: it is colorful, rich, decorative, over-the-top, and most of all, it embodies all that is luxurious.

michael nash associates

john galliano identity, 2003

DESIGNERS <u>ANTHONY MICHAEL</u> AND <u>STEPHANIE NASH</u>, AT MICHAEL NASH ASSOCIATES, HAVE CREATED THIS NEW IDENTITY FOR FASHION DESIGNER <u>JOHN GALLIANO</u>. THE AIM OF THE WHOLE BRANDING PROCESS WAS TO REDEFINE "JOHN GALLIANO" WITHIN THE INTERNATIONAL FASHION WORLD. THE RESULT IS A STRONG VISUAL IDENTITY THAT SUITS BOTH <u>GALLIANO</u>'S COLLECTIONS AND HIS CHARACTER; OLD IS MIXED WITH NEW AND THERE IS A GOOD DOSE OF HUMOR TOO.

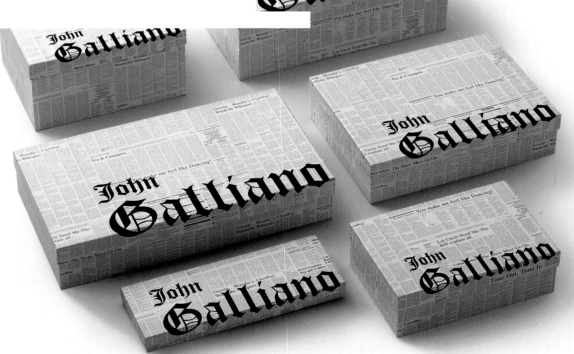

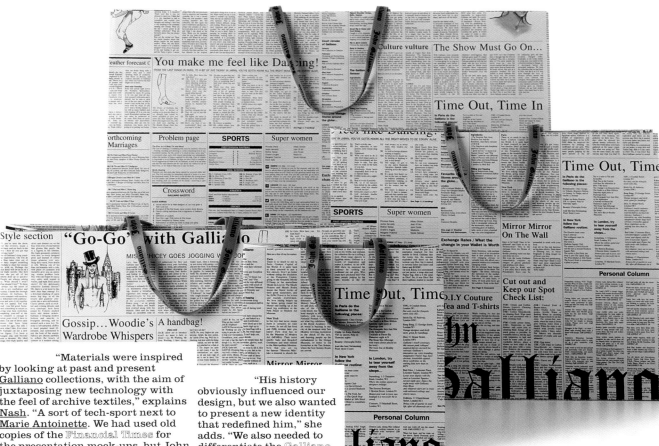

"Materials were inspired by looking at past and present Galliano collections, with the aim of juxtaposing new technology with the feel of archive textiles," explains Nash. "A sort of tech-sport next to Marie Antoinette. We had used old copies of the Financial Times for the presentation mock-ups, but John wanted to produce a Galliano Gazette, so his studio wrote all the copy and our first part of the job was to design the newspaper.

We had known John Galliano in the past, through a mutual friend, and were at [London's] Central Saint Martins College at the same time. Because of this, we probably had to forget some of the history in order to create a new identity that could be truly international."

"His history obviously influenced our design, but we also wanted to present a new identity that redefined him," she adds. "We also needed to differentiate the Galliano brand from the Dior brand. This was probably the most important aspect of the project.

After experimentation with new typefaces, the designers chose to keep the original Gothic-style font and play instead with the size, positioning, and application of it on the packaging, stationery, garment labeling, and other branding elements. Headlines in the paper include Mirror Mirror on the Wall, You Make me Feel Like Dancing, and Tea and Crumpets, under which is copy that has a distinct sense of English humor. The identity has proved so popular that elements of the Galliano Gazette have since been used on wearable products including handbags, shoes, and lingerie.

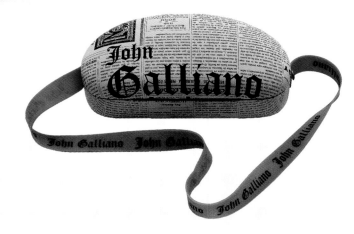

HAVING DESIGNED KYLIE MINOGUE'S FEVER ALBUM COVER IN 2001, TONY HUNG, AT LONDON-BASED DESIGN STUDIO ADJECTIVE NOUN, WAS COMMISSIONED TO CREATE ALL THE MERCHANDISE, INCLUDING THIS SOUVENIR TOUR BOOK, FOR KYLIE'S FEVER TOUR IN 2002. ESSENTIALLY, THE IDEA BEHIND THE DESIGN WAS TO MIRROR THE SHOW—THE EFFECTS, COSTUMES, VISUALS, AND SO ON—TO MAKE IT A VERSION OF SHOW IN PRINT. HUNG MET WITH THE SHOW'S CREATORS, WILLIAM BAKER AND ALAN MACDONALD, AND THE THINKING WAS TO CREATE SOMETHING UNIQUE, USING EXCLUSIVE MATERIAL.

UNITED KINGDOM
adjective noun
fever, book design, 2002

 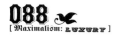

In addition, the book's cover was made from a specially formulated material, Radiant Opel, that gives the cover the reflective qualities of the playable side of a CD. The book's pages were printed in six colors—four-color process plus metallic silver and spot varnish—and there is a perforated card insert. The imagery used is a mixture of specially commissioned photography, shot by Lee Jenkins, existing photography, and a number of manipulated images. The book won Hung the Adline Award for Best use of Printing in 2002.

The first part of the show was set in the future. Kylie was raised onto the stage with a half-robot, half-human appearance. Slowly she was revealed, as sections of a specially created Kyborg suit were lifted off mechanically. This was the basis of much of the inspiration behind the book design. "I loved the idea of this spectacular opening and I wanted to capture it somehow," explains Hung. "I looked into the idea of the book looking and feeling like a package sent from the future, or outer space, and that's how the silver bubble-wrap package for the book came into play."

PANDORA'S BOX IS A STUDY OF THE RELATIONSHIP BETWEEN MEN AND WOMEN IN A NEW YORK SEX CLUB. IT WAS DESIGNED BY **BROWNS** (LONDON) AND **MAGNUM** PHOTOGRAPHER <u>SUSAN MEISELAS</u>. TOGETHER WITH <u>MEISELAS</u>, <u>JONATHAN ELLERY</u>, CREATIVE DIRECTOR AT **BROWNS**, VISITED THE CLUB TO GET AN IN-DEPTH IDEA OF WHAT GOES ON THERE AND WHAT IT IS LIKE INSIDE. HE DISCOVERED THAT THE CLUB HAS MANY DIFFERENT ENVIRONMENTS AND THEMES WHICH GIVE BOTH THE MALE AND FEMALE CLIENTS THE CHANCE TO LIVE OUT THEIR SEXUAL FANTASIES. THIS IS REFLECTED WITHIN THE DESIGN OF THE BOOK.

UNITED KINGDOM

browns

pandora's box, book design, 2002

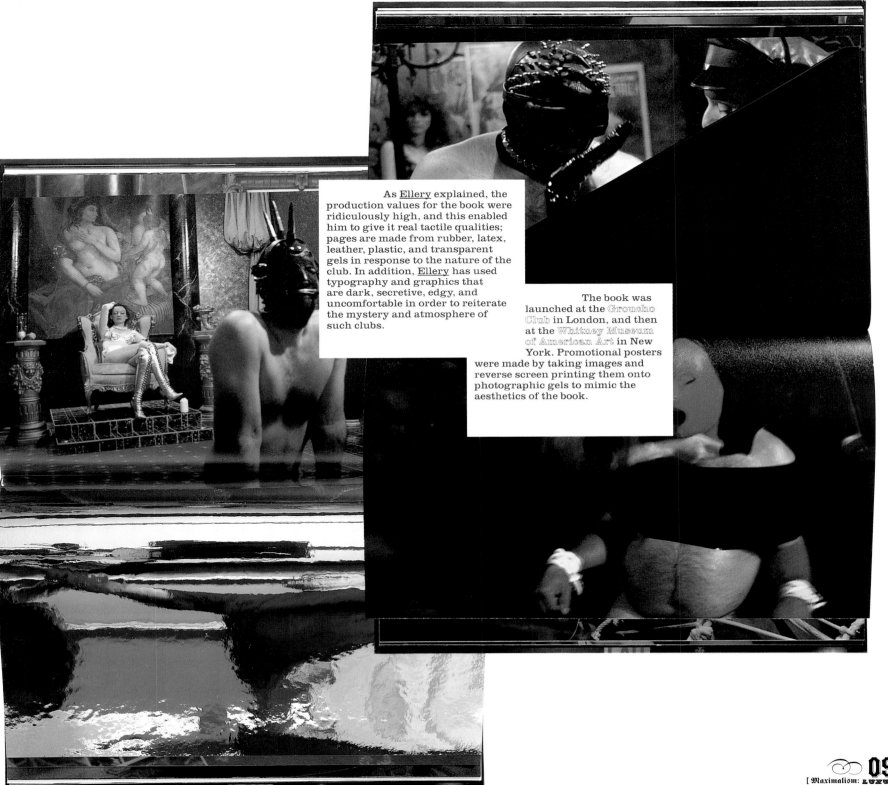

As Ellery explained, the production values for the book were ridiculously high, and this enabled him to give it real tactile qualities; pages are made from rubber, latex, leather, plastic, and transparent gels in response to the nature of the club. In addition, Ellery has used typography and graphics that are dark, secretive, edgy, and uncomfortable in order to reiterate the mystery and atmosphere of such clubs.

The book was launched at the Groucho Club in London, and then at the Whitney Museum of American Art in New York. Promotional posters were made by taking images and reverse screen printing them onto photographic gels to mimic the aesthetics of the book.

jonathan ellery

muhammad ali poster for the henry peacock gallery, 2004

Muhammad Ali

★ ★ ★
Waldorf Astoria Hotel
New York City
September 1974

Designed by Jonathan Ellery
Limited edition run of thirty
Henry Peacock Gallery
London 2004

DONE WRASSLED WITH AN ALLIGATOR, I DONE TUSSLED WITH A WHALE, I DONE HANDCUFFED LIGHTNING. THROWN THUNDER IN JAIL, THAT'S BAD ONLY LAST WEEK MURDERED A ROCK, INJURED A STONE, HOSPITALIZED A BRICK, I'M SO MEAN I MAKE MEDICINE SICK.

IN 2003, LONDON-BASED DESIGNER JONATHAN ELLERY WAS COMMISSIONED BY THE HENRY PEACOCK GALLERY, LONDON, TO DESIGN A POSTER THAT WOULD FORM PART OF A SHOW THAT OPENED IN EARLY 2004, ENTITLED PUBLIC ADDRESS SYSTEM.

A number of graphic designers from around the world were invited to interpret a well-known speech of their own choice, typographically. Jonathan Ellery, Partner at Browns, chose this famous Muhammad Ali speech. "I done wrassled with an alligator, I done tussled with a whale, I done handcuffed lightening, thrown thunder in jail. That's bad. Only last week I murdered a rock, injured a stone, hospitalized a brick. I'm so mean I make medicine sick."

"In the absence of a commercial client, the brief was a joy to receive," Ellery explains. "I chose this speech for no other reason than I loved the words and think Ali is a very special individual."

Production of these posters was highly indulgent and luxurious; the 30 A2 (c. $16\frac{1}{2} \times 23\frac{3}{8}$in) posters in the limited-edition run were foil blocked in gold onto four different materials, including both gold and silver Chromolux, and black and red Splendorlux.

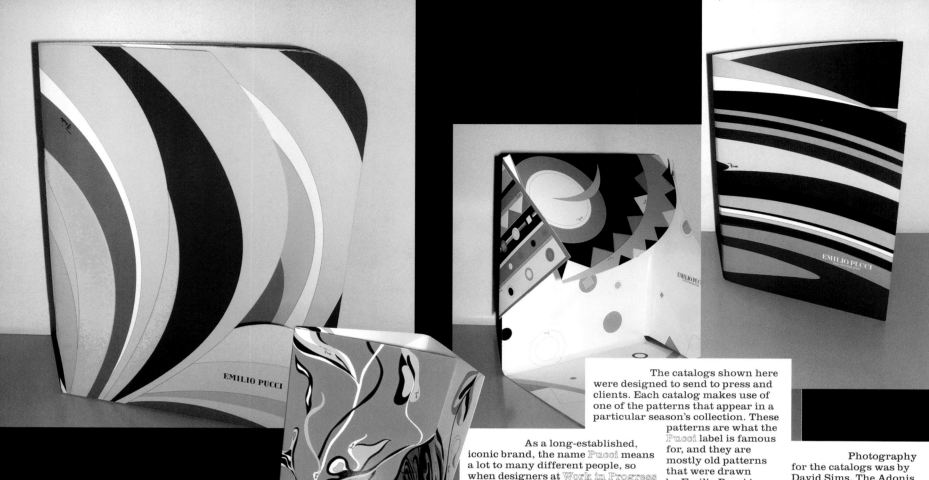

The catalogs shown here were designed to send to press and clients. Each catalog makes use of one of the patterns that appear in a particular season's collection. These patterns are what the Pucci label is famous for, and they are mostly old patterns that were drawn by Emilio Pucci in the sixties. Their psychedelic influences are clear. Work in Progress interpreted the selected patterns in a 2-D and 3-D environment, which meant that the form and size of the catalog changed every season.

As a long-established, iconic brand, the name Pucci means a lot to many different people, so when designers at Work in Progress were commissioned to develop their brand image and communication, the challenge was to make it a relevant brand in today's market.

Photography for the catalogs was by David Sims. The Adonis typeface was used throughout, and special printing and finishing techniques, including varying paper weights, die cutting, and varnishing, were used to give the catalogs an air of luxury.

FRENCH FASHION LABEL EMILIO PUCCI IS PART OF THE LVMH GROUP. ITS PRET-A-PORTER COLLECTIONS ARE DESIGNED BY THE LEGENDARY FRENCH FASHION DESIGNER CHRISTIAN LACROIX. BEFORE PARIS-BASED DESIGNERS WORK IN PROGRESS BEGAN WORKING WITH THE LABEL FIVE SEASONS AGO, PUCCI HAD NOT EMPLOYED ANY FORM OF VISUAL COMMUNICATION FOR A NUMBER OF YEARS.

FRANCE
work in progress
pucci promotional catalogs, 2003

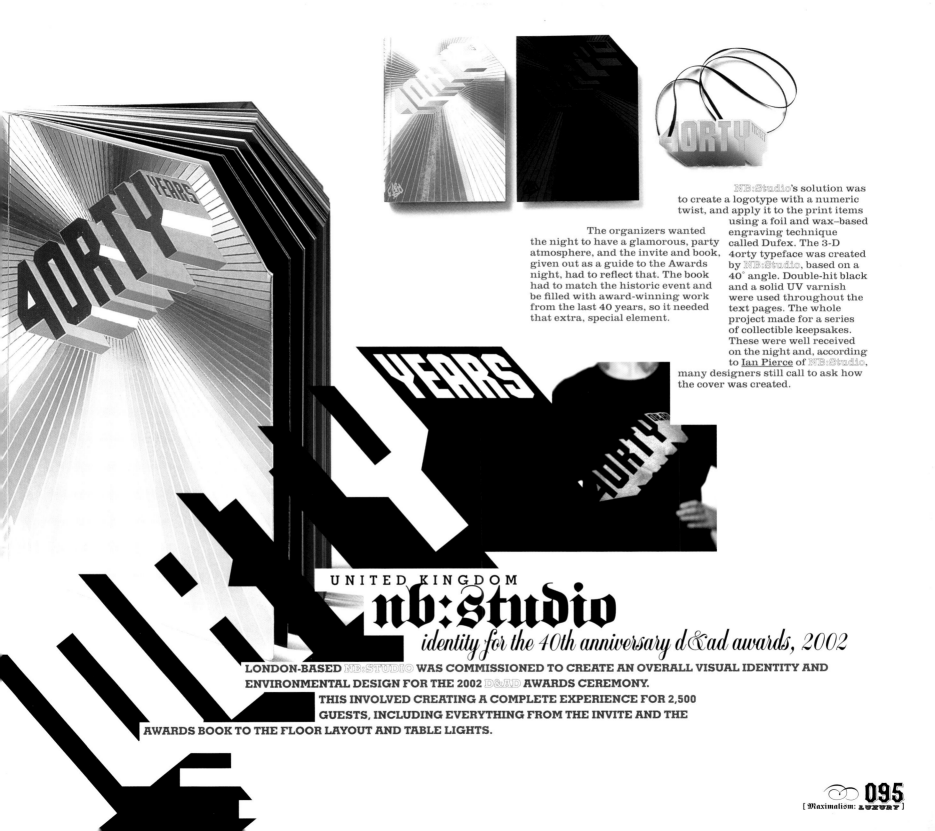

The organizers wanted the night to have a glamorous, party atmosphere, and the invite and book, given out as a guide to the Awards night, had to reflect that. The book had to match the historic event and be filled with award-winning work from the last 40 years, so it needed that extra, special element.

NB:Studio's solution was to create a logotype with a numeric twist, and apply it to the print items using a foil and wax–based engraving technique called Dufex. The 3-D 4orty typeface was created by NB:Studio, based on a 40° angle. Double-hit black and a solid UV varnish were used throughout the text pages. The whole project made for a series of collectible keepsakes. These were well received on the night and, according to Ian Pierce of NB:Studio, many designers still call to ask how the cover was created.

UNITED KINGDOM

nb:studio

identity for the 40th anniversary d&ad awards, 2002

LONDON-BASED NB:STUDIO WAS COMMISSIONED TO CREATE AN OVERALL VISUAL IDENTITY AND ENVIRONMENTAL DESIGN FOR THE 2002 D&AD AWARDS CEREMONY.
THIS INVOLVED CREATING A COMPLETE EXPERIENCE FOR 2,500 GUESTS, INCLUDING EVERYTHING FROM THE INVITE AND THE AWARDS BOOK TO THE FLOOR LAYOUT AND TABLE LIGHTS.

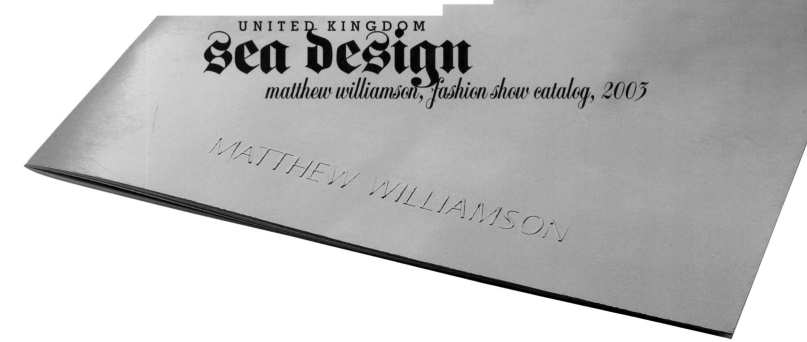

THIS CATALOG IS THE RESULT OF A COLLABORATION BETWEEN THREE OF LONDON'S TOP CREATIVES: FASHION DESIGNER MATTHEW WILLIAMSON, PHOTOGRAPHER RANKIN, AND GRAPHIC DESIGN TEAM SEA. THE CATALOG WAS CREATED TO ACCOMPANY WILLIAMSON'S FALL 2003 FASHION SHOW IN NEW YORK, SO THE DESIGNERS AT SEA HAD TO CREATE SOMETHING SPECIAL, SOMETHING AS UNIQUE AND COLLECTIBLE AS WILLIAMSON'S CLOTHES— A CATALOG THAT WOULD IMPRESS THOSE IN THE FICKLE WORLD OF FASHION.

UNITED KINGDOM

sea design

matthew williamson, fashion show catalog, 2003

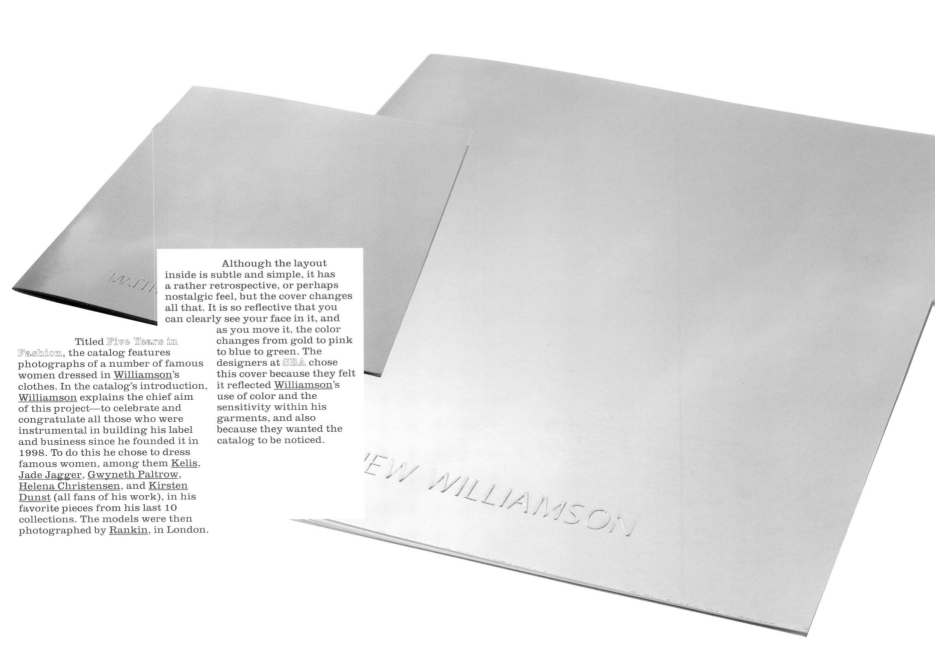

Titled Five Years in Fashion, the catalog features photographs of a number of famous women dressed in Williamson's clothes. In the catalog's introduction, Williamson explains the chief aim of this project—to celebrate and congratulate all those who were instrumental in building his label and business since he founded it in 1998. To do this he chose to dress famous women, among them Kelis, Jade Jagger, Gwyneth Paltrow, Helena Christensen, and Kirsten Dunst (all fans of his work), in his favorite pieces from his last 10 collections. The models were then photographed by Rankin, in London.

Although the layout inside is subtle and simple, it has a rather retrospective, or perhaps nostalgic feel, but the cover changes all that. It is so reflective that you can clearly see your face in it, and as you move it, the color changes from gold to pink to blue to green. The designers at SEA chose this cover because they felt it reflected Williamson's use of color and the sensitivity within his garments, and also because they wanted the catalog to be noticed.

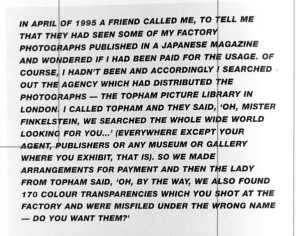

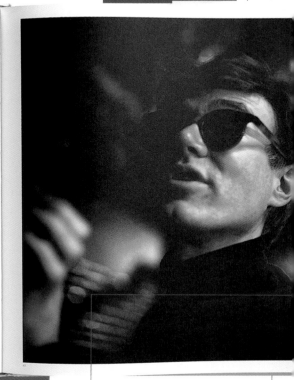

IN APRIL OF 1995 A FRIEND CALLED ME, TO TELL ME THAT THEY HAD SEEN SOME OF MY FACTORY PHOTOGRAPHS PUBLISHED IN A JAPANESE MAGAZINE AND WONDERED IF I HAD BEEN PAID FOR THE USAGE. OF COURSE, I HADN'T BEEN AND ACCORDINGLY I SEARCHED OUT THE AGENCY WHICH HAD DISTRIBUTED THE PHOTOGRAPHS — THE TOPHAM PICTURE LIBRARY IN LONDON. I CALLED TOPHAM AND THEY SAID, 'OH, MISTER FINKELSTEIN, WE SEARCHED THE WHOLE WIDE WORLD LOOKING FOR YOU...' (EVERYWHERE EXCEPT YOUR AGENT, PUBLISHERS OR ANY MUSEUM OR GALLERY WHERE YOU EXHIBIT, THAT IS). SO WE MADE ARRANGEMENTS FOR PAYMENT AND THEN THE LADY FROM TOPHAM SAID, 'OH, BY THE WAY, WE ALSO FOUND 170 COLOUR TRANSPARENCIES WHICH YOU SHOT AT THE FACTORY AND WERE MISFILED UNDER THE WRONG NAME — DO YOU WANT THEM?'

ONE YEAR LATER FOUND ME AT THE ANDY WARHOL MUSEUM IN PITTSBURG, SHOWING THE LOST AND FOUND TRANSPARENCIES TO THE MUSEUM ARCHIVIST, JOHN SMITH. 'AHA,' HE SAID, 'SO IT IS YOU.' JOHN WENT TO A DRAWER AND PULLED OUT A SMALL PACKET OF SEVEN TRANSPARENCIES FROM THE SAME SHOOTINGS. 'WE FOUND THESE AMONGST ANDY'S PERSONAL COLLECTION. DO YOU WANT THEM?' AND HERE THEY ARE.

IN 1964, NEW YORK–BASED PHOTOGRAPHER <u>NAT FINKELSTEIN</u> BECAME THE UNOFFICIAL COURT PHOTOGRAPHER FOR <u>ANDY WARHOL</u>'S FACTORY, AND REMAINED SO FOR MORE THAN TWO YEARS. THIS BOOK, DESIGNED BY <u>ANGUS HYLAND</u> AT PENTAGRAM, LONDON, IS HOME TO THE IMAGES THAT HE CAPTURED DURING THAT TIME.

UNITED KINGDOM

pentagram

andy warhol: the factory years, 1964-1967, book design, 1999

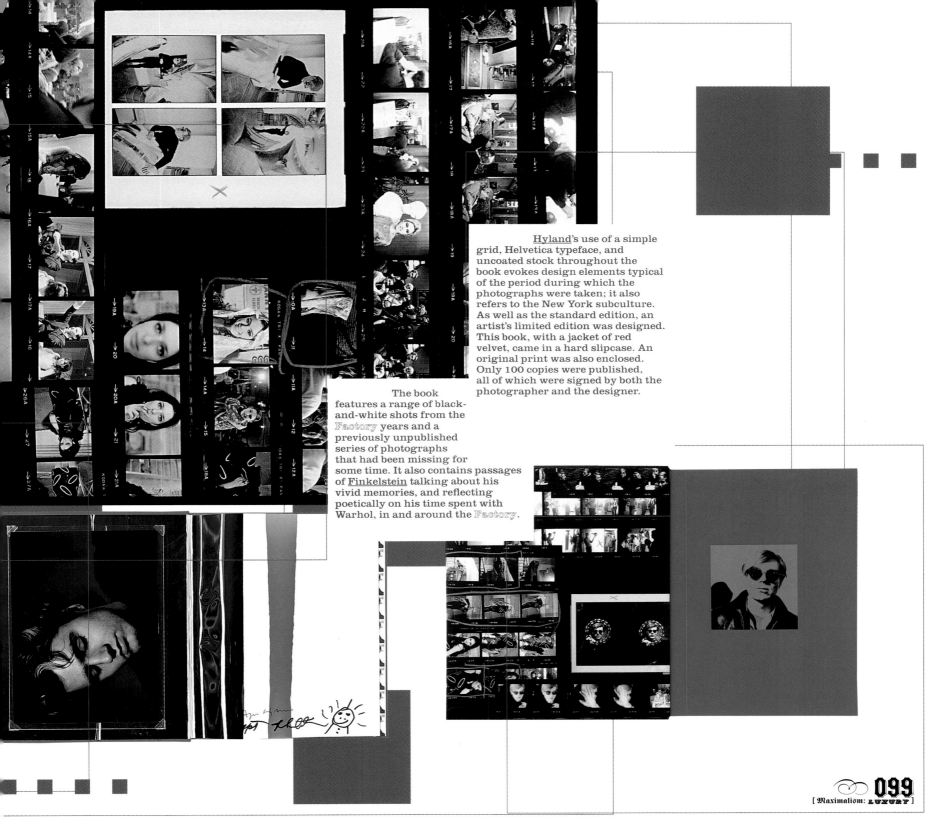

Hyland's use of a simple grid, Helvetica typeface, and uncoated stock throughout the book evokes design elements typical of the period during which the photographs were taken; it also refers to the New York subculture. As well as the standard edition, an artist's limited edition was designed. This book, with a jacket of red velvet, came in a hard slipcase. An original print was also enclosed. Only 100 copies were published, all of which were signed by both the photographer and the designer.

The book features a range of black-and-white shots from the Factory years and a previously unpublished series of photographs that had been missing for some time. It also contains passages of Finkelstein talking about his vivid memories, and reflecting poetically on his time spent with Warhol, in and around the Factory.

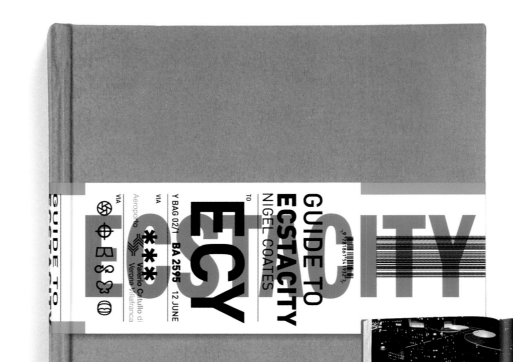

GUIDE TO
ECSTACITY
NIGEL COATES

ECSTACITY

GUIDE TO ECSTACITY
NIGEL COATES

TO

Y BAG 02/1 BA 2595 12 JUNE

VIA
VIA

Aeroporto

Valerio Catullo di
Verona Villafranca

ECY

ECSTACITY

nigel coates

THE AUTHOR OF ECSTACITY, PUBLISHED BY LAWRENCE KING IN 2003, IS NIGEL
COATES, ARCHITECT AND PROFESSOR OF ARCHITECTURE AT THE ROYAL
COLLEGE OF ART, LONDON. THIS BOOK EXPLORES THE DYNAMICS OF
CITIES, CONVEYED THROUGH HIS CONCEPT
METROPOLIS ECSTACITY, AN AMALGAM OF LONDON,
NEW YORK, TOKYO, CAIRO, AND ROME. LONDON-
BASED DESIGNERS WHY NOT ASSOCIATES
WERE COMMISSIONED TO DESIGN AND ILLUSTRATE THIS VISION WITHIN
A 408-PAGE BOOK.

UNITED KINGDOM
why not associates
ecstacity, book design, 2003

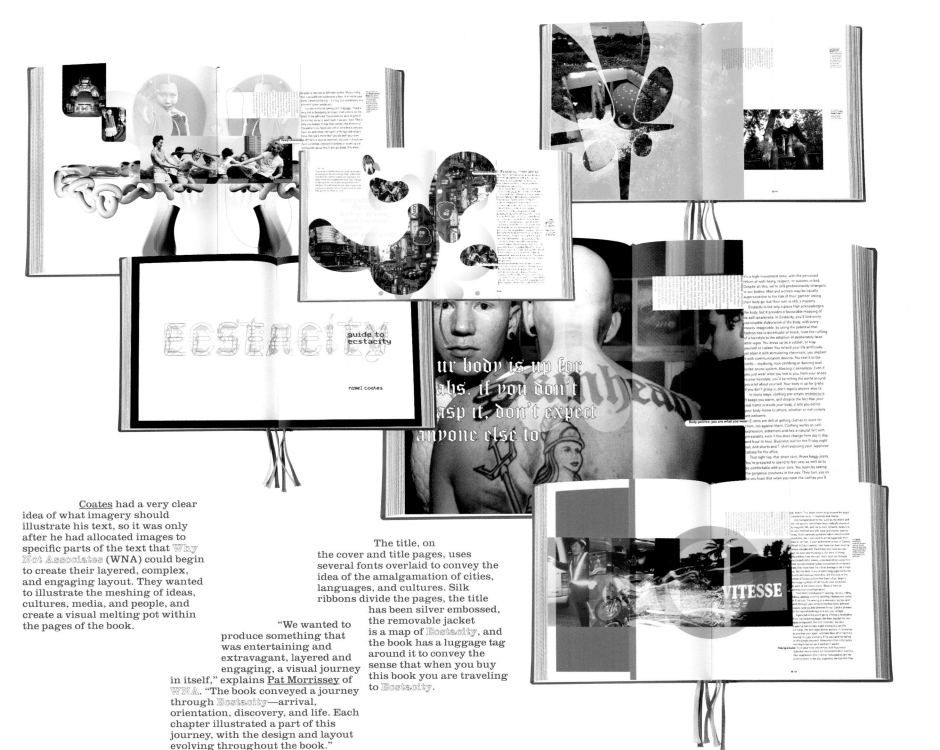

Coates had a very clear idea of what imagery should illustrate his text, so it was only after he had allocated images to specific parts of the text that Why Not Associates (WNA) could begin to create their layered, complex, and engaging layout. They wanted to illustrate the meshing of ideas, cultures, media, and people, and create a visual melting pot within the pages of the book.

"We wanted to produce something that was entertaining and extravagant, layered and engaging, a visual journey in itself," explains Pat Morrissey of WNA. "The book conveyed a journey through Ecstacity—arrival, orientation, discovery, and life. Each chapter illustrated a part of this journey, with the design and layout evolving throughout the book."

The title, on the cover and title pages, uses several fonts overlaid to convey the idea of the amalgamation of cities, languages, and cultures. Silk ribbons divide the pages, the title has been silver embossed, the removable jacket is a map of Ecstacity, and the book has a luggage tag around it to convey the sense that when you buy this book you are traveling to Ecstacity.

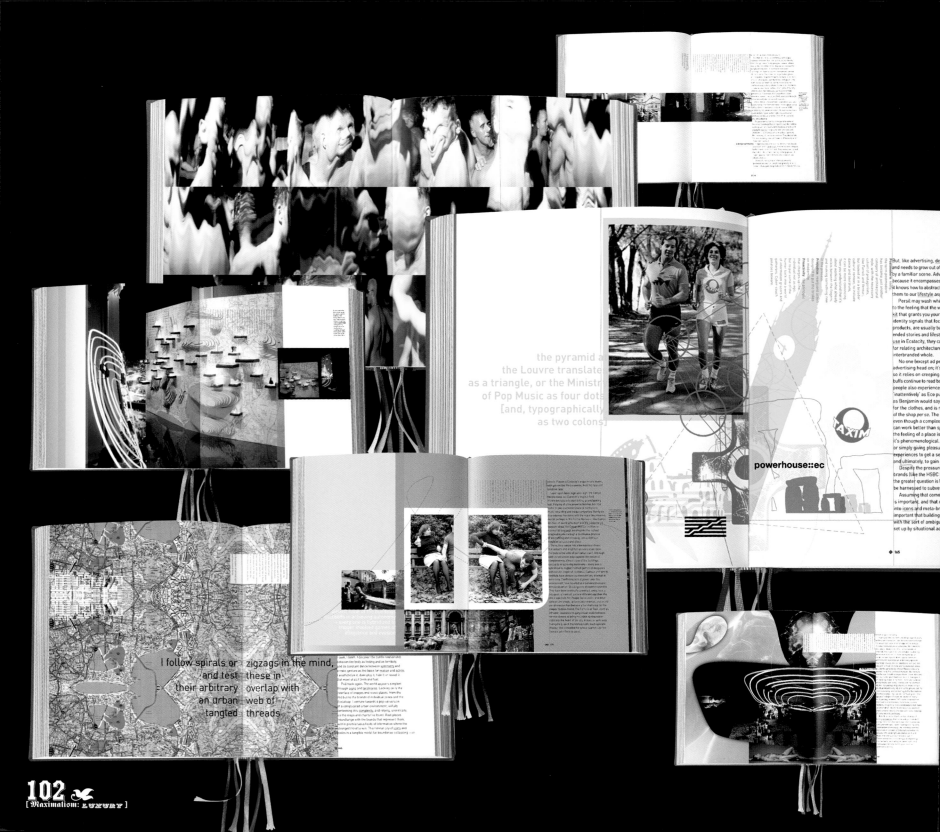

the pyramid a[t]
the Louvre translate[d]
as a triangle, or the Ministr[y]
of Pop Music as four dots
[and, typographically]
as two colons]

I follow spirals or zigzags in the mind,
and test these in
their arbitrary overlap with
an urban web of
tangled threads

powerhouse::ec

TAXIM

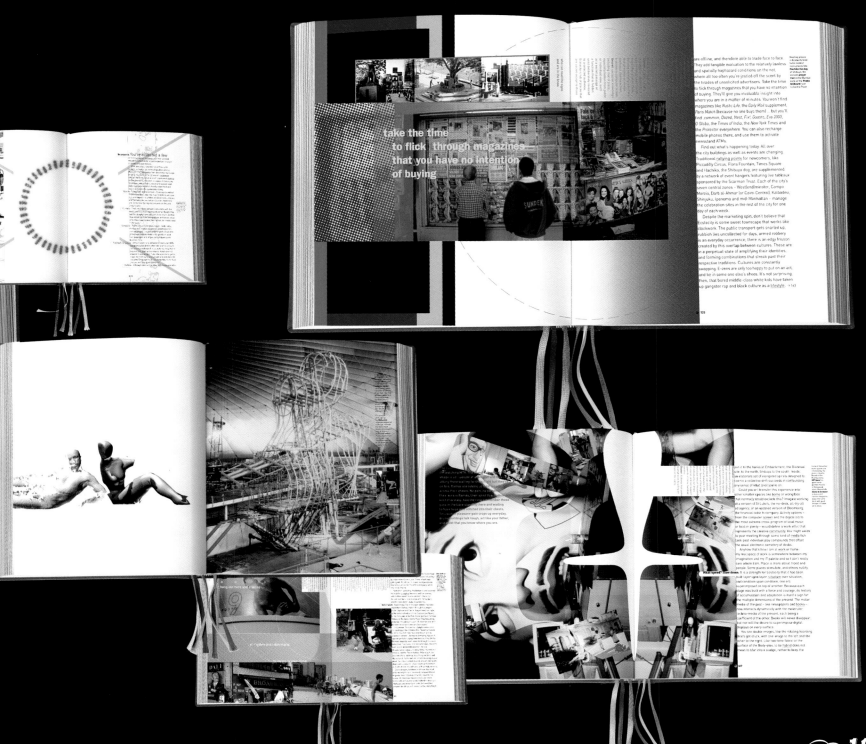

take the time
to flick through magazines
that you have no intention
of buying

ITALY

sartoria, mode 2, harry peccinotti, grafiche damiani

the calendar, images and design, 2003

THIS CALENDAR, DESIGNED BY ITALIAN DESIGN STUDIO <u>SARTORIA</u>, BASED IN MODENA, IS A REINTERPRETATION OF THE CLASSIC SOFT-CORE <u>PIRELLI</u> CALENDARS BY PHOTOGRAPHY LEGEND <u>HARRY PECCINOTTI</u>. HOWEVER, FOR THIS PROJECT, THE WORK OF A DIFFERENT LEGEND, GRAFFITI ARTIST <u>MODE 2</u>, COMPLEMENTS THE SIGNATURE <u>PECCINOTTI</u> IMAGES. THE OWNER OF THE CALENDAR CAN CHOOSE TO DISPLAY EITHER <u>MODE 2</u> OR <u>PECCINOTTI</u>'S PICTURE FOR EACH MONTH, AS BOTH HAVE CREATED IMAGES FOR JANUARY THROUGH TO DECEMBER.

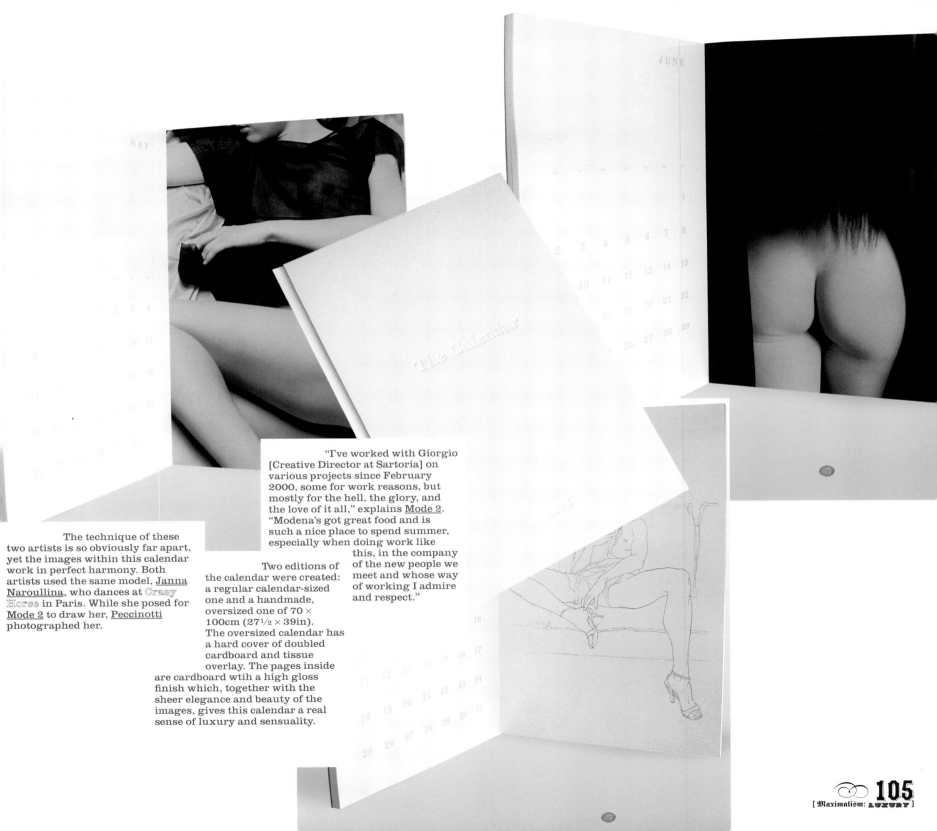

The technique of these two artists is so obviously far apart, yet the images within this calendar work in perfect harmony. Both artists used the same model, Janna Naroullina, who dances at Crazy Horse in Paris. While she posed for Mode 2 to draw her, Peccinotti photographed her.

"I've worked with Giorgio [Creative Director at Sartoria] on various projects since February 2000, some for work reasons, but mostly for the hell, the glory, and the love of it all," explains Mode 2. "Modena's got great food and is such a nice place to spend summer, especially when doing work like this, in the company of the new people we meet and whose way of working I admire and respect."

Two editions of the calendar were created: a regular calendar-sized one and a handmade, oversized one of 70 × 100cm (27½ × 39in). The oversized calendar has a hard cover of doubled cardboard and tissue overlay. The pages inside are cardboard wtih a high gloss finish which, together with the sheer elegance and beauty of the images, gives this calendar a real sense of luxury and sensuality.

FANTASY WITHIN GRAPHICS REQUIRES DESIGNING WITH UNRESTRAINED IMAGINATION, IN SOME CASES FINDING THE CHILD INSIDE AND MEMORIES OF FAIRY TALES AND MAKE-BELIEVE. IT MAY INVOLVE PUTTING WILDLY DIFFERENT IMAGES TOGETHER TO FORM ONE FANTASY GRAPHIC. IMAGES THAT ARE ABUNDANT WITH COLOR, PLAYFUL, AND INSPIRING.

Illustration's current renaissance has been flourishing for a number of years, and it doesn't appear to be dying down. Once thought of as the hillbilly cousin of photography, it has firmly established itself as a valid visual medium for advertising, editorial spreads, packaging, poster design, and the list goes on. That is what this chapter attempts to show.

For example, the promotional material created by Amsterdam-based KesselsKramer for Diesel's spring/summer 2004 collection asks people to "become nature lovers for successful living." The image mixes nature and sex in one big fantasy paradise setting (see pages 136–137).

San Francisco–based artist/illustrator Michael Gillette has created a series of images for the Los Angeles and San Francisco Levi's stores that show women with stylized fantasy hair (see pages 108–109). London-based Insect's illustrations for U.K. department store Selfridges are a great example of creating fantasy within a commercial environment (see page 143), and New York–based Vault49, with its fantastic illustrations for clothing lines and magazine covers (see pages 112–113 and 122–123), shows how fantasy complements the idea of ~~maximalist~~ design.

This chapter is full of playful images that conjure up all sorts of thoughts and feelings. Most of them are illustrated or computer-generated images; the return of illustration has led to the emergence of countless image-makers around the world, working with open minds to create wildly imaginative environments and characters. The way illustrators are now using the Mac has created a new digital aesthetic, and this has had a huge impact on magazine, record, and fashion design. This impact is evident in the work presented here.

CHAPTER FOUR

Fantasy

designing with imagination

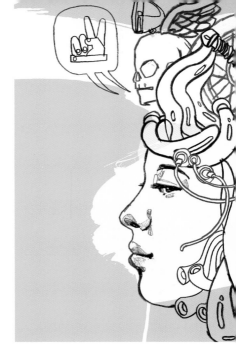

UNITED STATES

michael gillette

in-store design for levi's stores, los angeles and san francisco, 2003

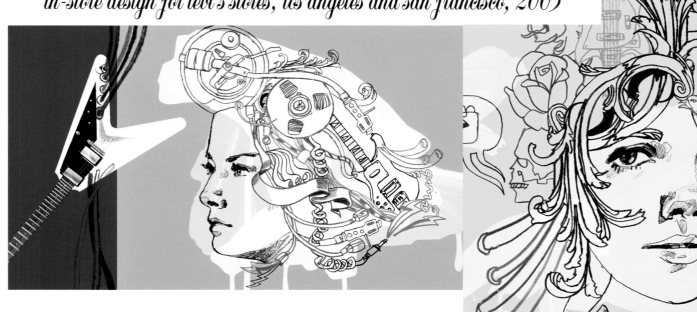

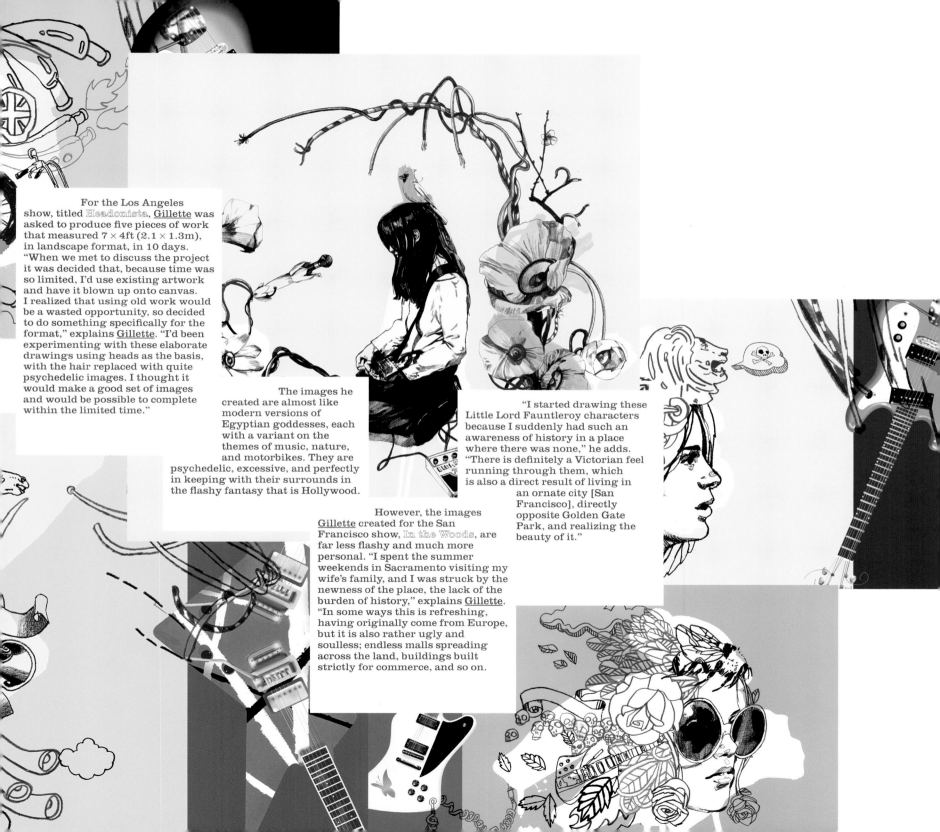

For the Los Angeles show, titled Headonista, Gillette was asked to produce five pieces of work that measured 7 × 4ft (2.1 × 1.3m), in landscape format, in 10 days. "When we met to discuss the project it was decided that, because time was so limited, I'd use existing artwork and have it blown up onto canvas. I realized that using old work would be a wasted opportunity, so decided to do something specifically for the format," explains Gillette. "I'd been experimenting with these elaborate drawings using heads as the basis, with the hair replaced with quite psychedelic images. I thought it would make a good set of images and would be possible to complete within the limited time."

The images he created are almost like modern versions of Egyptian goddesses, each with a variant on the themes of music, nature, and motorbikes. They are psychedelic, excessive, and perfectly in keeping with their surrounds in the flashy fantasy that is Hollywood.

"I started drawing these Little Lord Fauntleroy characters because I suddenly had such an awareness of history in a place where there was none," he adds. "There is definitely a Victorian feel running through them, which is also a direct result of living in an ornate city [San Francisco], directly opposite Golden Gate Park, and realizing the beauty of it."

However, the images Gillette created for the San Francisco show, In the Woods, are far less flashy and much more personal. "I spent the summer weekends in Sacramento visiting my wife's family, and I was struck by the newness of the place, the lack of the burden of history," explains Gillette. "In some ways this is refreshing, having originally come from Europe, but it is also rather ugly and soulless; endless malls spreading across the land, buildings built strictly for commerce, and so on.

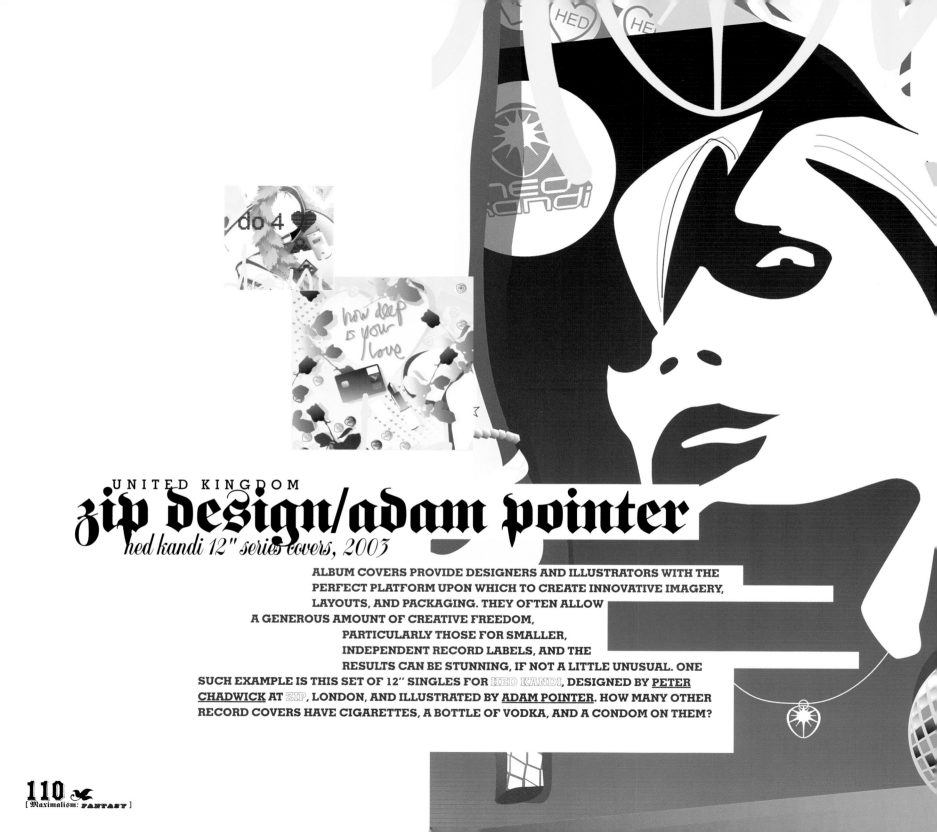

UNITED KINGDOM
zip design/adam pointer
hed kandi 12" series covers, 2003

ALBUM COVERS PROVIDE DESIGNERS AND ILLUSTRATORS WITH THE
PERFECT PLATFORM UPON WHICH TO CREATE INNOVATIVE IMAGERY,
LAYOUTS, AND PACKAGING. THEY OFTEN ALLOW
A GENEROUS AMOUNT OF CREATIVE FREEDOM,
PARTICULARLY THOSE FOR SMALLER,
INDEPENDENT RECORD LABELS, AND THE
RESULTS CAN BE STUNNING, IF NOT A LITTLE UNUSUAL. ONE
SUCH EXAMPLE IS THIS SET OF 12″ SINGLES FOR HED KANDI, DESIGNED BY PETER
CHADWICK AT ZIP, LONDON, AND ILLUSTRATED BY ADAM POINTER. HOW MANY OTHER
RECORD COVERS HAVE CIGARETTES, A BOTTLE OF VODKA, AND A CONDOM ON THEM?

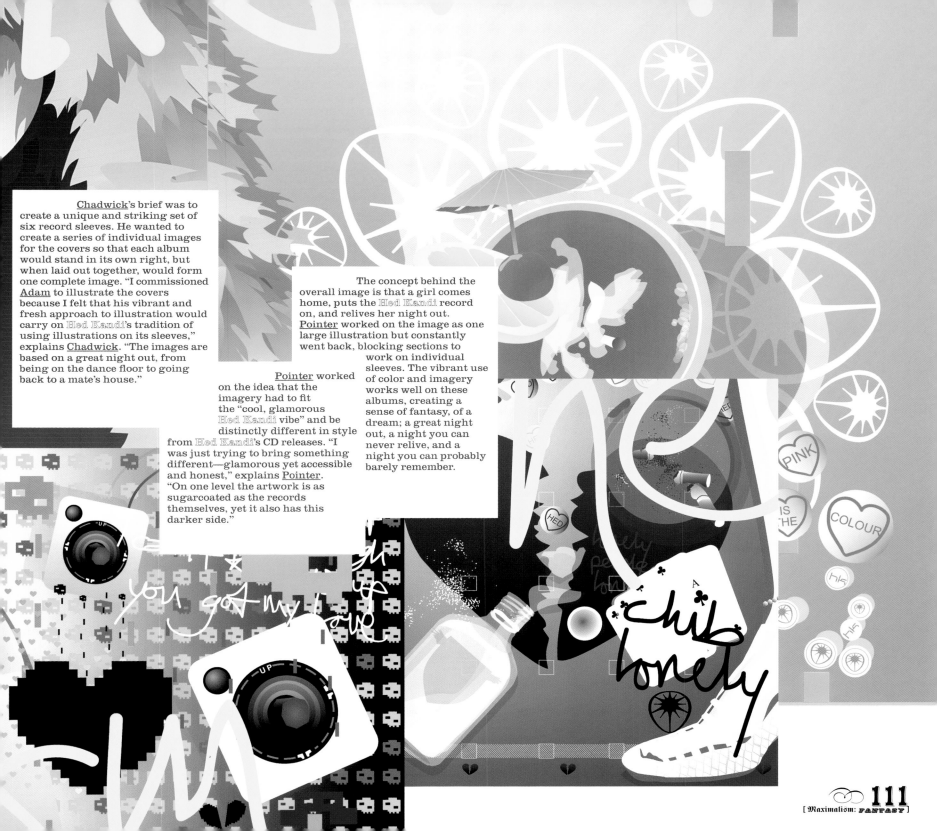

Chadwick's brief was to create a unique and striking set of six record sleeves. He wanted to create a series of individual images for the covers so that each album would stand in its own right, but when laid out together, would form one complete image. "I commissioned Adam to illustrate the covers because I felt that his vibrant and fresh approach to illustration would carry on Hed Kandi's tradition of using illustrations on its sleeves," explains Chadwick. "The images are based on a great night out, from being on the dance floor to going back to a mate's house."

Pointer worked on the idea that the imagery had to fit the "cool, glamorous Hed Kandi vibe" and be distinctly different in style from Hed Kandi's CD releases. "I was just trying to bring something different—glamorous yet accessible and honest," explains Pointer. "On one level the artwork is as sugarcoated as the records themselves, yet it also has this darker side."

The concept behind the overall image is that a girl comes home, puts the Hed Kandi record on, and relives her night out. Pointer worked on the image as one large illustration but constantly went back, blocking sections to work on individual sleeves. The vibrant use of color and imagery works well on these albums, creating a sense of fantasy, of a dream; a great night out, a night you can never relive, and a night you can probably barely remember.

UNITED STATES

vault49

express hang tags, 2003

U.S. DESIGN GROUP VAULT49 IS FAMED FOR ITS MAXIMALIST APPROACH TO
DESIGN AND ILLUSTRATION, AND THIS PROJECT FOR CLOTHING COMPANY EXPRESS IS NO
EXCEPTION. AIMED AT THE FASHION-CONSCIOUS FEMALE,
THESE HANG TAGS WERE DESIGNED FOR
EXPRESS' DENIMWEAR RANGE, ALTHOUGH
THE IMAGES WERE ALSO APPLIED TO
T-SHIRTS AND USED IN STORE WINDOWS THROUGHOUT
THE U.S. THE BRIEF WAS TO CREATE IMAGERY THAT WAS SEXY
AND PROVOCATIVE, USING A COMBINATION OF VIBRANT COLORS, GOTHIC AND
FAIRYESQUE CHARACTERS, AND MULTILAYERED IMAGERY.
THE VAULT49 TEAM DID JUST THAT.

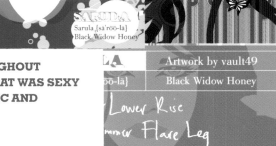

SARULA
Sarula {sa'rōō-lä}
Black Widow Honey

SARULA
Sarula {sa'rōō-lä}
Black Widow Honey

| LA | Artwork by vault49 |
| 'ōō-lä} | Black Widow Honey |

Lower Rise
mmer Flare Leg

vault49.com

sweet potato pie, but believe me, that girl is pure sarula...

| SARULA | Artwork by vault49 |
| Sarula {sa'rōō-lä} | Black Widow Honey |

Lower Lower Rise
Slimmer Flare Leg

vault49.com

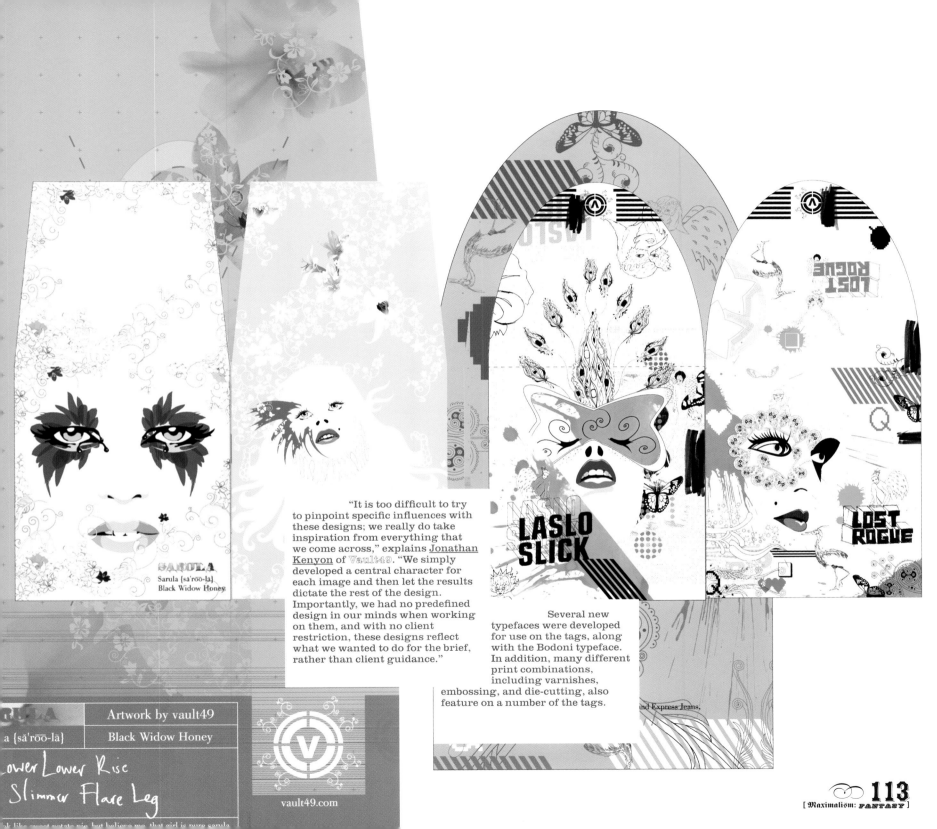

SARULA
Sarula (sä'roō-lä)
Black Widow Honey

LASLO SLICK

LOST ROGUE

"It is too difficult to try to pinpoint specific influences with these designs; we really do take inspiration from everything that we come across," explains Jonathan Kenyon of Vault49. "We simply developed a central character for each image and then let the results dictate the rest of the design. Importantly, we had no predefined design in our minds when working on them, and with no client restriction, these designs reflect what we wanted to do for the brief, rather than client guidance."

Several new typefaces were developed for use on the tags, along with the Bodoni typeface. In addition, many different print combinations, including varnishes, embossing, and die-cutting, also feature on a number of the tags.

Artwork by vault49
Black Widow Honey

a (sä'roō-lä)

ower Lower Rise
Slimmer Flare Leg

vault49.com

SWEDEN

vår
angelic black, illustration for commons & sense magazine, 2001

THIS ILLUSTRATION WAS CREATED BY SWEDISH DESIGN/ILLUSTRATION DUO VÅR (KARL GRANDIN AND BJÖRN KÄRVESTEDT) FOR JAPANESE MAGAZINE COMMONS & SENSE. THE THEME OF THE ISSUE WAS 100 COLORS, SO THE PUBLISHERS ASKED 100 ARTISTS, INCLUDING POETS, PHOTOGRAPHERS, ILLUSTRATORS, AND DESIGNERS, TO INTERPRET ONE COLOR EACH IN ANY WAY THEY WISHED. GRANDIN AND KÄRVESTEDT CHOSE ANGELIC BLACK.

"When Björn and I do an artwork together like this, we work in a collage-based style," explains Grandin. "First we structure the ideas and the basic composition together, then we work separately on the different parts of the drawing, and finally put the artwork together. In this image we experimented with a lot of different shades of black and mixing different methods of drawing." The result is this dark, fairy tale–like image of a young girl surrounded by butterflies and insects.

"I tried to avoid typically sixties' colors to give it a more contemporary feel," explains Pollack. "The images are a mixture of pictures taken while shooting the video [for a single from Candy Rain] and images that I have scanned from old magazines and so on. I wanted to try to use as many layers as possible to give the image depth, but still have a graphic clarity. I like things with a lot of layers. It means that you can see new things every time you look at them."

THIS RETRO-STYLE POSTER WAS CREATED TO PROMOTE THE DEBUT ALBUM, CANDY RAIN, OF SWEDISH ARTIST PAULINE. IT WAS DESIGNED BY MIKA POLLACK, WHO WORKS UNDER THE NAME KINGSIZE AND IS REPRESENTED BY SWEDISH AGENCY WOO AGENTUR. INSPIRED BY FILLMORE AND AVALON POSTERS, AND PSYCHEDELIC SIXTIES' MUSIC, THE RESULTING IMAGE HAS A JACKSON POLLOCK/HIPGNOSIS FEEL ABOUT IT, BUT WITH A MODERN TWIST.

SWEDEN
kingsize
candy rain, promotional poster for pauline, 2003

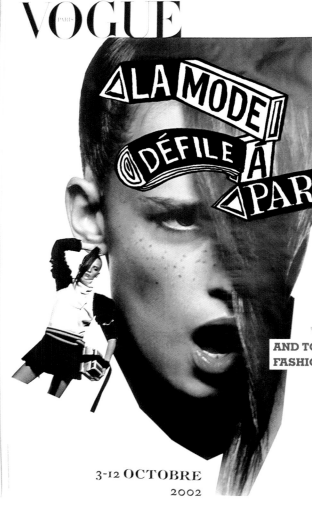

VOGUE

△LA MODE DÉFILE À PARIS

3-12 OCTOBRE
2002

"Vogue Paris, Fall 2002 street poster." 2002. Art Direction and design: M/M (Paris). Photograph: Inez van Lamsweerde and Vinoodh Matadin. © Les Publications Condé Nast (France) S. A.

FRANCE
m/m (paris)
vogue paris design, 2001-2003

VOGUE PARIS HAS UNDERGONE A GRADUAL REDESIGN SINCE OCTOBER 2001 AND TODAY STANDS OUT AS ONE OF THE FEW INTERNATIONAL FASHION MAGAZINES THAT HAS TRULY BROKEN THE SLICK, GLOSSY MOLD. IT IS STILL CHIC, STILL ELEGANT, AND STILL VERY FRENCH—THE MAIN CONCEPT BEHIND ITS REVAMP IS THE REDEFINITION OF LUXURY, FRENCHNESS, AND FASHION—BUT SINCE THE ART DIRECTION AND DESIGN BECAME THE RESPONSIBILITY OF FASHION'S FAVORITE FRENCH DESIGN STUDIO M/M (PARIS), COLLAGE, HAND-DRAWN TYPEFACES, AND A SOMEWHAT ANTIFASHION FEEL HAVE CREPT INTO VOGUE PARIS.

A new editorial team, appointed in early 2001 (Carine Roitfeld, Editor, Emmanuelle Alt, Fashion Editor, and Marie-Amélie Sauvé, Fashion Consultant), brought with it a complete editorial and design rethink. M/M (Paris) began the redesign with structural changes in October 2001, and had set up a completely new typographic system by April 2002. They continued with the art direction until October 2003, when Fabien Baron took on that role.

The new typographic system is made up of an M/M-created, rough-edged, schoolbook typeface, Gulliver, for headlines and an existing typeface that they had previously designed, Carine, for fashion spreads. It is an attempt by M/M to use typography that complements the contemporary images found within the pages of Vogue Paris.

M/M continue to work as graphic consultants for the magazine, something of an unusual, but seemingly fruitful relationship. Its success is probably down to the fact that having worked for fashion designers, including Yohji Yamamoto, Martine Sitbon, and Balenciaga, M/M knows how to bridge the gap between fashion and design—something that few other studios do.

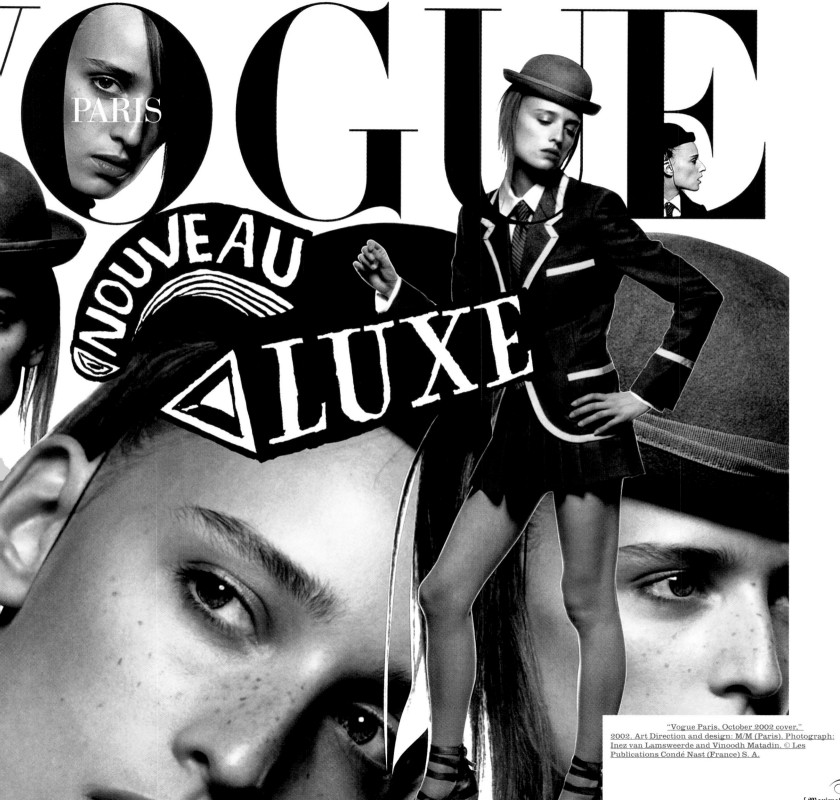

VOGUE

PARIS

NOUVEAU
▲ LUXE

NEAL ASHBY DESIGNS ALBUM COVERS AND BOOK JACKETS.
HE ALSO DESIGNS WEDDING INVITATIONS, CLASSIFIED
NEWSPAPER ADS, YARD SALE SIGNAGE, TREADS FOR MOST
AMERICAN TIRE MANUFACTURERS, CUSTOM LETTERING FOR
T-SHIRTS, DETERGENT BOXES, ADDRESS RETURN LABELS,
AND LOGOS FOR SMALL CHURCHES. BUT MOSTLY ALBUM
COVERS AND BOOK JACKETS.

PHONE 410.263.4983

5 MARYLAND AVE. NO. 1

ANNAPOLIS MD, 21401

UNITED STATES

ashby design

ashby design business cards, 2001

Ashby Design was
founded by <u>Neal Ashby</u> in 1996. In
2001 he redesigned the company's
business cards, basing them on a
collection of images he had gathered
over the years. "I collect antique
picture frames, so I'm always
buying old framed photographs and
paintings and then taking them all
apart to salvage the frames,"
explains <u>Ashby</u>. "Once I found an
interesting illustration from a
children's book behind a photograph
from the forties. It was of a boy on
a mountain top serenading other
children with his violin. The picture
was fascinating to me; children
presented with melancholy in such
an innocent way. I keep a folder
of found images like this and refer
back to it every so often, and this
was the case with the business
cards," he adds.

<u>Ashby</u> combined the
found children's illustration with an
image of a period View-Master box
to create the series of images that
was applied to the reverse side of
Ashby Design's business cards. The
cards were produced
in sets of 12, inviting
the viewer to choose
his or her favorite.
They were printed on
baseball-card stock,
with fluorescent inks.

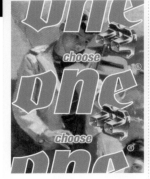
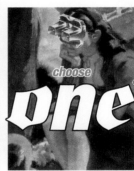
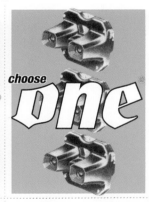

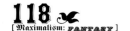

FRANCE

address

cerrone album cover, 2003

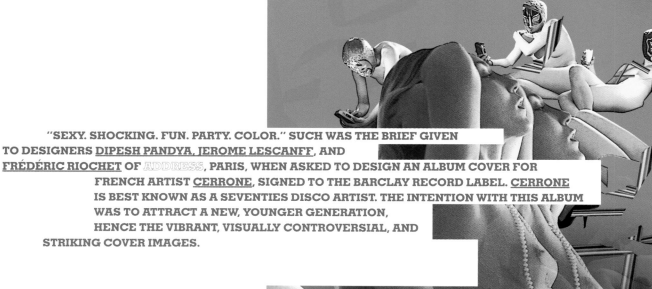

"SEXY. SHOCKING. FUN. PARTY. COLOR." SUCH WAS THE BRIEF GIVEN TO DESIGNERS <u>DIPESH PANDYA</u>, <u>JEROME LESCANFF</u>, AND <u>FRÉDÉRIC RIOCHET</u> OF ADDRESS, PARIS, WHEN ASKED TO DESIGN AN ALBUM COVER FOR FRENCH ARTIST <u>CERRONE</u>, SIGNED TO THE BARCLAY RECORD LABEL. CERRONE IS BEST KNOWN AS A SEVENTIES DISCO ARTIST. THE INTENTION WITH THIS ALBUM WAS TO ATTRACT A NEW, YOUNGER GENERATION, HENCE THE VIBRANT, VISUALLY CONTROVERSIAL, AND STRIKING COVER IMAGES.

Address created the cover images using photographs shot by French photographer <u>Geoffroy de Boismenu</u>. These were cut up and layered to "create the ambience that formed the artwork for the singles and album," explains <u>Pandya</u>.

"The idea behind the design comes from a certain style of film poster for Indian Cinema; the cut-and-paste layering effect, and of course the color," he continues. "It was not so much inspired by the music but more so by the huge possibilities of creating a rich imagery from the base of Geoffroy's photographs."

The <u>Cerrone</u> logo had been in use by the artist since the seventies, so other typefaces used on the album were chosen to work with the logo in a seventies' retro style, in contrast with the deliberately angular Hysteria logo. In addition, selective varnish was used on the singles and the album. Graphics were developed for all the promo singles, maxi CDs, vinyl and album, together with press ads and posters.

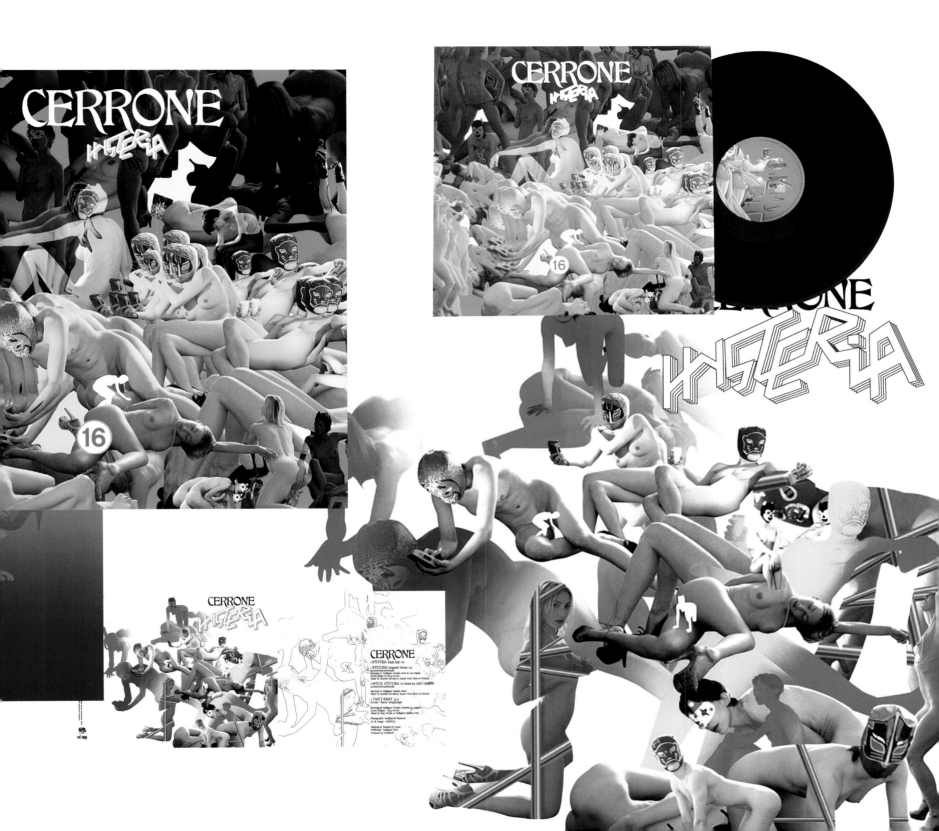

LOS ANGELES–BASED FLAUNT MAGAZINE WAS LAUNCHED IN 1998,
STARTING LIFE AS A WEST-COAST STYLE MAGAZINE AND AN OFFSHOOT OF DETOUR. TODAY,
48 ISSUES LATER, IT IS ONE OF PUBLISHING'S GREAT SUCCESS STORIES AND ONE OF THE MOST
BEAUTIFUL MAGAZINES TO BE FOUND ON NEWSSTANDS. IT IS ALSO,
TO MY KNOWLEDGE, THE ONLY MAGAZINE TO WRAP EVERY ISSUE IN TWO
COVERS; THE OUTER COVER IS A SELECTED ARTIST'S IMPRESSION OF THE
ACTUAL PHOTOGRAPHED COVER THAT LIES UNDERNEATH. OFTEN EMBOSSED
OR DIE-CUT, AND
FEATURING ARTWORK BY
INTERNATIONALLY
KNOWN ARTISTS,
ILLUSTRATORS, AND
DESIGNERS, FLAUNT'S
COVERS MAKE IT A
MAGAZINE THAT ANYONE
WOULD BE PROUD TO
DISPLAY ON THEIR
COFFEE TABLE.

UNITED STATES
vault49
flaunt magazine cover, 2003

For the Halloween 2003 issue, it was the turn of U.S.-based design and illustration collective Vault49 (at that time based in the U.K.) to work its magic on Flaunt. "Rather than them contacting us, we approached Flaunt for the very reason that their history of experimentation was appealing to us, and we wanted to be a part of it by producing our own unique interpretation," explains Jonathan Kenyon at Vault49. "Flaunt is fantastic for its unique approach to magazine-cover design. We were able to integrate an embossed image in our design to complete the cover."

Being the Halloween issue, the "idea" behind the design, as described by Kenyon, is this: "A stroll in the park turns into a gothic nightmare for this unsuspecting girl as she is attacked by all sorts of creepy-crawlies. And thorns. And fluff-balls." Of course, there is also a large element of humor. Imagery used to create the cover came from second-hand books and from Vault49's bug collection. While this collection dates from pre-Vault49 days, it has grown since the group's inception and is a big influence on their work. "It is fascinating to be surrounded by such intricate examples of natural beauty. The bugs, in many ways, reflect our work with their high level of detail and complexity only being apparent on close inspection," explains Kenyon.

The Flaunt typeface was developed especially for this issue to form an integral part of the design. It is this attention to detail and design that puts Flaunt very much at the cutting edge of fashion and style publishing. Despite cover subjects that include celebrities such as Snoop Dogg, Brittany Murphy, Brad Pitt, and Kylie Minogue, and big-name advertisers like Dior, Gucci, Calvin Klein, and Diesel, Flaunt maintains an editorial originality and freshness that few other magazines manage to achieve. Its fantastical covers serve simply as an extremely luxurious icing on the cake.

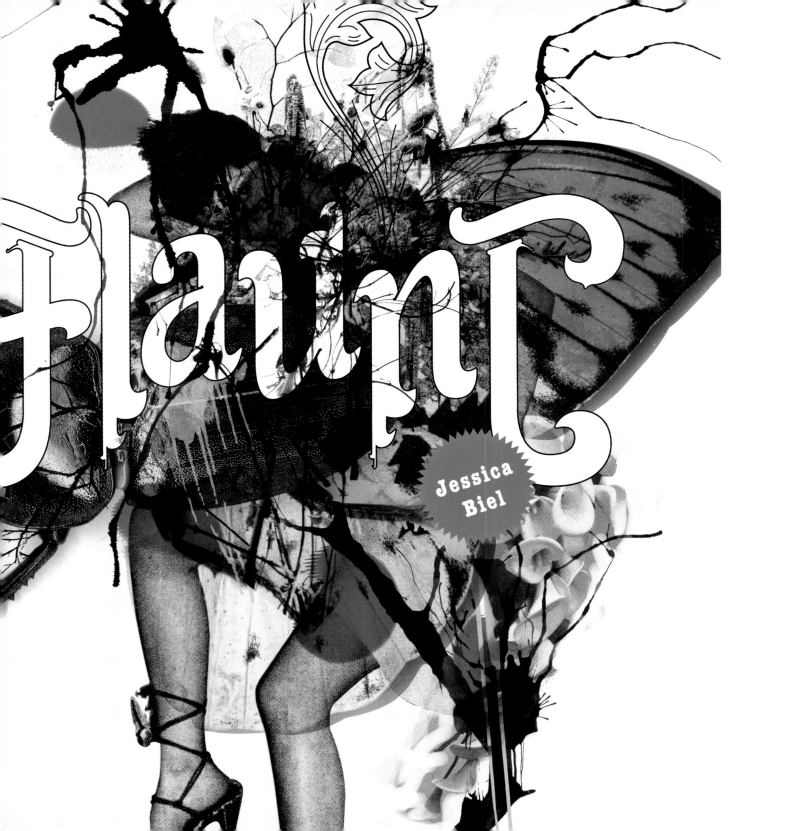

Haunt

Jessica
Biel

ashby design
dream big, poster for the art directors club of metropolitan washington, 2000

IT'S PRETTY OBVIOUS WHAT INSPIRED THIS POSTER FOR THE ART DIRECTORS CLUB OF METROPOLITAN WASHINGTON'S 50TH ANNUAL SHOW—POPSICLES. "MAYBE IT'S THE EIGHT-YEAR-OLD IN ME, BUT I'M ALWAYS DRAWN TO THOSE TOURISTY POPSICLE VANS AT THE MALL IN WASHINGTON, DC," NEAL ASHBY AT ASHBY DESIGN SAYS. "I LOVE THE WAY THE POPSICLES ARE ADVERTISED—A HAPHAZARD COLLAGE OF COLORFUL STICKERS COVERING EVERY OPEN INCH OF SPACE—SO I STARTED A COLLECTION OF THEM, KEPT THEM IN A FOLDER, BUT WAS NEVER QUITE SURE WHAT I WOULD EVER DO WITH THEM."

Well, this is what he did; he created a fun, attention-grabbing poster to announce a design contest with the simple message "dream big." Most of the Popsicles on the original stickers were obscured with type, so Ashby redrew large parts of them in Photoshop. In addition, he used various tools in Photoshop to create over-the-top, color-saturated images on which to apply his own type.

"I like design concepts about things out of context," explains Ashby. "It was fun to get into designing my own Popsicle stickers. It was a project where I had to think a little differently. It was about how to create an assault on people's senses."

THE NETHERLANDS

studio dumbar

pulchri studio promotional posters, 2002/2003

PULCHRI STUDIO **IS AN ARTISTS' SOCIETY AND EXHIBITION SPACE THAT WAS FOUNDED MORE THAN 100 YEARS AGO. IT HAS MEMBERS OF ALL AGES, OLD AND YOUNG. THESE POSTERS TO PROMOTE THE SOCIETY AND ITS EXHIBITIONS, DESIGNED BY** STUDIO DUMBAR **, ATTEMPT TO EMBODY THE CONTRAST BETWEEN THE OLD (THE TRADITIONAL PRINTING TECHNIQUE WITH PMS COLORS INSTEAD OF CMYK) AND THE NEW (COMPUTER ILLUSTRATION).**

Studio Dumbar designer Dennis Koot explains. "Since Pulchri Studio is all about art and artists, I chose to approach the poster design in an autonomous and original way; like an artist. The ~~maximalist~~ approach is the outcome of this more personal, autonomous approach to the design. This not only enabled me to put forward my own preference for busy textures and drawings, and to experiment with new illustration techniques, but also enables the client to distinguish itself from other galleries and artists' societies and to promote itself as a modern institute."

Through using images that are neither traditional illustrations nor photographs, a "synthetic" visual language is created to connect the two posters. Together with their use of intense colors, including metallic green and fluorescent yellow details, this gives the posters a surreal feel.

Voorjaarstentoonstell

Werk van leden
29 maart t/m 21 april 2003

In Pulchri Studio én in het Atrium van het Haagse Sta

Openingstijden Pulchri: dinsdag t/m zondag 11.00 - 17
1e paasdag gesloten, 2e paasdag geopend.
Lange Voorhout 15 / 2514 EA Den Haag / T (070) 346 17

Ontwerp: Studio Dumbar (Dennis Koot)

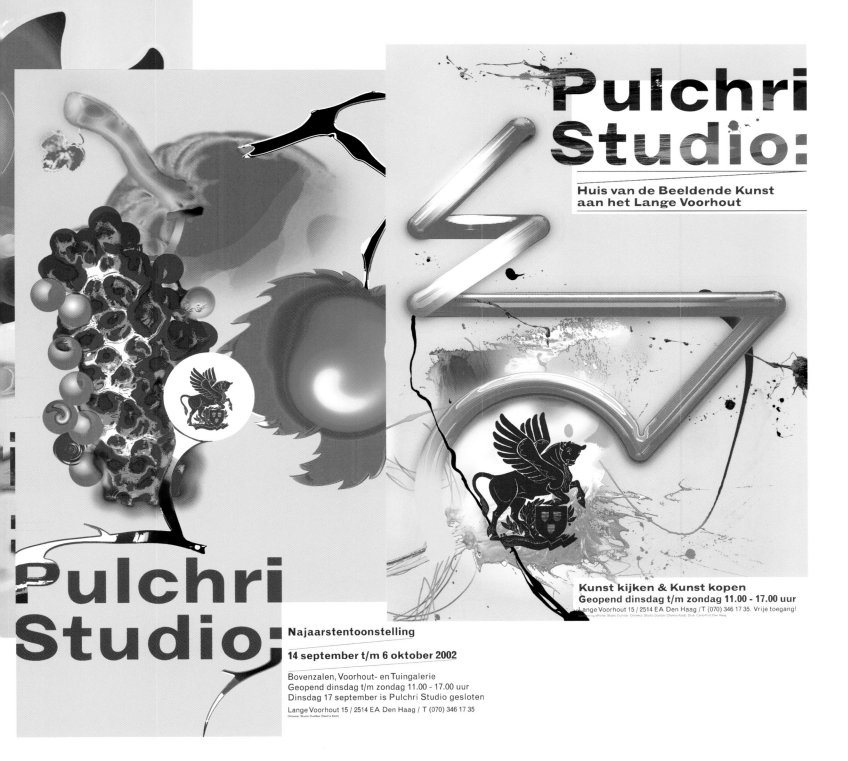

Pulchri
Studio:

Huis van de Beeldende Kunst
aan het Lange Voorhout

Kunst kijken & Kunst kopen
Geopend dinsdag t/m zondag **11.00 - 17.00 uur**
Lange Voorhout 15 / 2514 EA Den Haag / T (070) 346 17 35. Vrije toegang!
Vormgeving affiche: Studio Dumbar Ontwerp: Studio Dumbar (Dennis Koot) Druk: CartoPrint Den Haag

Pulchri
Studio:

Najaarstentoonstelling

14 september t/m 6 oktober 2002

Bovenzalen, Voorhout- en Tuingalerie
Geopend dinsdag t/m zondag 11.00 - 17.00 uur
Dinsdag 17 september is Pulchri Studio gesloten

Lange Voorhout 15 / 2514 EA Den Haag / T (070) 346 17 35
Ontwerp: Studio Dumbar (Dennis Koot)

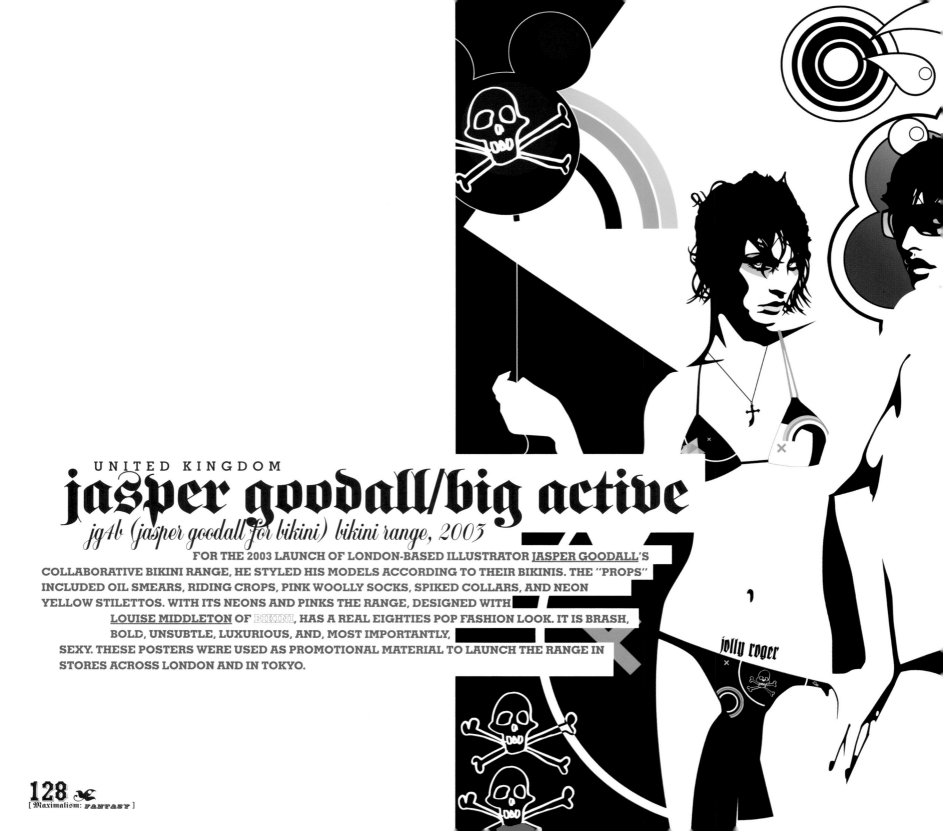

jasper goodall/big active

jg4b (jasper goodall for bikini) bikini range, 2003

FOR THE 2003 LAUNCH OF LONDON-BASED ILLUSTRATOR JASPER GOODALL'S COLLABORATIVE BIKINI RANGE, HE STYLED HIS MODELS ACCORDING TO THEIR BIKINIS. THE "PROPS" INCLUDED OIL SMEARS, RIDING CROPS, PINK WOOLLY SOCKS, SPIKED COLLARS, AND NEON YELLOW STILETTOS. WITH ITS NEONS AND PINKS THE RANGE, DESIGNED WITH LOUISE MIDDLETON OF BIKINI, HAS A REAL EIGHTIES POP FASHION LOOK. IT IS BRASH, BOLD, UNSUBTLE, LUXURIOUS, AND, MOST IMPORTANTLY, SEXY. THESE POSTERS WERE USED AS PROMOTIONAL MATERIAL TO LAUNCH THE RANGE IN STORES ACROSS LONDON AND IN TOKYO.

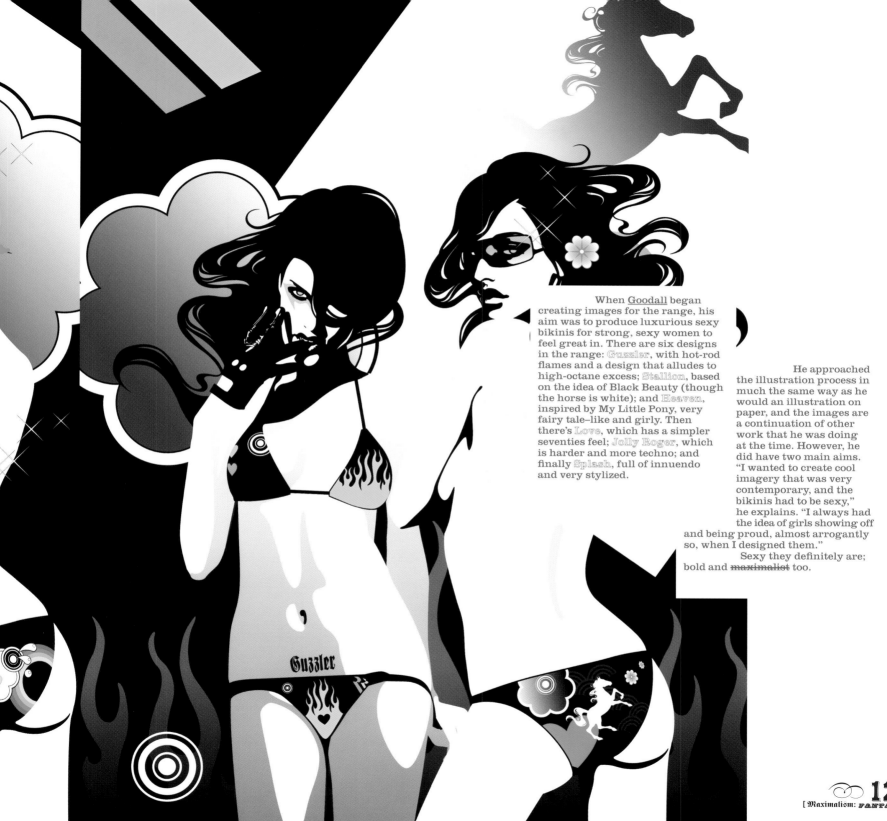

When Goodall began creating images for the range, his aim was to produce luxurious sexy bikinis for strong, sexy women to feel great in. There are six designs in the range: Guzzler, with hot-rod flames and a design that alludes to high-octane excess; Stallion, based on the idea of Black Beauty (though the horse is white); and Heaven, inspired by My Little Pony, very fairy tale–like and girly. Then there's Love, which has a simpler seventies feel; Jolly Roger, which is harder and more techno; and finally Splash, full of innuendo and very stylized.

He approached the illustration process in much the same way as he would an illustration on paper, and the images are a continuation of other work that he was doing at the time. However, he did have two main aims. "I wanted to create cool imagery that was very contemporary, and the bikinis had to be sexy," he explains. "I always had the idea of girls showing off and being proud, almost arrogantly so, when I designed them."

Sexy they definitely are; bold and maximalist too.

BRAZIL
clarissa tossin
brazil magazine cover, 2003
the man, poster for tekko 03, 2003
the city, poster for tekko 03, 2003

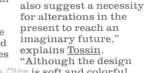

MUCH OF SÃO PAULO–BASED <u>CLARISSA TOSSIN</u>'S WORK HAS AN ELEMENT OF FANTASY TO IT, WITH A HEAVY USE OF COLOR AND DECORATION. WHEN SHE CREATED THIS ILLUSTRATION (LEFT), FOR THE COVER OF A MONTHLY GUIDE TO BRAZIL (A SUPPLEMENT THAT COMES WITH VOGUE RG), HER CHOICE OF COLORS WAS INSPIRED BY BRAZILIAN NATURE. THE OUTLINE OF THE COUNTRY'S MAP FORMS THE PRINCIPAL ELEMENT OF THE ILLUSTRATION AND ALTHOUGH ITS SHAPE IS EASILY IDENTIFIABLE, IT ALSO LOOKS PRETTY ABSTRACT. <u>TOSSIN</u>'S IDEA WAS TO APPROACH BRAZIL IN A GENERIC WAY, LEAVING OUT THE CLICHÉS AND STEREOTYPES THAT ARE USUALLY ASSOCIATED WITH THE COUNTRY.

The other work shown here, The Man and The City, are two posters that <u>Tossin</u> designed for the Tekko 03 poster exhibition, in Toronto, Canada. They present her imaginary view of the future of man and the future of the city, and are very much related to the idea of fantasy and dreams. "Although the posters' aesthetic is full of color and fantasized compositions, the images also suggest a necessity for alterations in the present to reach an imaginary future," explains <u>Tossin</u>. "Although the design in The City is soft and colorful, it actually shows a <u>Le Corbusier</u> building silhouette exploding, and The Man poster shows the mutation of a female silhouette into a butterfly outline. This way, both posters emphasize a need for change."

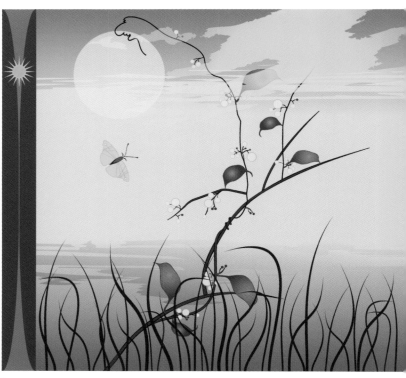

agnieszka gasparska, petter ringbom, fischerspooner

maypop, interactive project for amnesty international, 2002

MAYPOP IS AN INTERACTIVE, ANIMATED WORK THAT EXPLORES THE IDEA OF LIGHT, HOPE, AND ACTION BEING SYNONYMOUS WITH GROWTH, MOVEMENT, AND BEAUTY. IT WAS CREATED AS PART OF SHINE02.ORG, AN ONLINE EXHIBITION CELEBRATING THE 40TH ANNIVERSARY OF AMNESTY INTERNATIONAL. THE THEME OF SHINE02 WAS THE POWER OF COMMUNICATION IN ACTIVISM. DESIGNERS AGNIESZKA GASPARSKA AND PETTER RINGBOM COLLABORATED WITH BAND FISCHERSPOONER TO CREATE MAYPOP, WHICH CONSISTS OF A STAGED, ONLINE ENVIRONMENT IN WHICH A USER'S INTERACTION WITH VARIOUS ELEMENTS DIRECTLY AFFECTS VISIBILITY, MOVEMENT, GROWTH, AND SOUND ON THE SITE.

BY RELYING ON THE USER'S PRESENCE AND INTERACTION, THE WORK AIMS TO REPRESENT THE IDEA THAT ACTION CREATES LIGHT AND LIGHT CREATES LIFE, GROWTH, MOVEMENT, AND BEAUTY. IF A USER CHOOSES TO TAKE NO INITIATIVE AND SIMPLY WATCHES THE LANDSCAPE PASSIVELY, GROWTH AND ACTIVITY REMAIN MINIMAL AND THERE ARE NO SIGNS OF LIFE.

 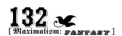

The richness and beauty of the images on this site make it hard to believe that they are computer generated. The organic forms that move and change with the Fischerspooner track playing in the background make it appear almost like a music video. "We wanted to create a sort of surreal and strange landscape that was also really sensual and sexy, with richness and beauty all over it," explains Gasparska. "Since we were working with a specific Fischerspooner song in mind, a lot of their aesthetic choices, both in music as well as in what they do visually, were an inspiration for us. What we hope we've achieved is the same sense that overcomes an audience under the influence of a live Fischerspooner performance; that you are overwhelmed by the overorchestrated chaos, that you cannot be sure if a detail is accidental or purposeful, organic or orchestrated."

Initially, Maypop was a Web-based project only, but it has since been used as a stage projection during Fischerspooner shows, and it is featured on their DVD Fischerspooner #1, a limited-edition, enhanced CD, with full-length DVD (2003). It has also been released on an enhanced Amnesty International CD, Music for Human Rights (2003).

For <u>Eriksen</u>, that usually means climbing mountains or going snowboarding, which is where the imagery in this poster came from. "I was on my own climbing Store Skagastølstind, a mountain in an alpine part of Norway. I had to turn around and climb down 20m (c. 65½ft) below the top because of a hailstorm and what seemed to be accelerating bad weather," explains <u>Eriksen</u>. "Three hours later I was standing underneath it, taking this photograph, with sun shining. The top peak was still partly hidden by clouds, but now and then one could get a glimpse of it. A true tease. It was a very good climb."

"I believe real-life experiences can never be substituted by what could be called second-, third-, or fourth-generation experiences—watching, reading about, being told of things," he explains. "The inspiration comes from working and living as a designer. Working too much, living too little, that is. Then getting really really tired of it all and having to do something about that."

<u>Eriksen</u> has used one of his own typefaces, Kit Fat, for all text except the title, You are Gonna Die, which is set in <u>Geoff Kaplan</u>'s deconstructed version of Fraktur called Sucker, But. "I've used that to connect my message to the realm of tattoos, heavy metal, hip-hop, urban brotherhoods, and the mystery of death," he concludes.

THIS IS A SELF-PROMOTIONAL POSTER FOR DESIGN AGENCY PRODUCTS OF PLAY. THE INSPIRATION BEHIND IT IS DIRECTLY LINKED TO THE HISTORIC TRADITION OF "MEMENTO MORI" (REMEMBER DEATH). FOR THE POSTER'S DESIGNER, <u>ERIK JOHAN WORSØE ERIKSEN</u>, THAT MEANS LIVE TODAY AND FILL LIFE WITH SOMETHING PRECIOUS EVERY DAY, OR AT LEAST EVERY WEEKEND.

NORWAY
products of play
memento mori plakat, self-promotional poster, 2002

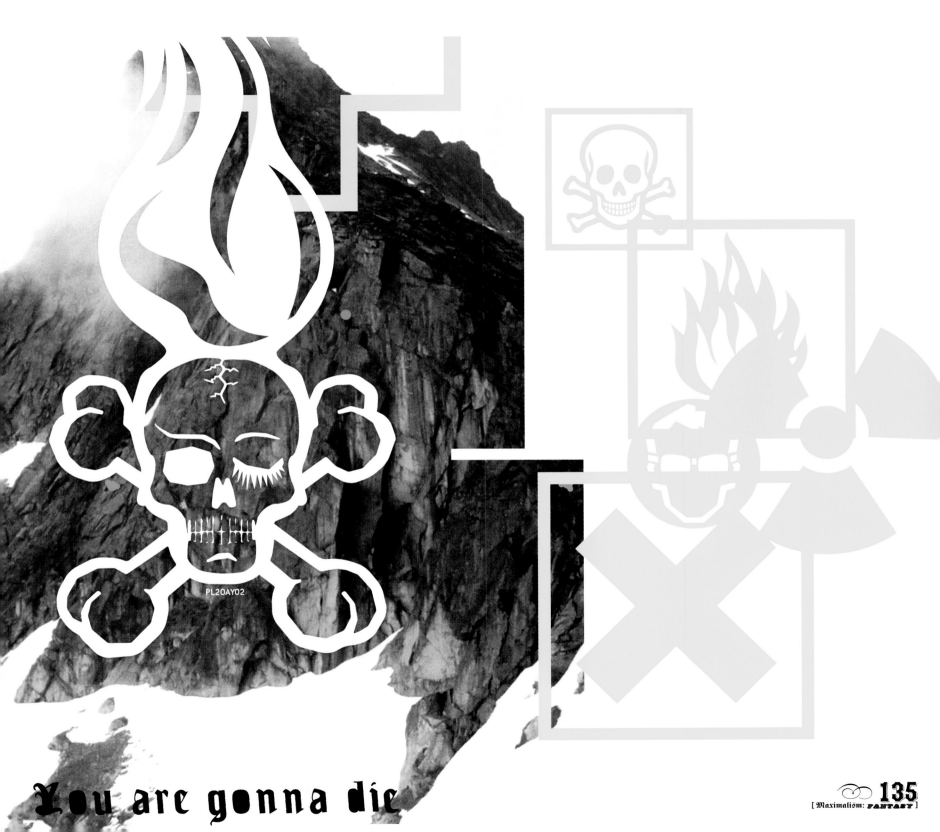

You are gonna die

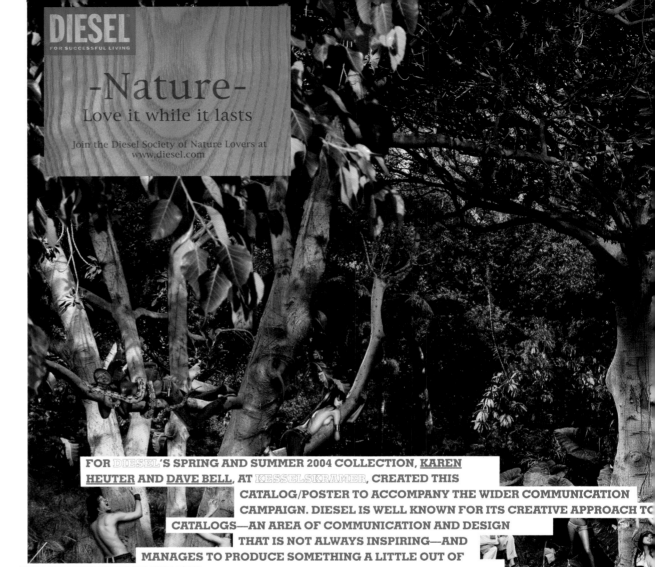

-Nature-
Love it while it lasts

Join the Diesel Society of Nature Lovers at
www.diesel.com

FOR DIESEL'S SPRING AND SUMMER 2004 COLLECTION, KAREN HEUTER AND DAVE BELL, AT KESSELSKRAMER, CREATED THIS CATALOG/POSTER TO ACCOMPANY THE WIDER COMMUNICATION CAMPAIGN. DIESEL IS WELL KNOWN FOR ITS CREATIVE APPROACH TO CATALOGS—AN AREA OF COMMUNICATION AND DESIGN THAT IS NOT ALWAYS INSPIRING—AND MANAGES TO PRODUCE SOMETHING A LITTLE OUT OF THE ORDINARY EACH SEASON.

THE NETHERLANDS
kesselskramer
diesel catalog/poster, 2004

The clothes in the spring and summer 2004 collection had a natural, tropical feel to them and KesselsKramer used this as the inspiration for the communication campaign. The main idea of the campaign is that it asks people to "become nature lovers for successful living." The image in this poster reflects the strapline, Nature: Love it While it Lasts, showing people quite literally getting it on with plants—giving flowers oral sex, rubbing up against trees, hugging eggs, and displaying other physical expressions of love.

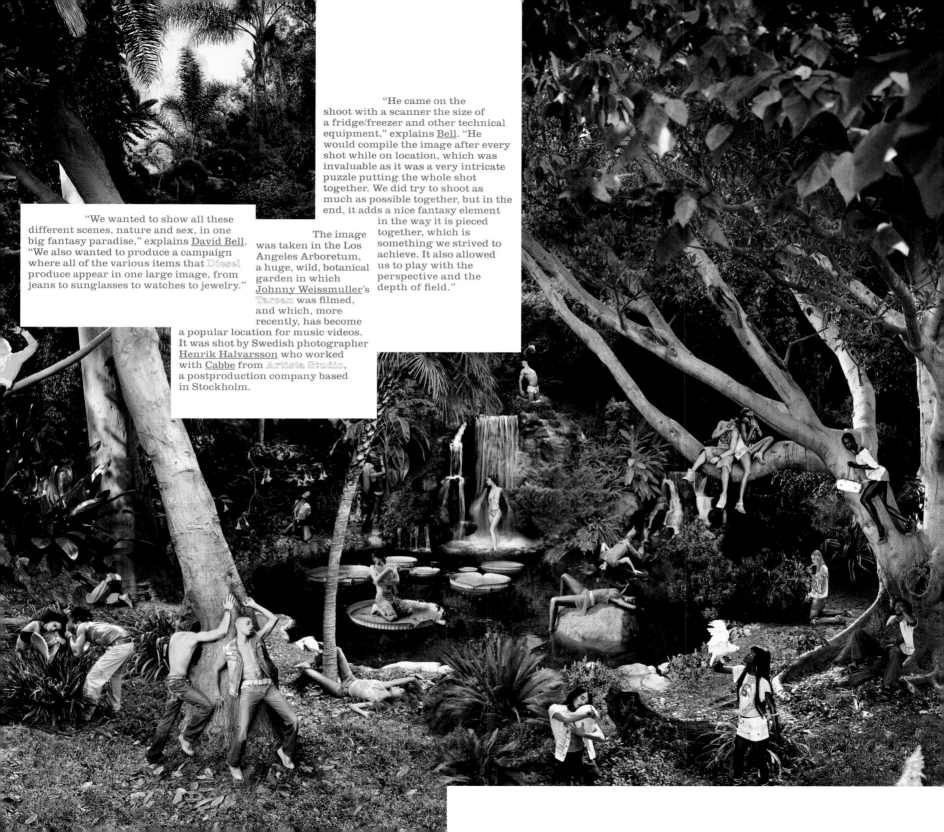

"We wanted to show all these different scenes, nature and sex, in one big fantasy paradise," explains David Bell. "We also wanted to produce a campaign where all of the various items that Diesel produce appear in one large image, from jeans to sunglasses to watches to jewelry."

"He came on the shoot with a scanner the size of a fridge/freezer and other technical equipment," explains Bell. "He would compile the image after every shot while on location, which was invaluable as it was a very intricate puzzle putting the whole shot together. We did try to shoot as much as possible together, but in the end, it adds a nice fantasy element in the way it is pieced together, which is something we strived to achieve. It also allowed us to play with the perspective and the depth of field."

The image was taken in the Los Angeles Arboretum, a huge, wild, botanical garden in which Johnny Weissmuller's Tarzan was filmed, and which, more recently, has become a popular location for music videos. It was shot by Swedish photographer Henrik Halvarsson who worked with Cabbe from Artista Studio, a postproduction company based in Stockholm.

CLUB FLYERS AND POSTERS ARE USUALLY SEEN AS THROW-
AWAY OBJECTS WITH A SHORT LIFE SPAN, BUT THESE EXAMPLES FOR THE MONTHLY MISH
MASH CLUB NIGHTS IN LONDON AND GLASGOW HAVE
LONGEVITY. "WE SEE EACH POSTER
AND FLYER AS A WORK OF ART IN ITS OWN RIGHT,"
EXPLAINS THE MAN BEHIND THE DESIGN AND
CREATIVE DIRECTOR AT INSECT, **PAUL HUMPHREY**.

UNITED KINGDOM
insect
mish mash posters and flyers, 2003/2004

"The images are inspired by what was happening around us at the time of illustrating each piece," explains Humphrey. "By just pulling in influences from everything. London life. We gather images from all sorts of places; from my personal CD library—which I have been gathering for nearly 10 years—to my mom's amazing collection of old illustrated books."

The cut-and-paste style, the symmetry, and the "mish mash" of imagery forms a link between these club posters, creating a series from what started out as simple flyers. Now the Insect team plans to exhibit the posters, stripping them of type, enlarging them to A0 (c. $33 \times 46^{7}/\sin$) size, and treating the London club itself as a gallery space.

The name Mish Mash suggested a visual concoction of different images, and that is where Humphrey started on each piece of artwork. He and his team gathered together imagery that was somehow politically or seasonally linked with each month. There was no brief as such; the club night's promoter simply wanted something that reflected the eclecticism of the club's music policy.

mish mash
Sat 3rd January

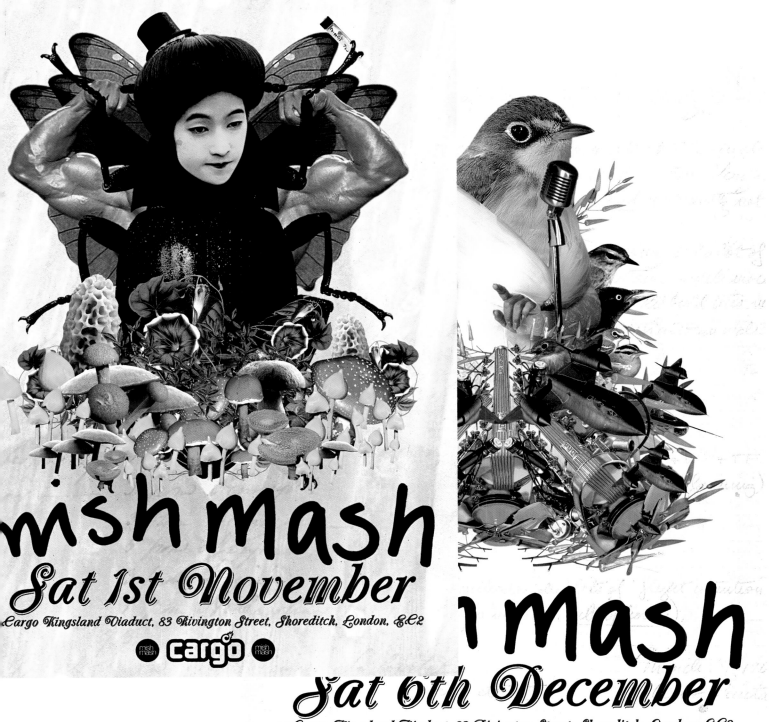

mish mash

Sat 1st November

Cargo Kingsland Viaduct, 83 Rivington Street, Shoreditch, London, EC2

m mash

Sat 6th December

at Cargo Kingsland Viaduct, 83 Rivington Street, Shoreditch, London, EC2

UNITED KINGDOM

andrew wyatt

the story of perfume, personal project, 2000
chocolate poodles, personal project, 2003

LONDON-BASED <u>ANDREW WYATT</u> HAS BEEN CREATING FANTASTICALLY KITSCH BUT
THOUGHTFUL IMAGES FOR A VARIETY OF CLIENTS FOR MORE THAN 15 YEARS. HIS LAYERED
COLLAGES ARE INSPIRED BY THE WORK OF SUCH ARTISTS AS <u>RICHARD DADD</u>, <u>HIERONYMUS BOSCH</u>, <u>JOHN
MARTIN</u>, AND <u>TERRY GILLIAM</u>, AND BY HIS MEMORIES OF GROWING UP ON AN ÜBERMODERN,
1971 HOUSING ESTATE. HERE BEGAN HIS KEEN INTEREST IN COLLECTING EPHEMERA FROM THE PAST—THE REMNANTS LEFT BY
FAMILIES MOVING OUT TO NEW ESTATES.

"I always wanted to create something dreamlike that just went on and on," explains <u>Wyatt</u>. "I would do drawings of subjects, like a period of architecture, that just evolved over tacked-on pieces of drawing paper. Then I discovered the quirky power of cutting out magazine pictures and sticking big heads on little bodies, making rooms and little worlds to put the strange figures into. I love something rich that the viewer can spend time looking at."

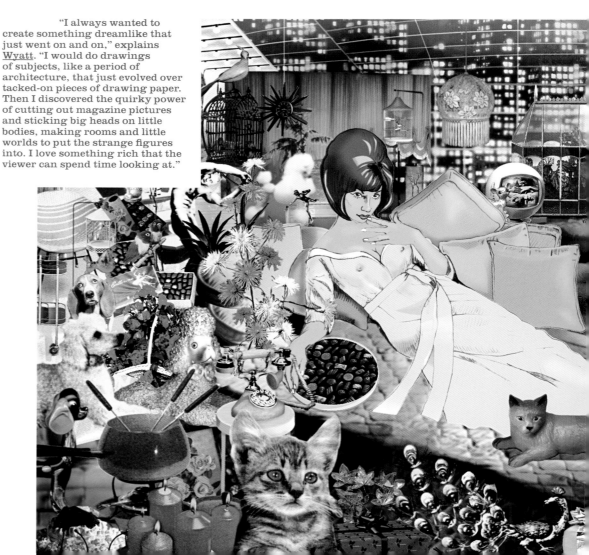

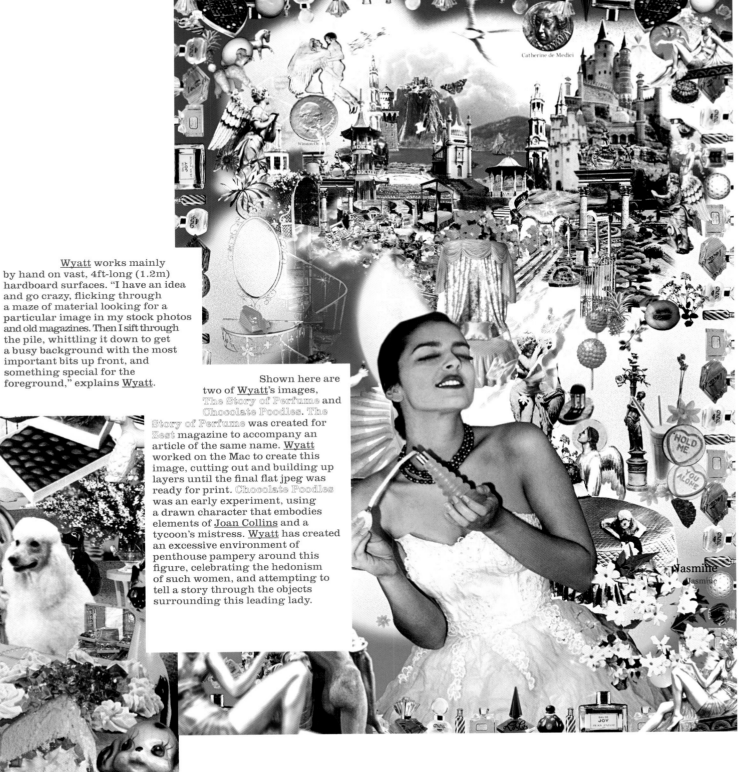

Wyatt works mainly by hand on vast, 4ft-long (1.2m) hardboard surfaces. "I have an idea and go crazy, flicking through a maze of material looking for a particular image in my stock photos and old magazines. Then I sift through the pile, whittling it down to get a busy background with the most important bits up front, and something special for the foreground," explains Wyatt.

Shown here are two of Wyatt's images, The Story of Perfume and Chocolate Poodles. The Story of Perfume was created for Zest magazine to accompany an article of the same name. Wyatt worked on the Mac to create this image, cutting out and building up layers until the final flat jpeg was ready for print. Chocolate Poodles was an early experiment, using a drawn character that embodies elements of Joan Collins and a tycoon's mistress. Wyatt has created an excessive environment of penthouse pampery around this figure, celebrating the hedonism of such women, and attempting to tell a story through the objects surrounding this leading lady.

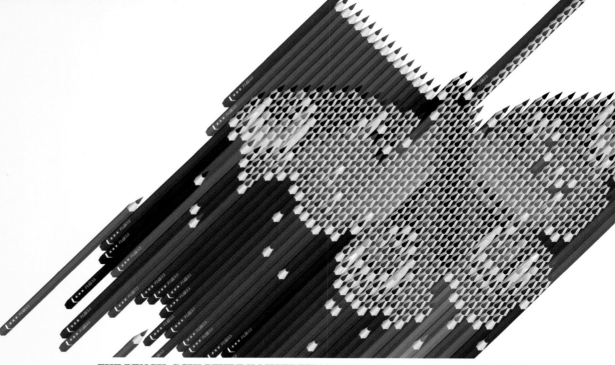

THE PENCIL SCULPTURE ILLUSTRATION SERIES IS A SELF-INITIATED PROJECT BY
LONDON-BASED DESIGN GROUP FL@33. THE SCULPTURES WERE MADE USING FABER
AQUARELL PENCILS. EYE SCULPTURE CONTAINS 470 PENCILS, BUTTERFLY SCULPTURE 818.

EYE SCULPTURE WAS FIRST PUBLISHED IN JULY 2002
AS A SELF-PROMOTIONAL SPREAD IN FRENCH MAGAZINE OFR, BUT
WAS LATER USED ON AN A2 (C. 16½ × 23⅜IN) PROMOTIONAL
POSTER FOR THE BOOK LAUNCH OF GB: GRAPHIC BRITAIN AT
MAGMA GALLERY, LONDON. BUTTERFLY SCULPTURE WAS
DESIGNED ESPECIALLY FOR THIS LAUNCH.

UNITED KINGDOM
fl@33
pencil sculpture posters, personal project, 2002

So how were these
images created? "We found a
collection of 200 or so Faber
Aquarell pencils and took photos,
made drawings, and looked at a
handful of them for a long time,"
explains Agathe Jacquill at FL@33.
"Then, inspired by the intriguing
45° isometric drawing, usually used
for technical drawings, we started
experimenting. The 45° effect allows
for very surprising visual effects
when used in carefully composed
artworks, and that is how we created
these images. The pencils were
created as vector graphics and
then generated digitally using
Macromedia FreeHand."

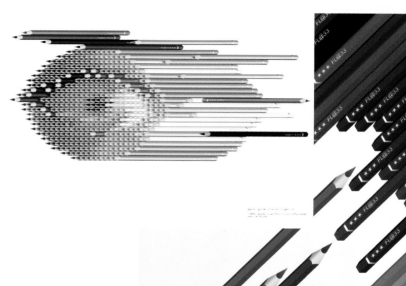

UNITED KINGDOM
insect
the selfridges magazine feature illustration, 2003

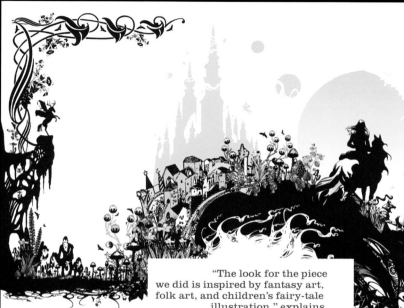

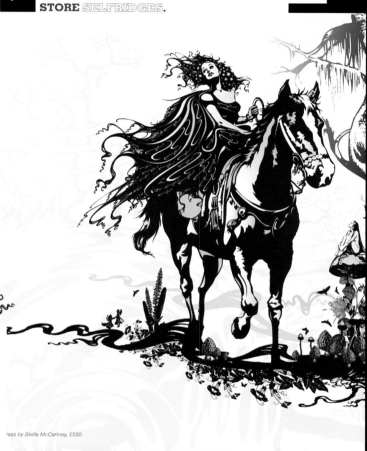

"The look for the piece we did is inspired by fantasy art, folk art, and children's fairy-tale illustration," explains Paul Humphrey of Insect. "However, we tried to give it a contemporary edge."

The magazine is produced by Tyler Brûlé's London-based agency Winkreative. Winkreative commissioned Insect to create an illustration for a story about the then latest fashion offering from designer Stella McCartney. The brief was simply for Insect to produce an illustration that would fit in with the article, which was about images of fantasy being used in fashion.

This piece of work, featured in issue 4 of The Selfridges Magazine, has also been used, along with other designers' work, in a book put together by Los Angeles–based design group PLINKO. For this, 25 designers from around the world swapped projects and they all redesigned each other's work.

...ress by Stella McCartney, £550

FRANCE

surface to air

SURFACE TO AIR IS KNOWN FOR ITS STRIKING POSTER DESIGNS. THE EXAMPLES HERE EPITOMIZE THE IDEA OF MAXIMALISM IN BOTH CONTENT AND DESIGN. THEIR ECLECTIC MIX OF BOLD TEXT AND GRAPHIC ILLUSTRATION PRODUCES STRONG, POWERFUL IMAGES.

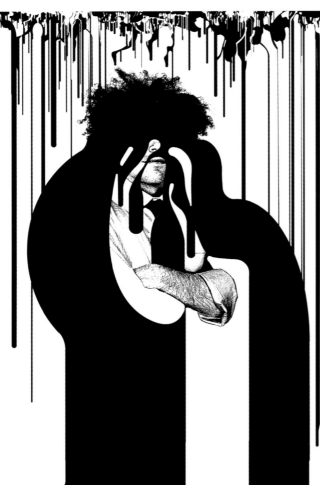

passerby, personal project, 2003–2004

 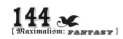

Heavy Change/Police Riot

For these posters, the designers played with images and graphics that are generally considered to be "outside" the official graphic design culture: skulls, heavy metal references, overloaded images, and violence. They combined these with Gothic-influenced, ornamental typefaces to produce heavy, information-loaded posters. "We are not antiminimalist. We like Swiss and informational design, but then we also like to combine them with overload graphics," add Marotto and Rozan. "I guess we believe that the graphic world is rich enough to play from one side to the other."

Passerby

These form part of one of Surface to Air's personal projects. As Santiago Marotto and Jérémie Rozan at Surface to Air explain, they are sometimes in the fortunate position of being able to do work on projects for themselves. "What we did to create these images was shoot pictures, mostly of friends, who passed by our gallery and photo studio over a period of a few months," explains Marotto. "We then scanned in their pictures and worked in a high-contrast photocopy style, making graphic interventions on the pictures, and playing around with them according to our personal interpretation of the portrait." The project developed into an exhibition, which was shown in Tokyo and Paris in 2004. The images were screen printed as a series of posters measuring 120 × 80cm (47 × 31½in). The images were also used on T-shirts and belts.

Heavy Change

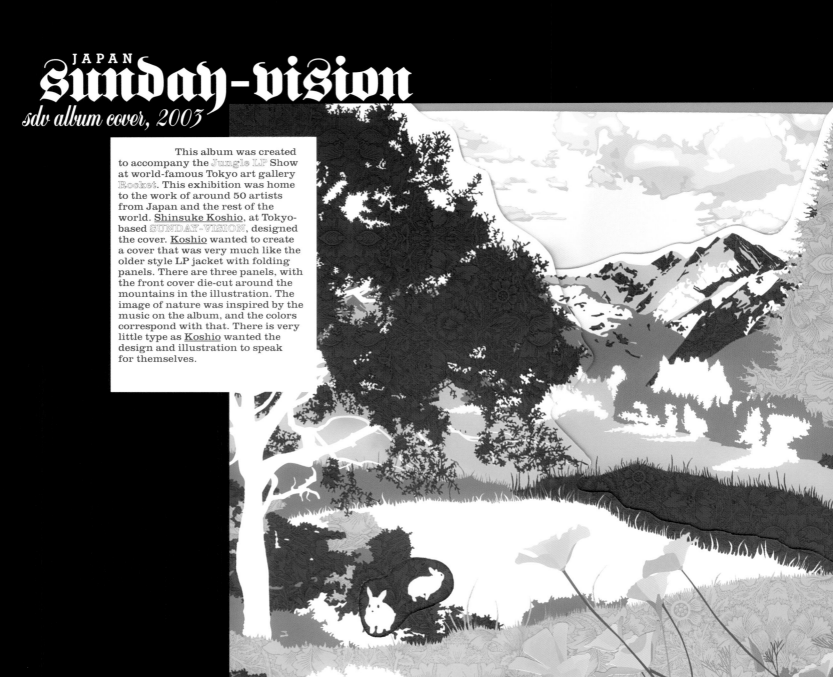

JAPAN
sunday-vision
sdv album cover, 2003

This album was created to accompany the Jungle LP Show at world-famous Tokyo art gallery Rocket. This exhibition was home to the work of around 50 artists from Japan and the rest of the world. Shinsuke Koshio, at Tokyo-based SUNDAY-VISION, designed the cover. Koshio wanted to create a cover that was very much like the older style LP jacket with folding panels. There are three panels, with the front cover die-cut around the mountains in the illustration. The image of nature was inspired by the music on the album, and the colors correspond with that. There is very little type as Koshio wanted the design and illustration to speak for themselves.

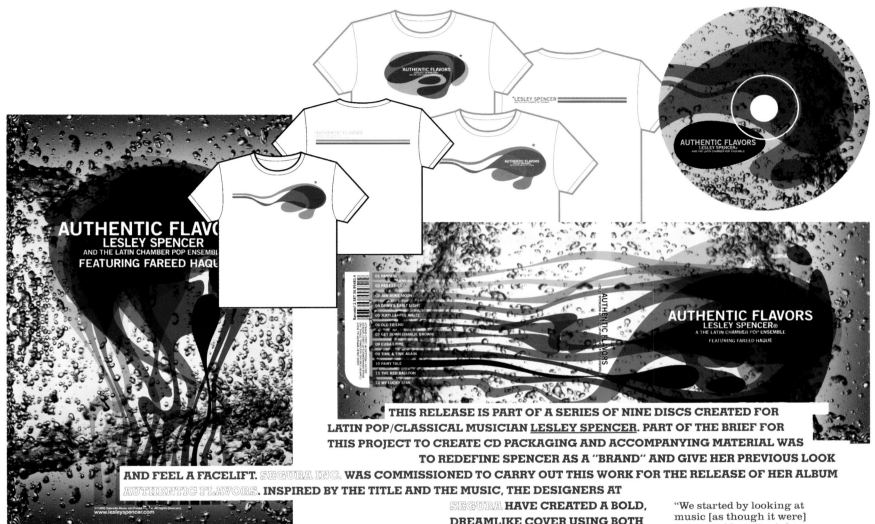

AUTHENTIC FLAVORS
LESLEY SPENCER
AND THE LATIN CHAMBER POP ENSEMBLE
FEATURING FAREED HAQUE

©2002 Gabrielle Music and Publishing, Inc. All Rights Reserved.
www.lesleyspencer.com

01 FANFARE
02 PAST LIVES
03 JAW-BONE MOON
04 DAWN'S EARLY LIGHT
05 JUKYLLAHYDE WALTZ
06 OLD FRIEND
07 GET DOWN CHARLIE BROWN!
08 CUBA LIBRE
09 TIME & TIME AGAIN
10 FAIRY TALE
11 THE RED BALLOON
12 MY LUCKY STAR

AUTHENTIC FLAVORS
LESLEY SPENCER®
A THE LATIN CHAMBER POP ENSEMBLE
FEATURING FAREED HAQUE

AUTHENTIC FLAVORS
LESLEY SPENCER
AND THE LATIN CHAMBER POP ENSEMBLE

*LESLEY SPENCER

THIS RELEASE IS PART OF A SERIES OF NINE DISCS CREATED FOR
LATIN POP/CLASSICAL MUSICIAN LESLEY SPENCER. PART OF THE BRIEF FOR
THIS PROJECT TO CREATE CD PACKAGING AND ACCOMPANYING MATERIAL WAS
TO REDEFINE SPENCER AS A "BRAND" AND GIVE HER PREVIOUS LOOK
AND FEEL A FACELIFT. SEGURA INC. WAS COMMISSIONED TO CARRY OUT THIS WORK FOR THE RELEASE OF HER ALBUM
AUTHENTIC FLAVORS. INSPIRED BY THE TITLE AND THE MUSIC, THE DESIGNERS AT
SEGURA HAVE CREATED A BOLD,
DREAMLIKE COVER USING BOTH
PHOTOSHOP AND ILLUSTRATOR.

"We started by looking at
music [as though it were]
spices and how it might
create a recipe for flavors,"
explains Carlos Segura.
"It was inspired by the idea
of colors as assorted flavors
and how they may relate to
music. The shape was born out of all
of the color combinations extruded
from each track name."

UNITED STATES
Segura inc.
authentic flavors, cd packaging and promotional material, 2003

SWEDEN

brilliant

video for paris' single "disco song," v2 records, 2003

THIS GRAPHIC IS TAKEN FROM A MUSIC VIDEO FOR SWEDISH POP GROUP PARIS' SINGLE "DISCO SONG." MANS NYMAN, WHO DIRECTED THE VIDEO, WANTED TO COMBINE FILMED MATERIAL OF THE BAND IN ACTION WITH COMPUTER ANIMATIONS. HE ASKED FRANS CARLQVIST AT STOCKHOLM-BASED DESIGN AGENCY BRILLIANT TO COME UP WITH IDEAS AND DESIGNS FOR THE ANIMATIONS.

This is a great example of how illustrators and designers are using the computer to create images that are as organic and free-flowing as a hand-drawn image can be.

Carlqvist created many different illustrations using Illustrator 8.0, and worked closely with Nyman and 3-D animator Jim Studt on many iterations to eventually come up with the series of bold, graphic, heavily patterned and colorful images that were used in the video.

So why the plants? "The song is about stuff you do in the summertime, being outdoors, wine, picnics, festivals, etc., so the idea was to put that summer feeling into the apartment. Since I've been into drawing nonexisting, experimental plants for a while, the surreal feeling and patterns came sort of natural," explains Carlqvist. "The idea is based on the beauty of nature. In the video, flowers and trees grow inside the band's apartment and turn it into the forest that you see here."

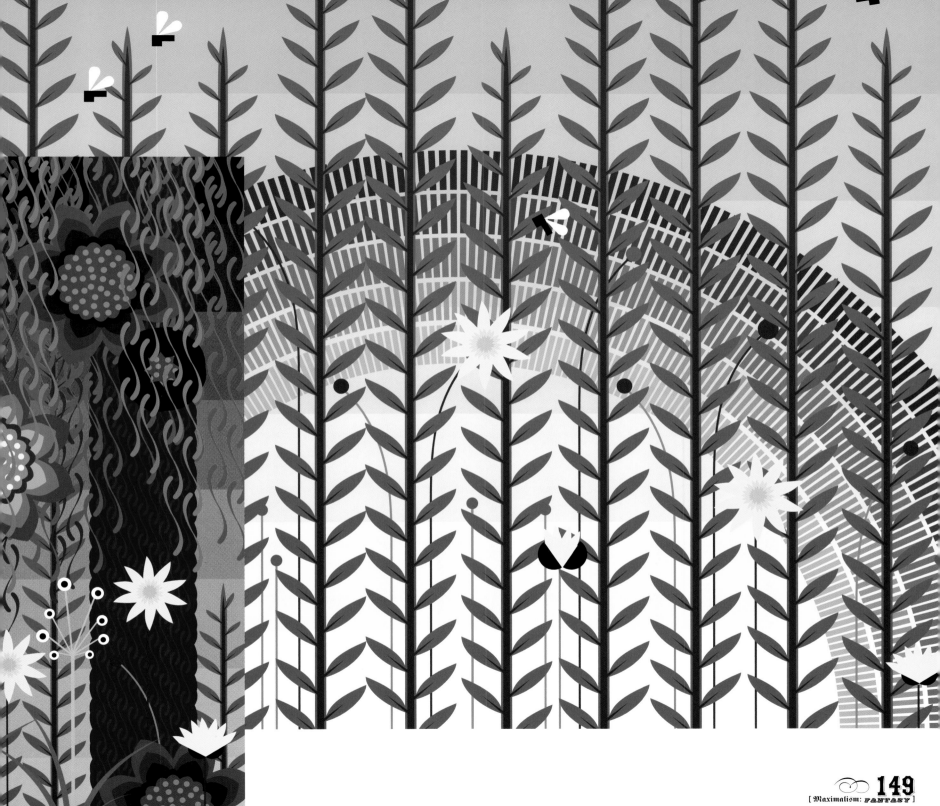

STUDIO18HUNDRED IS A NEW YORK–BASED DESIGN STUDIO, FOUNDED
BY CHRIS RUBINO, ROGER BOVA, AND SEAN DONNELLY, THAT SPECIALIZES IN SCREEN PRINTING. SHOWN
HERE ARE A NUMBER OF THE STUDIO'S PROJECTS. ARTSTART IS A NONPROFIT ART PROJECT THAT BENEFITS
UNDERPRIVILEGED YOUTH IN NEW YORK, GIVING THEM THE OPPORTUNITY
TO BECOME INVOLVED IN ART PROGRAMS AFTER SCHOOL. THIS SMALL
SCREEN PRINT WAS CREATED TO BE AUCTIONED OFF AT AN ARTSTART
BENEFIT. BASED ON THE CONCEPT OF ASCENT, A COMBINATION OF IMAGES TELLS THE STORY
FROM THE BOTTOM TO THE TOP OF THE PRINT.
THE IMAGE'S DECORATIVE AND MYSTICAL AIR ATTEMPTS TO
CONVEY THE ETHEREAL QUALITIES OF THAT STORY.

UNITED STATES

chris rubino/studio18hundred

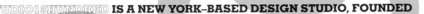

postcards, personal project, 2003

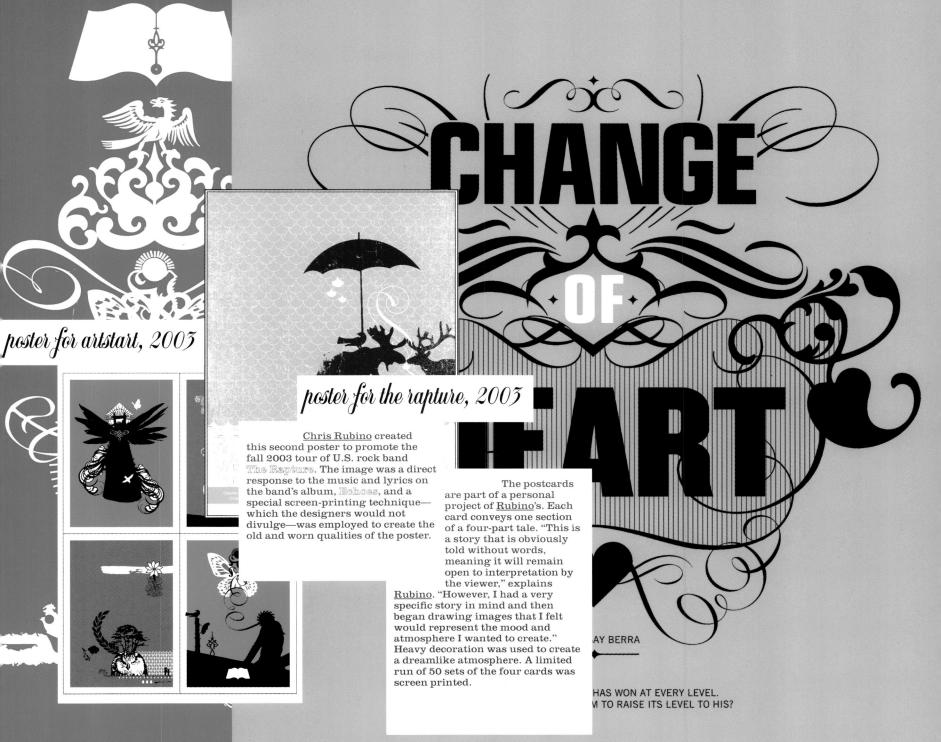

CHANGE OF ART

poster for artstart, 2003

poster for the rapture, 2003

Chris Rubino created this second poster to promote the fall 2003 tour of U.S. rock band The Rapture. The image was a direct response to the music and lyrics on the band's album, Echoes, and a special screen-printing technique—which the designers would not divulge—was employed to create the old and worn qualities of the poster.

The postcards are part of a personal project of Rubino's. Each card conveys one section of a four-part tale. "This is a story that is obviously told without words, meaning it will remain open to interpretation by the viewer," explains Rubino. "However, I had a very specific story in mind and then began drawing images that I felt would represent the mood and atmosphere I wanted to create." Heavy decoration was used to create a dreamlike atmosphere. A limited run of 50 sets of the four cards was screen printed.

AY BERRA

HAS WON AT EVERY LEVEL.
M TO RAISE ITS LEVEL TO HIS?

~ 1 ~

ART DIRECTOR, DESIGNER, AND ILLUSTRATOR SAIMAN CHOW, BORN IN
HONG KONG, NOW LIVES AND WORKS IN LOS ANGELES. THESE TWO ILLUSTRATIONS,
YAO MING AND CHINESE BABY, WERE CREATED FOR TOKION AND WIRED MAGAZINES, RESPECTIVELY.
LIKE MANY ILLUSTRATORS, CHOW WORKS IN PHOTOSHOP AND
ILLUSTRATOR, BUT THE BRIGHT, BOLD, COLORFUL, AND ENERGETIC QUALITIES OF THESE IMAGES
REFLECTS THE OBVIOUS INFLUENCE OF CHINESE CULTURE AND ITS TRADITIONAL ARTS.

"The Art Director at Wired really wanted the Chinese Baby illustration to have a Chinese propaganda poster look to it," explains Chow. "I try to make all my pieces as personal as I can, but in this case you still get the feeling for that propaganda look."

Chow has founded his own company, ESL, having left Los Angeles–based motion graphic company Brand New School, and plans to collaborate with different artists to produce products and prints, as well as exhibitions of his work. "I like line art, but at the same time I want to experiment with photo collage," explains Chow. "I also like mixing stuff together a lot and playing around with it. Sometimes it works, sometimes it doesn't. As long as I try something different every time I approach a piece, I'll be satisfied. Usually coming up with ideas is the hardest part. Once you have that, everything else tends to fall into place."

UNITED STATES

saiman chow at esl

yao ming, illustration for tokion magazine, 2004
chinese baby, illustration for wired magazine, 2004

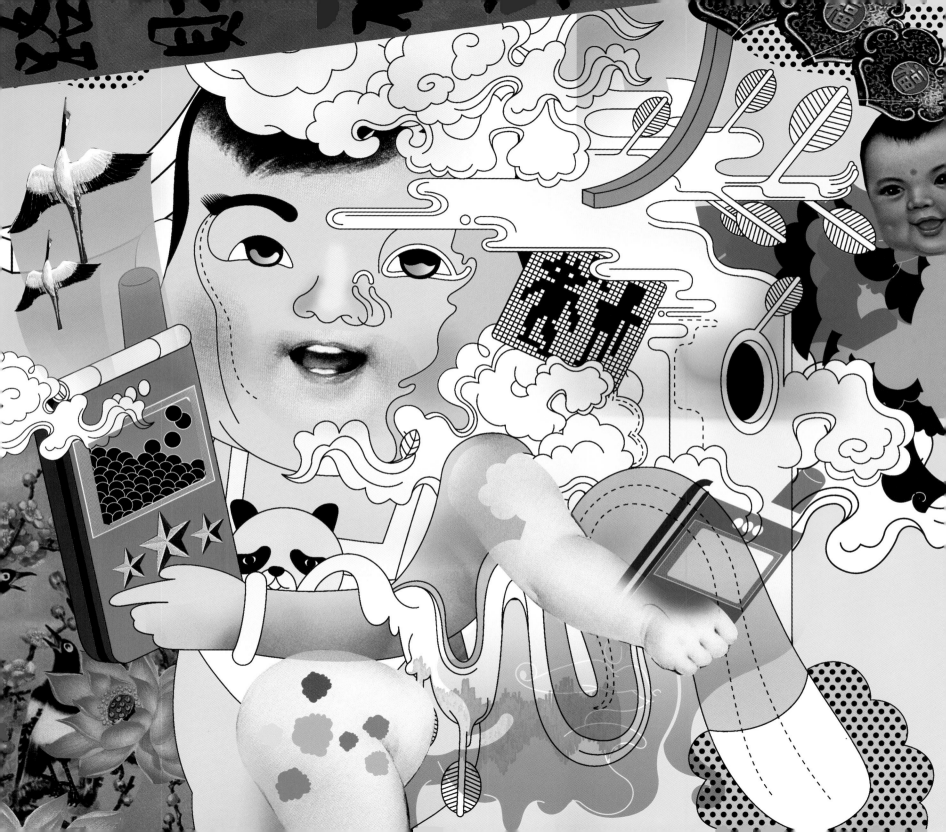

contact details

index_

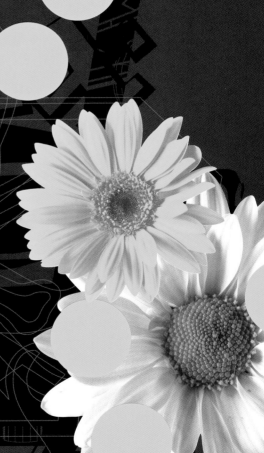